Portrait Photography:
From
Snapshots to
Great Shots

Portrait Photography:
From
Snapshots to
Great Shots

Erik Valind

Peachpit
Press

Portrait Photography: From Snapshots to Great Shots
Erik Valind

Peachpit Press
www.peachpit.com

To report errors, please send a note to errata@peachpit.com

Peachpit Press is a division of Pearson Education.
Copyright © 2014 by Peachpit Press

Project Editor: Valerie Witte
Production Editor: Katerina Malone
Developmental and Copyeditor: Anne Marie Walker
Proofreader: Patricia J. Pane
Composition: WolfsonDesign
Indexer: Valerie Haynes Perry
Cover Image: Erik Valind
Cover Design: Aren Straiger
Interior Design: Mimi Heft

ISBN-13: 978-0-321-95161-8
ISBN–10: 0-321-95161-1

4 17

Printed and bound in the United States of America

Dedication

To the muse; for when she resides in a person,
we cannot help but to take up our cameras.

Acknowledgements

I would like to sincerely thank all of my friends, family, and clients who have sat in front of my lens over the years. A real portrait is more about communication and trust than any combination of camera settings. Thank you for trusting me.

I want to thank the people who inspired me to pursue portrait photography in the beginning and who still inspire me to pick up the camera every day. Thank you, Danielle, for being my first muse, for drawing my gaze from action sports and the ocean to the people who actively pursue life instead. Thank you, Keely, for being my canvas and my mirror as I strove to learn how to shape light. You and so many others radiate beauty inside and out, and I hope that over the years I've managed to catch but a glimmer of that on film.

I definitely want to thank the entire team over at Peachpit. Especially Ted Waitt for bringing me into the family, and Valerie Witte for cracking the whip and making sure my first solo book turned out great. I also need to thank Anne Marie Walker, Katerina Malone, and Patricia Pane for assisting me in taking tons of content and crafting it into something pretty to look at and pleasant to read. Without the aid of a small army, my words and photos would be nothing more than a bloated blog post. The quality of their contributions will be obvious in the pages of this book, but their professionalism and patience throughout the entire process is what I appreciated the most.

Also a special thank-you to Olivier from Sylights.com, and to all companies that put an emphasis on education with their products and services.

Finally, I want to thank everyone who has read my books or attended one of my workshops or seminars. Learning one's craft is key to creating better work and realizing the images in your mind's eye. Thank you for giving me the opportunity to share what I'm passionate about with you, and for helping me become a better photographer and teacher in the process.

Erik Valind
New York, NY
February, 2014

Contents

INTRODUCTION IX

CHAPTER 1: TOP 10 TIPS TO BETTER PORTRAITS 1
How to Start Taking Better Portraits Right Out of the Box!

Poring Over the Picture 2

1. Shoot in Aperture Priority Mode 4

2. Set Your Metering Mode 5

3. Choose Your Picture Style 5

4. Turn Off Your Pop-up Flash 6

5. Step Back and Zoom In 8

6. Focus on the Eyes 10

7. Offset Your Subject in the Frame 12

8. Shoot Down on Your Subject 14

9. Look Out for Clean Headspace 15

10. Turn Your Subject Into the Light 17

Chapter 1 Assignments 19

CHAPTER 2: CAMERA SETTINGS AND LENS SELECTION 21
Use the right settings, composition, and lenses for
 capturing your photos

Poring Over the Picture 22

Camera Settings 24

Lens Selection 33

Composition 41

Cropping 49

Chapter 2 Assignments 55

CHAPTER 3: POSING, RAPPORT, AND PROBLEM SOLVING 57

How To Successfully Communicate, Plan, and Pose
 While Working with Your Subject

Poring Over the Picture	58
People First; All Else Second	60
Inspiration, Prep, and Props	60
Giving Direction	66
Getting Feedback	72
Chapter 3 Assignments	74

CHAPTER 4: WORKING WITH NATURAL LIGHT 77

Identify the Quality and Direction of Natural Light
 to Capture Great Shots 77

Poring Over the Picture	78
Understanding Light	80
Overcoming Difficult Lighting Scenarios	84
Chapter 4 Assignments	104

CHAPTER 5: WORKING WITH EXISTING INDOOR LIGHT 107

Conquer the Obstacles of Using Existing Light to
 Produce Great Shots

Poring Over the Picture	108
Color Temperature	110
Combating Camera Shake	119
Chapter 5 Assignments	127

CHAPTER 6: ON-CAMERA FLASH 129

An On-Camera Flash Can Light an Entire Scene or Just Add
 That Extra Sparkle to Your Subject's Eye

Poring Over the Picture	130
Flash Power	132
Pop-up Flash	134
Speedlights	138
On-Camera Flash Modifiers	144
Chapter 6 Assignments	151

CHAPTER 7: ADDING ARTIFICIAL LIGHT AND LIGHTING MODIFIERS **153**

Deciding What Type of Lighting to Use And When to Use It

Poring Over the Picture	154
Light Direction, Placement, and Quality	156
Light Modifiers	165
Light Sources	176
Lighting Scenarios	182
Chapter 7 Assignments	189

CHAPTER 8: SINGLE-PERSON PORTRAIT SCENARIOS **191**

Bringing It All Together

Poring Over the Picture	192
Studio Portraits	194
Headshots You Can Bank On	205
Environmental Portraits	214
Chapter 8 Assignments	217

CHAPTER 9: GROUP PORTRAIT SCENARIOS **219**

Establishing Depth of Field, Perspective, and Lighting

Poring Over the Picture	220
Camera Settings to Consider	222
Shooting Couples	224
Family Photos	228
Large Groups and Sportraits	233
Chapter 9 Assignments	239

INDEX **240**

Introduction

Many photo books that you'll see on the shelf do a great job of delving into specific aspects of photography. Some books cover narrow subjects, like studio portrait lighting, or using only natural daylight. I wrote this book with a goal of combining all of the different pieces that work together to make a great portrait, with any subject, regardless of the lighting conditions. Yes, it was a lofty goal, but I guarantee after reading this book you'll approach your subject, your gear, and your locations differently. With this newfound awareness, you'll be creating incredible portraits in no time.

Q: What can I expect to learn from this book?

A: In this book, you'll get a well-rounded guide to taking better portraits—from the technical camera settings and lens selection, to the intangible communication and direction with your subjects, and finally, to specific tools and techniques for conquering a wide range of lighting environments to make people look their best.

Q: What are the assignments all about?

A: Don't worry, the assignments aren't meant to feel like high school math homework. Personally, I learn best by doing, so each assignment covers techniques that were discussed in the chapter, and they encourage you to go out and put them into practice as soon as possible. This way you can focus on your subject at the next photoshoot, and not on trying a new tip or technique for the first time. Practice makes perfect. Then make sure to share your results with other readers on the book's Flickr page.

Q: Should I read the book straight through or can I skip around from chapter to chapter?

A: Definitely begin with Chapter 1. It is designed to improve your portrait photography skills in a matter of minutes, helping you dial in key camera settings and important tips on composition. After that most of the book is broken up in such a way that each chapter covers a specific scenario or lighting environment. You can skip ahead to a problem that's vexing you at the moment, or more importantly, you can use these chapters as references to reread before future portrait shoots.

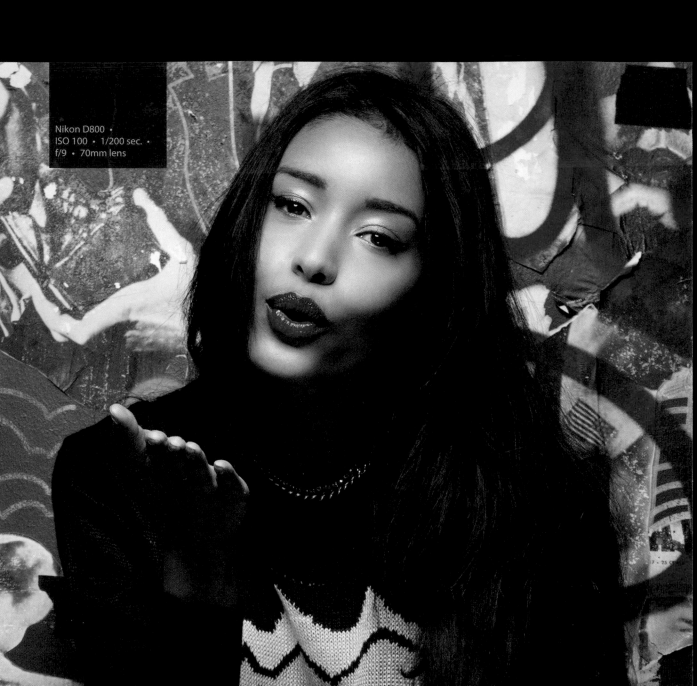

Nikon D800 ·
ISO 100 · 1/200 sec. ·
f/9 · 70mm lens

1

Top 10 Tips to Better Portraits

How to Start Taking Better Portraits Right Out of the Box!

If you only have time to read one chapter, this is it—the top tips to taking better portraits right out of the gate. It's not a chapter that tells you to go buy a better lens, or go hire world-class models, or even to fly to exotic locations for better backdrops. It deals with actions you can take right now.

Let's jump right in and start improving your portrait photography with the settings you have on the camera you already own. With a handful of tips and techniques that transcend equipment, you'll be taking great shots in no time.

Cameras at the ready!

I made sure to have the subject keep her nose turned toward the light throughout the shoot. Having her face aimed squarely at the light kept facial shadows to a minimum.

For this photo of a young model in the park I had to travel very light, as I had no assistant. We also had a short time to shoot before sunset. For these reasons I took only one lens and focused on these basic tips to get a great portrait out on location.

The camera was set to Aperture Priority mode, which gave me a constant aperture of f/2.8. This aperture has a very narrow depth of field that is perfect for isolating the subject's eyes, while letting the distracting background go soft.

Rather than using a wide-angle lens, which would distort the model's face and draw more attention to the background, I zoomed in to 85mm and stepped back to fill the frame with the model.

By offsetting the model in the frame, I created a more pleasing composition and left room for the model's hair to blow in the wind, guiding the viewer's eye across the frame.

Nikon D800 •
ISO 100 • 1/160 sec. •
f/2.8 • 85mm lens

1. Shoot in Aperture Priority Mode

Most manufacturers choose to paint their camera's "Auto mode" setting bright green on the mode dial. Maybe that's why when we see it, we instinctively stop thinking and just hit go. Well, from here on out you'll take another route. The goal is to take the wheel and steer. The purpose of Auto mode is to give you an average photo, not a good or great photo, just an average one so you won't return the camera and claim that it doesn't work. On a bright day the "average" for Auto mode setting might put your camera at an aperture of f/16, which renders everything in focus, including your subjects and the distracting background behind them. But in portrait photography, you want the subject to stand out from the background. An easy way to do this is to make the background fall out of focus by controlling the depth of field. (I'll explain what aperture and depth of field are in more depth in Chapter 2). To do this, switch your mode dial to "A" or "Av" for Aperture Priority mode and open up your lens as wide as possible (**Figure 1.1**) by using the smallest numbers available on your lens (f/1.4, f/2.8, or f/5.6). Your camera will then automatically adjust your shutter speed to give you a proper exposure, but the aperture and shallow depth of field will remain constant as you shoot.

Figure 1.1
A camera menu showing the use of Aperture Priority mode to lock in a large aperture for a shallow depth of field.

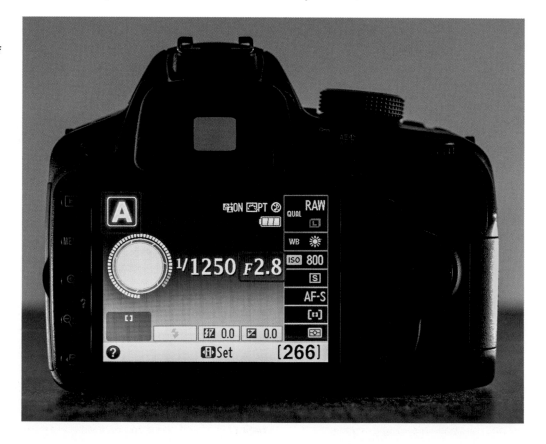

2. Set Your Metering Mode

Your camera has multiple metering modes to choose from. These modes tell your camera how to prioritize the scene when calculating the final exposure. Current cameras do an amazing job of this, allowing you to focus on subject interaction and composition. By default, your camera should be set to "multi-zone metering," which is specifically called Matrix Metering (Nikon) ▣ or Evaluative Metering (Canon) ▣ . This setting breaks up the frame into sections and weighs them against each other to decide what is most important in the scene, and sets the exposure accordingly. For most portraits, you should leave your camera at this setting. Simply set it there, let the camera do the math, and just sit back and direct the subject.

When you're just getting started, this is the most versatile metering mode for the different kinds of portraits you'll be taking. In Chapter 2, I'll cover other metering modes for heavily backlit subjects and other tricky lighting conditions that you'll want to explore after finishing this book.

3. Choose Your Picture Style

Picture Control (Nikon) or Picture Style (Canon) settings specify how your camera interprets the RAW data in a photo and displays it on your screen. When you shoot in the JPEG format, these settings are "baked in," meaning they are permanent. If you shoot in the

RAW file format, these settings can be changed later in postproduction software, like Adobe Lightroom, Apple Aperture, or Adobe Photoshop. (I recommend that all portrait photographers learn about the RAW file workflow because it gives you much more latitude to modify your images after they've been taken.)

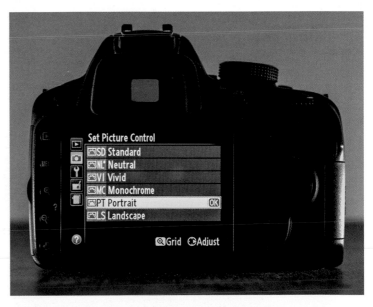

For portrait photography purposes, access this menu area and set it to the Portrait picture setting (**Figure 1.2**). This will put the priority on optimizing skin tones and color saturation while reducing sharpening for softer skin texture. Whether you're shooting RAW, JPEG, or both, you should set your camera to this mode once and forget it. Every photo thereafter will be primed for more pleasing portraits.

Figure 1.2 A camera menu showing the various Picture Styles or Controls. Setting this control to Portrait results in better skin tones and colors.

4. Turn Off Your Pop-up Flash

Most people can immediately see the difference between a professional portrait and a snapshot, but not everyone can articulate what makes that identifiable difference. The pesky pop-up flash on your camera is often the culprit. So right off the bat, *turn that thing off*!

In portrait photography, you're taking a beautiful three-dimensional subject and capturing a moment that is then shared via a two-dimensional medium—a computer screen or a print. During this transition you literally flatten out your subjects. To preserve that flattering 3D feel, you must shape your subjects with light by using the contrasting shadows to define that shape. So whether you're using the sun, lamplight, or a small flash, you want to ensure that the light not only illuminates your subject, but that it casts some kind of shadow as well.

So why not use the pop-up flash? It's true that the pop-up flash creates shadows like anything else, except that the light source is placed directly on top of your camera or *on-camera axis*. This means that the shadows it casts are behind the subject's head and can't be seen by the camera, which gives you that "snapshot" flat shadowless image that you want to avoid. Here are two examples of that pesky pop-up flash ruining a portrait: In **Figure 1.3**, the flash overpowers the daylight ambience, and in **Figure 1.4**, you can see its effect indoors, with a shiny, flat-looking model and an extremely underexposed background.

Figure 1.3 The pop-up flash ruins an outdoor shot with plenty of available light.

Nikon D3200 · ISO 100 · 1/160 sec. · f/5.6 · 70mm lens

Figure 1.4 The pop-up flash flattens out the model's features and leaves the background in the dark.

Nikon D3200 · ISO 800 · 1/200 sec. · f/8 · 70mm lens

Let's turn off that flash and take both of those photos again. I'll use Aperture Priority mode as discussed earlier to allow the camera to expose for the subject's face without the meddling flash. This should make a *big* difference, right? Look how natural and three-dimensional the people and environments look now in **Figure 1.5** and **Figure 1.6**.

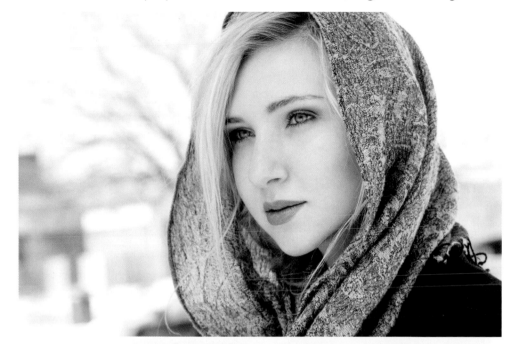

Figure 1.5
Using Aperture Priority mode and no flash, the lighting no longer flattens out the model, and more detail and natural contours are visible on her face.

Nikon D3200 •
ISO 100 • 1/160 sec. •
f/5.6 • 70mm lens

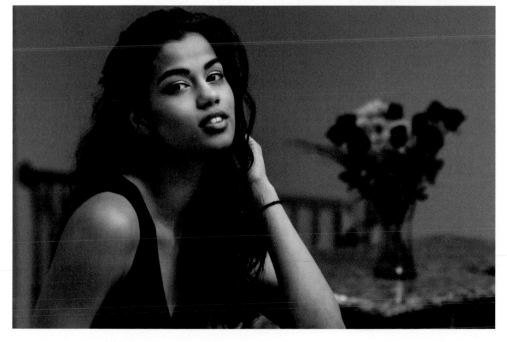

Figure 1.6
Using Aperture Priority mode and just natural light the resulting portrait looks more three dimensional and natural.

Nikon D3200 •
ISO 800 • 1/80 sec. •
f/2.8 • 70mm lens

5. Step Back and Zoom In

Most cameras come with a kit lens, which certainly isn't the best lens available or the one and only lens you'll likely own. But it's like a new toy that actually comes with batteries in the box! What fun would a new camera be if you couldn't immediately start taking an assortment of photographs with it? These kit lenses usually give you a range of focal lengths to work with, from fairly wide angle to medium telephoto. They are certainly versatile enough to get you started.

Often, a person's inclination is to zoom that lens out as wide as it will go. This allows you to see everything, right? Then they frame up their subjects and take the shot. The resulting images often look like the photo in **Figure 1.7**. Did you notice the telltale signs of a snapshot again? When you're shooting with a wide-angle lens, you do gain a larger field of view, but at this wider lens range there is noticeable distortion and bulging of the image. The result isn't that bad for landscape photos, but it's awful for portraits. Notice how this distortion stretches the face as it nears the edges of the frame, as well as makes the nose look rather bulbous.

Figure 1.7
A badly distorted portrait taken with a kit camera lens zoomed all the way out and placed close to the subject's face.
Nikon D3200 •
ISO 450 • 1/30 sec. •
f/4 • 18mm lens

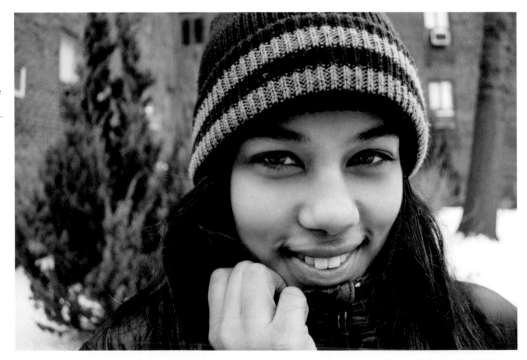

Your goal as portrait photographers is to make your subjects look their very best, not to apply carnival mirror tricks to their beautiful smiling mugs. These dreadful results are easy enough to correct: Simply zoom that lens all the way in and just step back. When photographers speak of "portrait lenses," they are referring to lenses in the telephoto range, generally from 85mm to 135mm and higher. Lenses on this end of the range have distortion as well, but it manifests itself as a more pleasing compression, which flatters a person's face. Now compare the image in **Figure 1.8** to the last one I took. Much better, right?

To take a more flattering portrait photo, remember to use the longest lens you have available and just step back until you fill the frame with your subject's face.

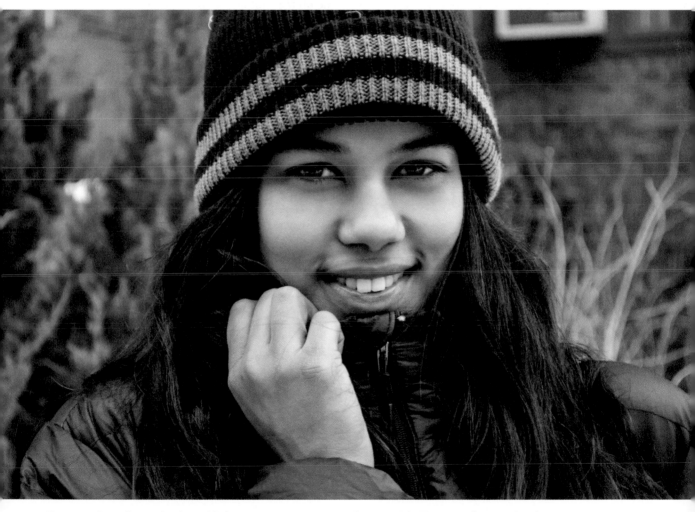

Figure 1.8 A good portrait taken with the same camera settings as the portrait in Figure 1.7 after zooming the kit lens all the way in and stepping back.

Nikon D3200 · ISO 450 · 1/30 sec. · f/4 · 55mm lens

6. Focus on the Eyes

When you're trying out various compositions, you don't want to lose sight of the real target—your subject's eyes. Many poetic references describe the eyes as the gateway to the soul. As photographers, your goal is to keep those eyes in focus and at the forefront of the photograph. This becomes extremely important as you work with lenses capable of a very shallow depth of field. I'll talk about depth of field more in Chapter 2, but for a quick example look at **Figure 1.9**, which was taken with an 85mm f/1.4 lens. Notice that the area in focus is very narrow and completely in the wrong place. You'll see that I accidentally focused on the lock of hair in the back, and the subject's eyes are not in focus at all. **Figure 1.10** is a step in the right direction: The back eye is in focus, but the front is not. Although one eye is in focus, it's the wrong eye. When only the back eye is in focus, it creates an awkward experience for the person viewing the photo. **Figure 1.11** finally shows that front eye in focus, which draws you in and results in the strongest portrait!

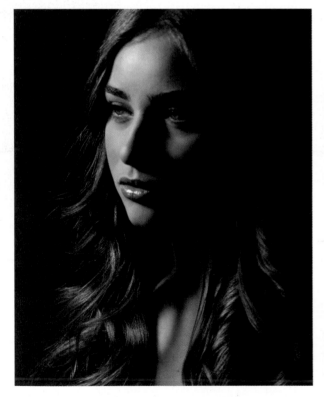

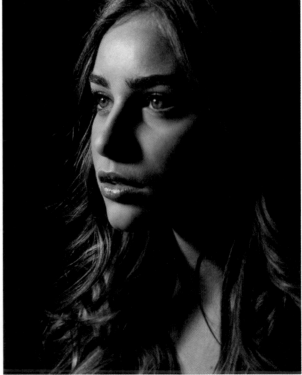

Figure 1.9 The very narrow area of focus completely missed the model's eyes.

Nikon D700 • ISO 110 • 1/250 sec. • f/4 • 85mm lens

Figure 1.10 Only the back eye is in focus here, which makes for an awkward portrait.

Nikon D700 • ISO 110 • 1/250 sec. • f/4 • 85mm lens

Figure 1.11

This is the correct use of a narrow depth of field, with the front eye being tack sharp.

Nikon D700 •
ISO 110 • 1/250 sec. •
f/4 • 85mm lens

7. Offset Your Subject in the Frame

Framing your subject is the next critical factor in enhancing your shots. Let's quickly refer back to Figure 1.8 again because there are actually two aspects of that photo you can improve. The wide-angle distortion was fixed by stepping back and zooming in on the subject, but this still leaves the subject smack-dab in the center of the frame. Centering your photo can make for a very boring composition, because it doesn't guide your viewer's eye through the frame. Rather than centering your subjects as though their face was the middle of a bull's-eye, try to move them around in the frame. Leave some empty or negative space, like the image in **Figure 1.12**. This creates a sense of tension in the photo and invites the viewer to follow the model's gaze across the image. Or, try to put something complementary in that now empty space, like a nice background to place your subject in a scene (**Figure 1.13**).

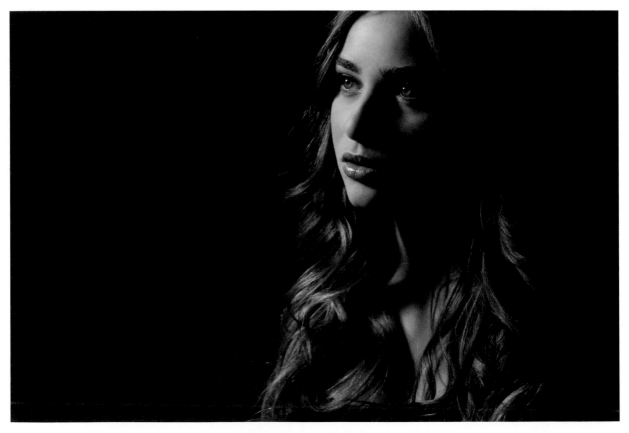

Figure 1.12 **The model was offset in the frame for better composition.**

Nikon D700 · ISO 100 · 1/250 sec. · f/4 · 85mm lens

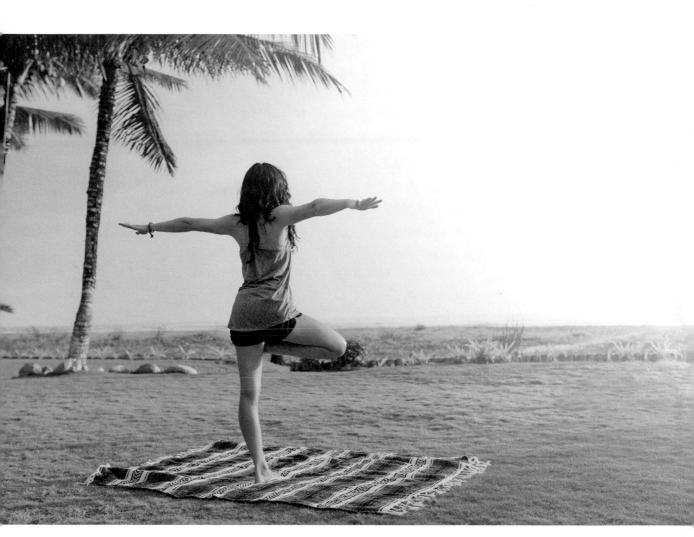

Figure 1.13 The model is offset in the frame, and the negative space is used to showcase her surroundings.

Nikon D800 • ISO 100 • 1/400 sec. • f/3.2 • 35mm lens

8. Shoot Down on Your Subject

You never want to *look* down on someone, but you should absolutely practice *shooting* down on your subject when you're taking his or her portrait. Next time you're photographing someone, think about where you're standing. Is the subject taller than you? Are you looking up her nose ever so slightly? **Figure 1.14** shows an example of a portrait from the perspective of a photographer who's shorter than his subject. It's not the best angle of most people, is it? When you're shooting up at someone, you exaggerate that person's chin and nose while minimizing the eyes. This is the opposite of flattering.

Remember that your focus should be on the eyes. To bring those back as the main attraction, all you need to do is shoot down on your subject. You don't need to run out and get shin implants or only photograph children. This is why in most professional photo studios you'll find apple boxes on hand for you to stand on, giving you the high ground to shoot from. However, you probably won't be shooting in a big studio most days, so I recommend getting a lightweight step stool to take with you on location. In **Figure 1.15**, you can see how from a higher perspective the focus is back on the eyes, and the chin and nose fade away. Perfect.

Figure 1.14 (left)
Shooting up at someone like this is unflattering because it exaggerates the nose and chin while minimizing the eyes.
Nikon D800 • ISO 200 • 1/250 sec. • f/5.6 • 70mm lens

Figure 1.15 (right)
Shoot down on people to focus the image on their eyes, while minimizing necks and noses to make people look thinner.
Nikon D800 • ISO 200 • 1/250 sec. • f/5.6 • 70mm lens

9. Look Out for Clean Headspace

Keeping an eye out for clean headspace doesn't mean clearing your mind, although you should have a clear head about you when you're trying to remember all of the steps in this chapter simultaneously. Up until now, you've mainly focused on the camera and the subject's face. Before this chapter comes to a close and you run out the door to start shooting, make a mental note about headspace. If you're in the studio and shooting against a solid background, there's nothing to worry about. But when you shoot out in the world, you have to place your subject's head somewhere, such as in **Figure 1.16**, where I accidentally placed the subject's head in front of a signpost, and in **Figure 1.17**, where it looks like this poor model has tree branches growing out of her head. In both photos, I forgot to mind my headspace.

Figure 1.16 Here I accidentally misplaced the model's head in front of a distracting post that was directly behind her.

Nikon D800 • ISO 640 • 1/250 sec. • f/2.8 • 70mm lens

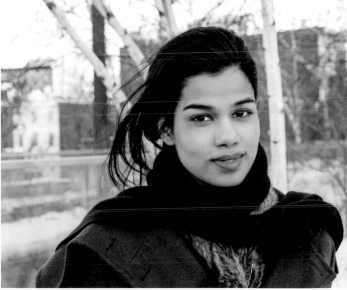

Figure 1.17 This was also a bad placement of the model's head, making it look like thick tree branches were growing from it.

Nikon D800 • ISO 640 • 1/160 sec. • f/8 • 70mm lens

What I should have done is found a clear patch of sky or thick sections of trees and simply recomposed the shot to place my subject's head in an uncluttered place, as in **Figure 1.18** (on the following page), which is much less distracting.

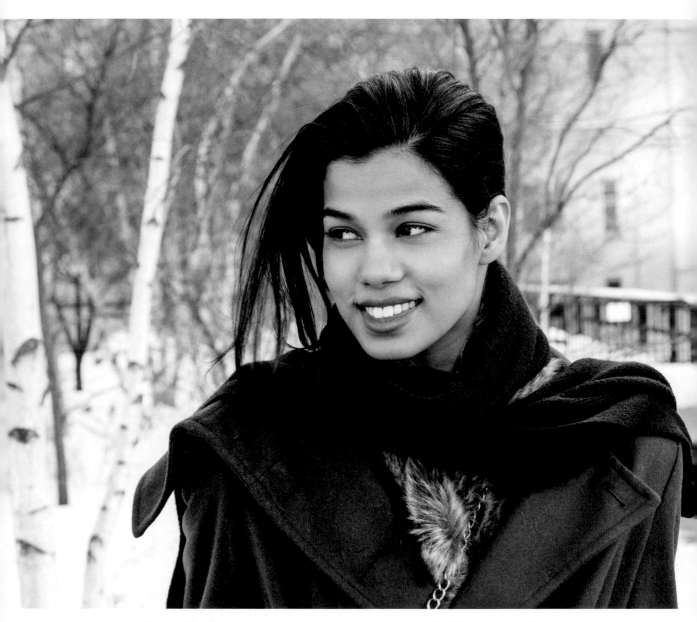

Figure 1.18 After recomposing the shot, a less busy space is behind the model's head so as not to distract from the portrait.

Nikon D800 · ISO 640 · 1/125 sec. · f/8 · 70mm lens

10. Turn Your Subject Into the Light

When you're directing your models, don't tell them to move toward the light. You need to keep their attention, but it is recommended that you have them look toward the light. Most of the time you'll be working with available light, such as the sun or a street lamp. Both are difficult light sources to pick up and move if you don't like the direction of the light they cast. This can lead to poorly lit photographs, like the one in **Figure 1.19** where the sun was hitting the model on the side of her face, leaving the other half in deep shadow. An easy remedy to fix this is to simply have your subject turn toward the light until both eyes are out of the shadow. With no light modifiers and the same camera settings, **Figure 1.20** (on the following page) shows a more pleasing portrait!

Figure 1.19 With the light coming in from the model's left side, half of her face is cast in shadow.

Nikon D800 • ISO 160 • 1/250 sec. • f/2.8 • 85mm lens

Figure 1.20 By directing your subjects to aim their nose at the main light source, you'll ensure a more evenly lit portrait with fewer shadows.

Nikon D800 • ISO 160 • 1/250 sec. • f/2.8 • 85mm lens

Chapter 1 Assignments

Set Up Your Camera

Set up your camera properly for better portraits. Be sure to turn off your pop-up flash. Set the mode dial to Aperture Priority mode and choose Matrix Metering (Nikon) or Evaluative Metering (Canon) to get you started with auto exposures. Then set the Picture Style to Portrait mode for best skin tones.

Practice Taking Some Shots

Get the communication going with your subject before snapping away. Then, after you've taken a few photos, review the first batch of your shots for focus, framing, composition, lighting, and headspace. You probably won't be creating masterpieces the moment you point your camera, but now you know what to look for to improve your images. Once you're warmed up, shoot again and try to avoid one or two of the mistakes mentioned in the Top 10 tips.

Remain Calm

Don't get overwhelmed. You'll learn tons of tips and techniques throughout the book, but the most important aspect of portrait photography is keeping a cool head and having fun with your subjects. Every journey begins with a single step, and you just finished the first chapter of this one.

Share your results with the book's Flickr group!
Join the group here: flickr.com/groups/portraitsfromsnapshotstogreatshots

Nikon D800 •
ISO 100 • 1/400 sec. •
f/3 • 90mm lens

2
Camera Settings and Lens Selection

Use the right settings, composition, and lenses for capturing your photos

It all begins with the basics, and this means understanding your camera settings, composition, and lens selection for each shot. Amazingly enough, half of the tips in the Top 10 countdown in Chapter 1 dealt with camera settings. Getting your settings dialed in before pulling the trigger goes a long way toward making your life easier as a photographer and toward producing better portraits as a result.

Let's wrap our heads around the necessary camera settings and then focus on creative decisions like lens selection, cropping, and composition. Thereafter, you'll be able to let the technical details take a backseat to the all-important interaction with your subjects, which I'll cover in Chapter 3.

Poring Over the Picture

Camera settings and lens selection are important in any kind of portrait. But they demand even more attention when your portrait subject is doing something active like yoga, and when you want to photograph your subject outdoors while showcasing the environment. Here's what I focused on when capturing this image in front of the Manhattan Bridge.

By using a longer telephoto lens at 90mm, I used the compression to bring the elements in the shot together. This made the bridge and subject look much closer to each other than they really were.

Although the background was important, I wanted to ensure that the subject remained the main focus. To make her stand out, I used an aperture of f/4, which created a shallow depth of field, leaving the subject sharp and blurring everything else.

Because the subject was constantly moving around in different poses, I set the camera to Continuous focus so that it would automatically refocus on her for each shot.

With active subjects, you don't want to have to worry about motion blur, so I used a faster shutter speed of 1/500 seconds to make sure the subject was frozen sharp.

Nikon D800 ·
ISO 100 · 1/500 sec. ·
f/4 · 90mm lens

Camera Settings

Your camera settings allow you to control how your camera sees the world. Understanding how each piece of the exposure puzzle works and what it controls will equip you with the tools necessary to express that vision through the camera lens. Let's first consider aperture and shutter speed, and then delve into the various camera modes available to you and which ones I recommend for portrait photography.

Aperture—Depth of Field

Aperture will be one of your primary focuses when you're dealing with camera settings as portrait photographers. Your aperture is the size of the hole inside the camera lens that lets varying amounts of the light through. Besides controlling how much light comes through the lens, it also controls *depth of field*. You can adjust the size of the opening and the depth of field in one-stop increments, which are represented by f-stops on your lens, such as f/2.8, f/4, f/5.6, f/8, f/11, and so on.

Depth of field is the distance or depth of the area that is in focus. Small f-stops, like f/2.8, are rather large openings, which efficiently let a lot of light in and also have very shallow depths of field, meaning a very narrow area that is actually in focus. *The larger the aperture opening, the shallower the depth of field.* This correlation is important to understand so you know how and when to adjust it depending on your subjects and the scene (**Figure 2.1**).

Figure 2.1
A chart relating aperture to depth of field and light-gathering power.

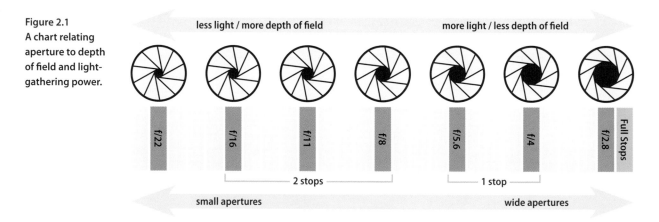

A shallow depth of field is often desired for portraits because it draws attention to the subject's face while blurring out the less important features. This selective focus is a great way to create strong portraits by directing the viewer straight to the subject's eyes. A shallow depth of field is also ideal for hiding distracting background elements. In **Figure 2.2**, the camera was set to f/16, which has a wide depth of field. That's why my model, Elena, is in focus, as well as all of the distracting background elements way behind her. In **Figure 2.3**, I opened up the aperture to f/1.4, and instantly the background became blurry, which made for a much better photo.

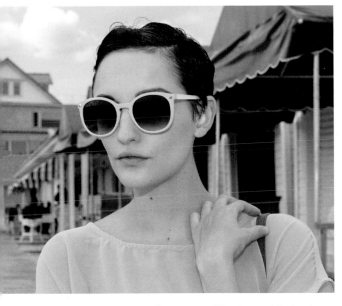 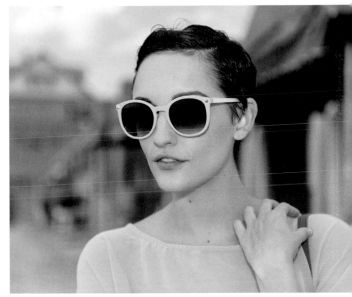

Figure 2.2 **Using a small aperture of f/16 has a wide depth of field, rendering everything in focus, including distracting background elements.**

Nikon D800 • ISO 400 • 1/200 sec. • f/16 • 70mm lens

Figure 2.3 **By switching to an aperture of f/2.8, the depth of field is now very shallow and everything but the model falls out of focus.**

Nikon D800 • ISO 400 • 1/6400 sec. • f/2.8 • 70mm lens

A large depth of field isn't always a bad thing. When you're taking group portraits you need to make sure everyone is in focus. Small apertures of f/8–f/22 will ensure that everyone in the shot is tack sharp. **Figure 2.4** shows a case of extreme group portraiture where I had to photograph 100 people on a beach for a political advertisement. I used an aperture of f/13 to make sure everyone was in focus. I also elevated my position to shift the plane of focus from straight up and down to more of a diagonal across the group. I'll cover group photos and the focal plane in-depth in Chapter 9.

Figure 2.4
For this extreme group portrait I needed a wide depth of field, so I chose an aperture of f/13 to keep everyone in focus.
...
Nikon D700 •
ISO 200 • 1/60 sec. •
f/13 • 20mm lens

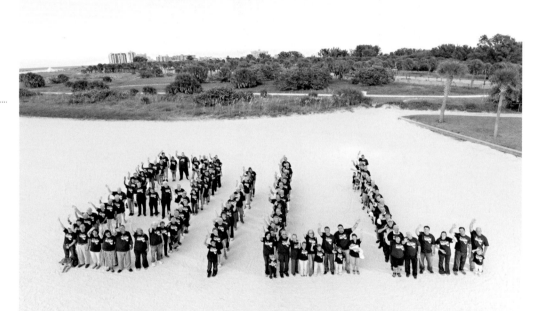

Shutter Speed—Freezing Motion

Shutter speeds are secondary to aperture in order of importance but still play a central role in every photo! Who wants a portrait in which the people are in focus but it's ruined by blur from camera shake? A fast shutter speed is what freezes your subjects in place, making doubly sure that you walk away with sharp photos.

In **Figure 2.5**, I used a slow shutter speed of 1/30 of a second. You'll notice a bit of blur from the camera moving around. After speeding up my shutter speed to 1/125 of a second, the next shot (**Figure 2.6**) is back to being sharp. The general rule of thumb is that you want to use a shutter speed that is at least equal to the length of your lens (minimum handheld shutter speed equals 1/lens focal length). So, if you're shooting with a 200mm lens, your minimum *handheld* shutter speed should be 1/200 of a second. For a 50mm lens, you can usually get away with handholding the shot at 1/50 of a second.

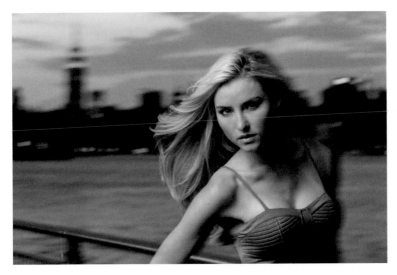

Figure 2.5
Because I used a slow
shutter speed, camera
shake and the subject's
movement created
motion blur in the image.

Nikon D800 ·
ISO 1600 · 1/30 sec. ·
f/8 · 85mm lens

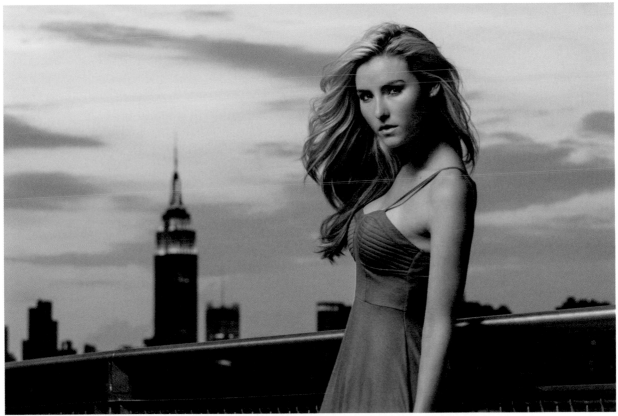

Figure 2.6 By using a shutter speed faster than my lens's focal length, I was able to handhold this photo
without blur.

Nikon D800 · ISO 1600 · 1/125 sec. · f/8 · 85mm lens

Using the correct shutter speed sounds easy enough, but wait! If you set your aperture for the subject and then set a minimum shutter speed based on your lens, how do you make sure the photo is properly exposed? What if it's now too dark? Well, you just adjust the ISO, which is your camera's overall sensitivity to light. In the basic Exposure Triangle (**Figure 2.7**), you have three variables to play with to get a proper exposure: aperture, shutter speed, and ISO. Let's look at the different camera modes to find the easiest way to achieve balance for the best exposure.

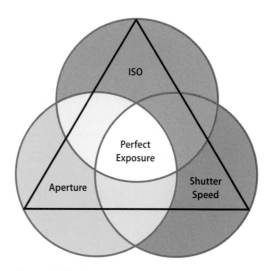

Figure 2.7 The Exposure Triangle.

Camera Modes

There's a good chance that the mode dial on top of your camera is full of letter abbreviations and hieroglyphics that may resemble mountains, faces, and flowers. Let's ignore the scene-specific icons for a moment because they merely try to do what you are about to do on your own. Instead, let's focus on P, S, A, and M, which are present on just about every DSLR on the market regardless of make or model (**Figure 2.8**):

- **P** represents Program Auto

- **S or Tv** represents Shutter Priority Auto

- **A or Av** represents Aperture Priority Auto

- **M** represents Manual mode

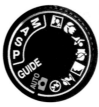

Figure 2.8
Camera mode dial.

These modes allow your camera to determine the correct shutter speed and aperture based on the brightness of the scene and your current ISO setting. By pressing down the shutter button halfway, you set the camera to work and can preview what the recommended settings are. Then, by pressing down the shutter button entirely, you apply these settings and take the shot. These modes can calculate shutter speed and aperture for you, or let you decide one factor while they figure out the others.

Camera Modes Defined

Ignoring all of the various auto or scene-specific modes, let's focus on the core camera modes, what they do, and which ones work best for you:

- **Program mode** is basically Auto mode where the camera sets everything for you. But in this mode you have the option to tweak the shutter speed and aperture after the camera decides where to start. It's basically flexible programming.

- **Shutter Priority mode** is where the user selects the desired shutter speed and the camera dials in all of the other settings, based on that shutter speed, to create a proper exposure. This is great for capturing fast-moving subjects where you know you'll need a fairly quick minimum shutter speed to avoid motion blur.

- **Aperture Priority mode** is where the user selects the desired aperture and the camera dials in all of the other settings, based on that aperture, to create a proper exposure. This is your go-to mode as portrait photographers because it lets the camera do the heavy lifting while allowing you to pick the aperture and the selective depth of field. Advanced shooters may switch to Manual mode for complete control.

- **Manual mode** is the ultimate control. You set the shutter speed, set the aperture, and take the photo; no settings will change unless you want them to. However, with great power comes great responsibility. The camera does zero thinking or tinkering with the exposure in Manual mode; the photographer has to set everything.

Exposure Metering Modes

In all of the modes except for Manual mode, the computer inside your camera makes the decision on what the correct exposure is. But what does your camera actually see? What is it looking at in the scene to make this determination? This is where the different metering modes come into play. Your camera takes in all of the light and dark data in a scene and then tries to average it out to achieve a proper exposure. This means that the camera takes in those really bright skies and very deep shadows, which is a tall order for it to determine the correct exposure without some direction on your part. By selecting various metering modes (**Figure 2.9** on the following page), you tell your camera what to look at in the scene to base its exposure calculations on.

The three most common metering modes in current DSLRs are:

- Matrix metering (Nikon) or Evaluative metering (Canon)

- Center-weighted metering

- Spot metering

Figure 2.9
Exposure metering
modes for Canon
and Nikon cameras.

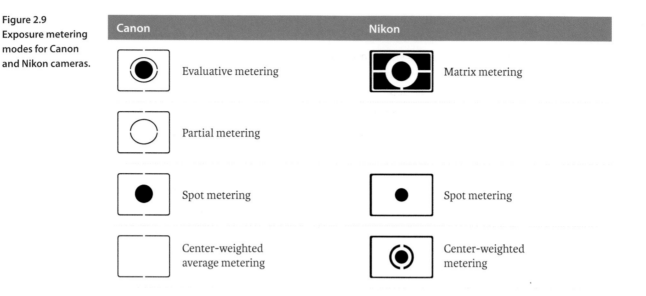

Canon		Nikon	
◉	Evaluative metering	◉	Matrix metering
◯	Partial metering		
●	Spot metering	●	Spot metering
☐	Center-weighted average metering	◉	Center-weighted metering

Matrix metering or Evaluative metering

The latest digital cameras are incredibly smart, so if you use the Matrix metering or Evaluative metering modes, they will do a great job in determining the proper exposure in most situations. These modes take into account the entire frame and make decisions as to what is the most important part. This metering is fine for general-purpose photography, but you want to ensure that the subject's face is properly exposed. Therefore, as portrait photographers, you know what is most important and don't want to leave this to chance. Let's keep looking for a mode that allows you that kind of control.

Center-weighted metering

Center-weighted metering measures the brightness at the center of the frame and then just averages it with the rest of frame: The center of the photo always gets the most consideration. This was a classical way of metering for portraits but not ideal, because you usually don't want to have the subject's face smack-dab in the center of the photo.

Spot metering or Partial metering

To measure only a specific spot in a scene, ideally the subject's face, you need a very precise metering mode, and Spot metering (Partial metering on Canon) is exactly what you're looking for! The camera meters based on the current focus point you have selected. So the more focus points your camera has, the more places around the frame you can meter off of. This is perfect when the person's face is offset in the frame; you just move the focus point on top of the person's face and meter away.

Spot and Partial metering are also perfect for high-contrast photos or heavily backlit shots. If you're shooting someone with pale skin and very dark hair, that person represents a big exposure range to average out. By spot metering only on the subject's face, you're guaranteed accurate skin tones in the final shot. This range becomes even more extreme when the sun is behind the subject's head in a heavily backlit situation. Rather than asking the camera to average out the blinding sun and a person's shadowed face, by spot metering just the person's face, you avoid getting a silhouette or the overexposed opposite.

Exposure Compensation

There are times when, even with the most precise metering, you still may want to tweak the resulting exposure a bit. To do this, turn to Exposure Compensation. This setting takes the exposure that your camera comes up with in Aperture Priority mode and then allows you to add or subtract to that exposure, often up to three whole stops. **Figure 2.10** shows a meter reading of +1, 2, 3 and –1, 2, 3. By changing these values, your camera will speed up or slow down the shutter speed

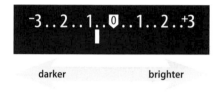

darker brighter

Figure 2.10 Exposure Compensation allows you to add or subtract brightness to a photo based on the original exposure that your camera came up with.

accordingly. Advanced users can achieve the same results shooting in Manual mode and adjusting the shutter speeds manually. Either way, Exposure Compensation allows you to fine-tune your photos on the fly.

Focusing Modes

Focusing mode is another in-camera mode you need to consider. At this point, you should be set up to achieve a proper exposure and have selected an aperture with the desired depth of field. Now you just need to lock down where to focus all of this. In **Table 2.1**, you'll see the nondescript names of each focusing mode from Nikon and Canon. The names may be different, but their function is the same.

Table 2.1

Camera Focusing Modes	
Nikon	**Canon**
AF-S (Single-servo AF)	One Shot AF
AF-C (Continuous-servo AF)	Predictive AI Servo AF
AF-A (Auto-servo AF)	AI Focus AF
M (Manual focus)	Manual focus

Lens Focal Lengths

Lenses are generally lumped into three category types:

- Wide-angle lenses
- Normal lenses
- Telephoto lenses

Wide-angle lenses

Wide-angle lenses include most focal lengths below 35–50mm (11–16mm and 14–24mm are popular wide-angle zoom ranges). They are great for indoor or outdoor architectural photography and landscape photography but not so much for shooting faces. They excel at separating elements in the scene, making background and foreground appear farther apart. They also come in handy when you're working in very closely and want to show more of the scene in a photograph.

Normal lenses

Normal lenses hover around focal lengths of 35mm–50mm and include that "nifty fifty" 50mm f/1.8 prime lens that is immensely popular for people just beginning to build a lens kit. Its popularity derives from its very fast, wide-open aperture and its affordability when compared to other fast prime lenses. A normal lens communicates a field of view similar to what the human eye sees, making it a very natural way to photograph and view the world. This lack of distorting the world is why it is a longtime favorite of journalists and wedding photographers alike.

Telephoto lenses

Telephoto lenses are best for photographing all things beyond the normal field of view. This is where you'll live most often as portrait photographers. A telephoto lens has such a narrow field of view that it tends to compress everything in the scene, bringing foreground and background elements close together. This exaggerated compression also renders a subject's face in a flattering manner. Popular "medium telephoto" lenses for portrait photography range from 85mm to 135mm.

Lens Compression and Distortion

I briefly mentioned how these different lenses compress and distort things, which is very important to keep in mind when selecting a lens to use. Now let's look at photographic examples of exactly what I mean.

Distortion in portraits

Now that you know all of your lens options, let's check out the results on a person. **Figure 2.12** was taken up close with a wide-angle 24mm lens. Immediately after taking this photo I apologized to the model for doing so! The resulting portrait is *very* unflattering because of the stretching distortion that wide-angle lenses create. Even with the subject in the center of the frame, notice how it stretches her face outward toward the edges.

For the next shot (**Figure 2.13**), I stepped back some and tried my luck with a normal 50mm lens. The results are noticeably better! After all, the 50mm focal length is how you're used to seeing a person, and I was working with a pretty model to begin with. Although a normal lens is a great value and very versatile, some bulging and distortion still exists if you look closely, meaning it's still not ideal for tight portraits.

Figure 2.12 A portrait taken with a wide-angle lens. This lens is very bad for headshots because the inherent distortion warps the subject's head in an unflattering manner.

Nikon D800 • ISO 800 • 1/250 sec. • f/4 • 24mm lens

Figure 2.13 A portrait taken with a 50mm lens. Although it is a normal perspective, some distortion still remains in the face.

Nikon D800 • ISO 800 • 1/250 sec. • f/4 • 50mm lens

The easiest way to see the amount of distortion created in a photo taken with a normal lens is to compare it to a proper shot taken with a 135mm telephoto portrait lens, as shown in **Figure 2.14**. I had to step back a little farther to fill the frame the same way I did with the 24mm and 50mm lenses, but with this narrow field of view you can see how the distortion is gone and her face is no longer being contorted by the lens selection.

Figure 2.14
A portrait taken with a telephoto lens, which resulted in a flattering rendering of the face and no distortion.
Nikon D800 •
ISO 800 • 1/250 sec. •
f/4 • 135mm lens

Lens selection and compression for storytelling

For tight headshots, like the ones you just saw in the preceding section, you'd seldom want to stray from using a telephoto lens due to its lack of distortion. The pleasing compression that comes with it also has benefits. At the same time, a wide-angle lens—although bad for headshots—is great for environmental portraits! Let's venture out and bend the rules a little to see what's possible.

In **Figure 2.15**, I wanted to include two subjects in a lifestyle environmental portrait. I needed to include the kayak, water, and trees as well to place them in that environment. This was a perfect situation for a wide 24mm lens! The wide field of view allowed me to 1) work in close to the action, and 2) still get everyone and everything in the shot. Yes, there was still the distortion to worry about, but by keeping the important parts—peoples' faces—in the center of the frame, that distortion is minimal. Keep in mind that, when you're using a wide-angle lens, you should place your subject toward the middle of the frame to minimize the distortion. Distortion increases as you get closer to the edge of the frame.

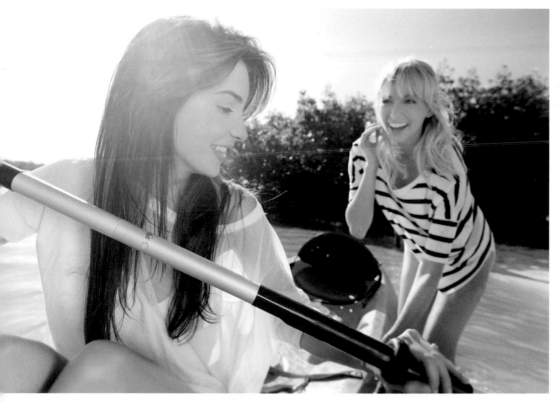

Figure 2.15
Correct usage of a wide-angle lens to include the subjects and environment in a single frame.
Nikon D700 •
ISO 400 • 1/1250 sec. •
f/5.6 • 24mm lens

To make the couple casually conversing at the bar in **Figure 2.16** appear natural—as if the viewer just walked into the bar and glimpsed the scene—I used a normal lens at 50mm so as not to distort the scene and rather just document the interaction.

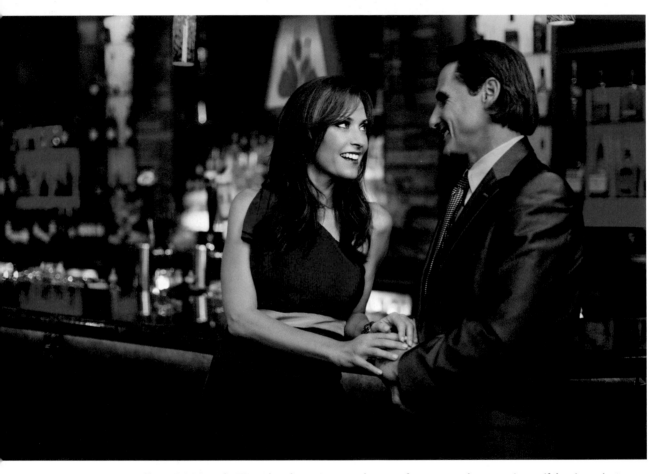

Figure 2.16 I used a 50mm lens here to convey the scene from a normal perspective, as if the viewer just walked up to the bar and saw this couple.

Nikon D800 · ISO 800 · 1/30 sec. · f/2 · 50mm lens

In **Figure 2.17**, I used a telephoto lens again and really took advantage of the compression that comes with it. The benefits are twofold: The first is that compression helps bring together the whole scene, making the steps, bushes, and subjects look close together and neatly packaged for viewing. The second is that with a very narrow field of view you can hide objects, like light stands, signs, and other unsightly elements, in the background. Check out the behind-the-scenes shot in **Figure 2.18** to see what the scene really looked like from a wide-angle perspective before I decided to zoom in with a 70–200mm telephoto lens.

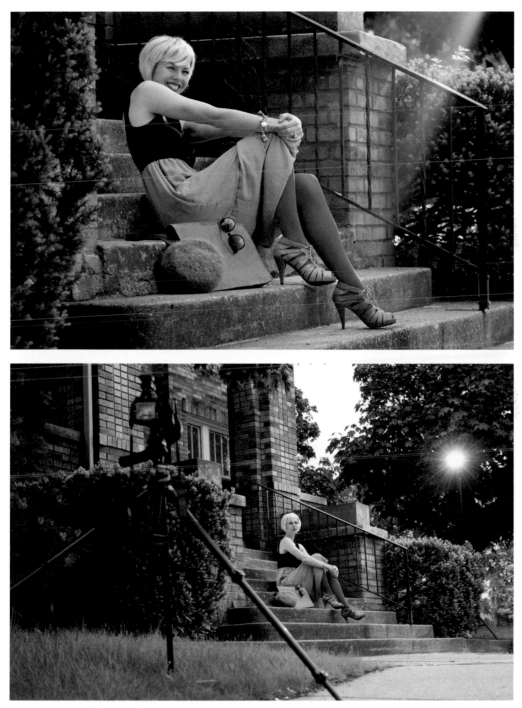

Figure 2.17
A compressed scene shot taken with a telephoto lens to neatly package the foreground, model, and background together.

Nikon D700 ·
ISO 200 · 1/200 sec. ·
f/5.6 · 105mm lens

Figure 2.18
A pulled-back view showing the light stand and sign that were hidden using the narrow field of view of the telephoto lens.

Nikon D700 ·
ISO 200 · 1/250 sec. ·
f/5.6 · 62mm lens

Working with zoom lenses is a great way to quickly capture varying focal lengths when you're shooting. Your ability to compress and distort the world gives you the ability to portray multiple stories without changing the players. **Figure 2.19** shows a loving couple caught in a moment. By shooting from the man's shoulder with a zoomed-out lens at a wide 24mm, the viewer is placed into the scene and experiences the moment with them. Then, just as quickly, you can step back and zoom in on the moment with a 70mm lens. The result in **Figure 2.20** makes the viewer feel privy to someone else's moment, viewing it from afar, separate from the action. Two different takes on the photo, shot within 2 seconds of one another, changes the story just by varying the focal length of the lens.

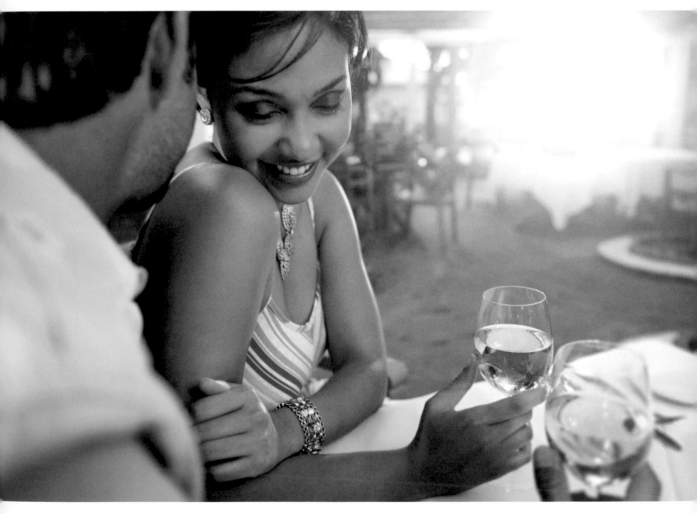

Figure 2.19 Shooting with a wide-angle lens right over the man's shoulder brings the viewer into the moment.
Nikon D700 • ISO 200 • 1/30 sec. • f/2.8 • 24mm lens

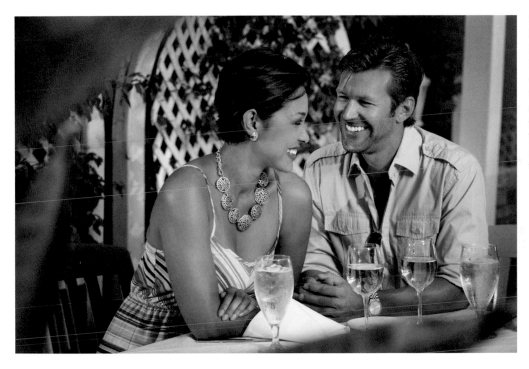

Figure 2.20
By quickly stepping back and zooming in, the story changes; now the viewer is looking in on a moment from the outside.

Nikon D700 • ISO 200 • 1/125 sec. • f/5.0 • 70mm lens

Composition

Composition is how you arrange or frame the different elements in your photographs. It isn't unique to photography; it spans all of the visual arts. I highly recommend that photographers look outside of their medium for visual inspiration. Master painters and designers are masters because they understand light, balance, and composition while knowing how to create it from scratch. You can take cues from these classics to inspire your own compositions.

Let's look at a few theoretical concepts and practical tips to help create compelling portraits through strong composition:

- Level horizons
- Rule of Thirds
- Leading lines
- Use of negative space
- Depth of elements in foreground, middle ground, and background

Level Horizons

Keep your horizons level, people! Nothing is more distracting than capturing a great portrait only to have the horizon line in the background so crooked that it appears the person is going to fall right off the side of the photograph. In **Figure 2.21**, the horizon line is distracting but doesn't have to be. Many DSLRs have built-in levels. They are usually accessible from the Live View menu on your camera. Consult your manual to learn how to view this level and consult it whenever you're shooting with a flat horizon line in the background. After a quick look at the level, the shot in **Figure 2.22** results in an even horizon line.

A trick I learned from landscape photographers is to purchase an affordable bubble level that physically sits on top of your camera that you can easily consult as well.

Figure 2.21 A nice portrait, but the uneven horizon in the background makes the subject appear as though she is going to fall off the edge of the photo.

Nikon D700 · ISO 100 · 1/4000 sec. · f/2.8 · 29mm lens

Figure 2.22 A portrait of the same subject, but a much better photo after ensuring that the horizon line was level.

Nikon D700 · ISO 100 · 1/4000 sec. · f/2.8 · 29mm lens

Rule of Thirds

When you're unsure of where to place a person in your portrait, a safe bet is to fall back on the Rule of Thirds. Using this rule, you imagine a grid over the photograph with three columns and three rows, as shown in **Figure 2.23**. You then place important elements, like a person's head or a subject's eye, at any one of the intersecting points. The advantage of using this compositional technique is that it eliminates that boring habit of placing people in the very center of the frame. This rule is used time and time again in classical portraiture when composing a vertical portrait like the one shown in **Figure 2.24**.

Many cameras have a grid overlay that you can turn on and display in your viewfinder to help you compose a shot using the Rule of Thirds on the fly.

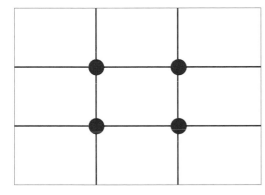

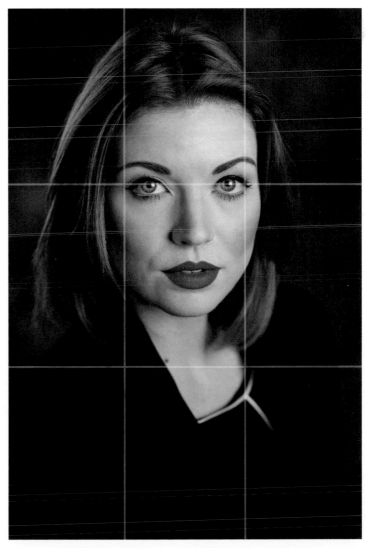

Figure 2.23 (above) Imagine a three-column, three-row grid like this when applying the Rule of Thirds. Place your subject's face or eyes where the grid lines intersect.

Figure 2.24 (right) A classic headshot showing the grid overlay and eye placement according to the Rule of Thirds.

Nikon D800 • ISO 50 • 1/200 sec. • f/2.8 • 85mm lens

Line

The use of line in composition is a powerful way to direct the viewer's eye across the photo. Part of being a strong photographer is your ability to keep viewers engaged in your photograph and to guide their eyes where you want them to go.

In **Figure 2.25**, I broke a classic compositional rule. I placed the subjects in the center of the frame! Even though I broke one rule, I applied another by using the rope in the photo as a "leading line." This line picks up the viewer's eye from the top-left edge of the frame and guides it into the subjects waiting in the middle. This leading line, paired with the converging lines of the dock fading into the background, created a lot of visual movement, which resulted in a dynamic photograph.

Leading lines are a perfect way to guide viewers' eyes through a photograph. Start them at the edge of the frame and work into your subject.

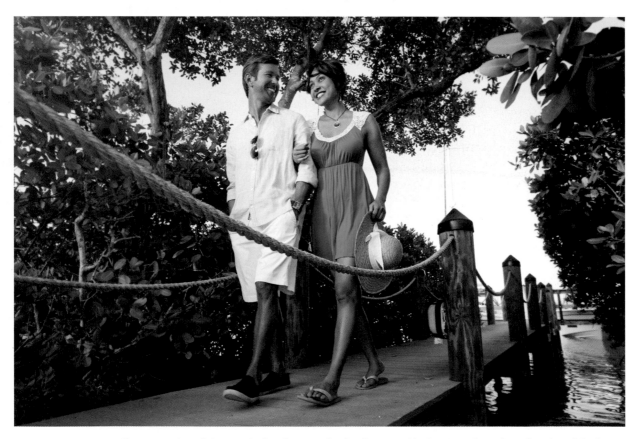

Figure 2.25 I used the rope in the photo as a leading line to guide the viewer's eye from the edge of the frame all the way to the subjects.

Nikon D700 • ISO 400 • 1/160 sec. • f/8 • 24mm lens

Space

Space can be positive or negative. As an artist you don't need to fill every bit of space in your frame. In fact, leaving an area black—negative space—can be an impactful compositional tool. Negative space invites viewers to engage and fill that space with their mind. In **Figure 2.26**, the pitch-black negative space to the left of the model oddly enough lends balance to the photo and adds to the somber feel. The viewer is left to imagine what is on the girl's mind.

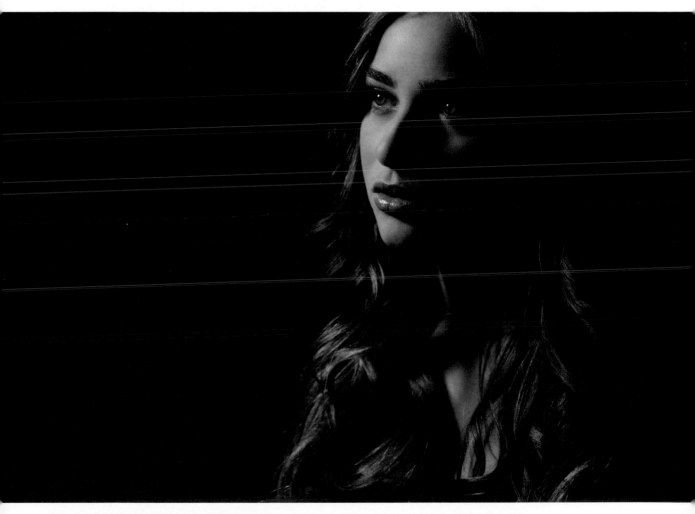

Figure 2.26 The negative space in this photo actually balances with the model and invites the viewer to imagine what the model might be thinking about.

Nikon D700 · ISO 100 · 1/250 sec. · f/4 · 85mm lens

You can also leave negative space in your photo to guide the viewers' eyes, just like you do with leading lines. By leaving negative space to the side where the man is looking in **Figure 2.27**, the viewer looks to his face and then follows his gaze across the photo. You can even take this compositional technique to the extreme, as in **Figure 2.28** where 90 percent of the photo is negative space—just clear blue pool water.

Figure 2.27
Negative space was used to allow the viewer to follow the man's gaze across the photograph.

Nikon D800 •
ISO 100 • 1/3200 sec. •
f/2 • 85mm lens

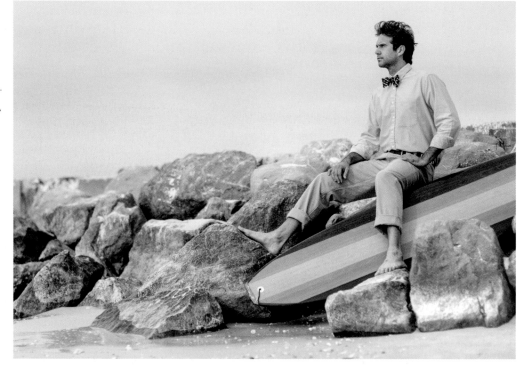

Figure 2.28
Negative space is taken to an extreme in this photo where the subject accounts for only 10 percent of the frame.

Nikon D700 •
ISO 200 • 1/1250 sec. •
f/4.5 • 70mm lens

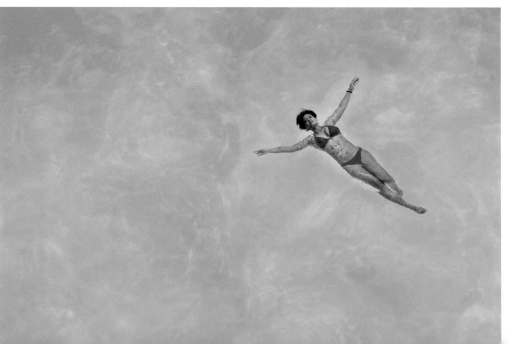

Depth

Another compositional tool, depth, is the distance that is perceived by the viewer and can be broken up and expressed with foreground, middle ground, and background elements. By tying these elements in with the inherent compression in wide-angle and telephoto lenses, photographers can greatly vary the depth in a scene.

In **Figure 2.29**, I used a 20mm lens. Remember that wide-angle lenses do a great job of separating elements. By placing leaves in the foreground, you really see the effects of this separation. The depth appears immense between the foreground, the subject, and the background.

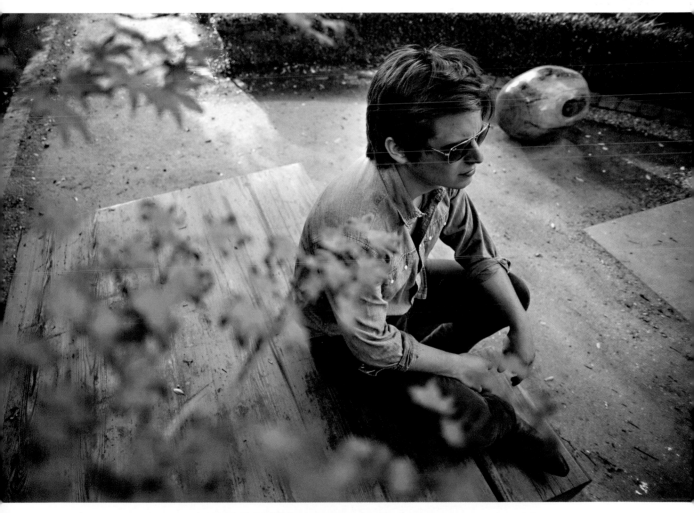

Figure 2.29 Although I was standing right on top of the subject, the use of a wide-angle lens expanded the foreground leaves, the subject, and the background to create the appearance of depth.

Nikon D700 • ISO 200 • 1/160 sec. • f/2.8 • 20mm lens

The opposite also works. You can compress the perceived depth in a scene in much the same way. In **Figure 2.30**, I placed the shrubs in the foreground, the subjects in the middle, and a red building in the background. By using the narrow field of view of a 70–200mm telephoto lens, I grabbed all of these elements and squished them together to create a tightly composed image.

Figure 2.30
By using a telephoto lens, I was able to bring the building, the subjects, and the bushes tightly together, even though they are all quite far away from each other.

Nikon D700 •
ISO 200 • 1/640 sec. •
f/2.8 • 70mm lens

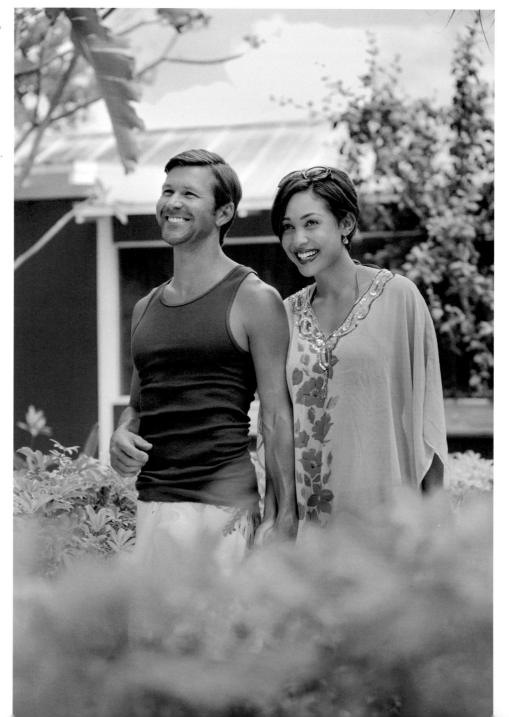

Combining all of these tips and rules will help you create better, compositionally strong images. Note that in the example photos that were used in these composition sections, even though one rule was discussed, elements of the other rules were present or used as well. Don't focus on one rule to the exclusion of the others. These foundations, when coupled with great interaction with your subject, will help you capture some incredible portraits in no time. In Chapter 3, I'll discuss working with your subjects after you've mastered the technical aspects of photography in this chapter.

Cropping

The camera is set, lens selection is taken care of, and the composition is sound! But did you accidentally amputate your subject at the very end? Even after everything else falls into place, you can still kill a portrait with an awkward crop. If you're photographing someone from head to toe, you need only worry about composition, but when you start to frame up only a portion of the person, cropping comes into play. With a little guidance and a rule or two, composing and cropping people will become second nature.

Cropping No-No's

The main rule to keep in mind when cropping your photo is to never crop someone off at a joint with the edge of your frame. By cropping at an area of the body that flexes, you create the illusion of your subject having lost an appendage at that point. So make sure to zoom in or out as necessary to avoid cutting off a person at a joint with the edge of your frame. Here is a quick list of where *not* to crop a photo:

- Ears
- Elbow
- Wrist
- Knuckles
- Knees
- Ankles
- Toes

Body Cropping

Body cropping encompasses everything from the standard three-quarter composition to half-body shots and everything up to a tight headshot. What are you left with if you can't crop your subject at the joints? Well, a lot really; let's take a look:

- Biceps
- Mid-waist
- Just below the belt
- Mid-thigh
- Mid-shin

Fortunately, these OK-to-crop sections cover more surface area than the off-limits areas, which leaves you plenty of wiggle room to frame the shot. The graphic in **Figure 2.31** recaps where you should and shouldn't crop. Based on this illustration, you can see that **Figure 2.32** is improperly cropped at the model's fingers and wrist, causing them to look stumpy, and otherwise cropped too low on her brow as well. **Figure 2.33** shows a proper crop above the head and mid-shin on the bottom.

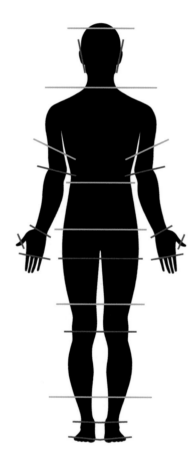

Figure 2.31 An illustration of where to crop and not to crop your photographs. The red lines indicate where not to crop. The green lines are where it is OK to crop.

Figure 2.32 A photo demonstrating improper cropping at the hand joints.

Nikon D800 · ISO 400 · 1/320 sec. · f/2.8 · 85mm lens

Figure 2.33
A photo demon-
strating the proper
places to crop, at
the shins and above
the head.

Nikon D800 •
ISO 400 • 1/320 sec. •
f/2.8 • 85mm lens

Figure 2.38 shows an example of a proper close cropping of a man as well. Note that the top of the frame begins just below the top of his head, and the bottom of the frame neatly ends the photo below the neck.

Whether you're shooting head and shoulders, three-quarter length, or full-body shots, be sure to experiment with different crops and compositions to get some variety. The great thing about the newest DSLRs with all their megapixels is that you can now do a lot of the cropping after the fact on your computers. So if you're worried about cropping your images, it's safest to shoot a little wide and then just crop your images closer in postproduction using software like Adobe Lightroom or Adobe Photoshop. It's best to get the shot right in the field, of course, but don't overlook the ability to crop in postproduction; it allows you to change the feel of a shot even after it's been taken.

Now that you have a firm grasp on your camera's settings and the compositional elements that go into a good photograph, you can begin to look past the technical and get ready to engage in the personal aspects of portrait photography, your subjects. The next chapter explains how to get the absolute best from your subjects!

Figure 2.38
A tight horizontal cropping shown on a man. Notice the slight cropping of the head and ample room below the chin.

Nikon D700 •
ISO 100 • 1/160 sec. •
f/4.5 • 85mm lens

Chapter 2 Assignments

Review Camera Settings

Reread the "Camera Settings" section at the beginning of the chapter. Only this time do it with your DSLR in hand so you can familiarize yourself with each setting and dial them in on the spot. Then you'll be ready to shoot the next time you walk out the door with your camera.

Focal Length Fun

Go out and find a subject—a person or an object—and spend a few minutes photographing it with the same camera settings for every shot. As you shoot, mix up your lenses! Shoot some images at a wide focal length, then a normal focal length, and then a telephoto focal length. Compare how drastically different each set of shots is, even with identical exposures.

Practice Cropping and Rule of Thirds

All modern post-processing software contains a Crop tool. Most will have a grid overlay that is accessible from the main menu that you can apply as well, much like the ones in your camera. Use the Crop tool to experiment with different crops on pictures that you've already taken.

Share your results with the book's Flickr group!
Join the group here: flickr.com/groups/portraitsfromsnapshotstogreatshots

Poring Over the Picture

By adding an appropriate prop and compressing the model against the bridge in the distance, a "travel" theme emerges from the photo, making it more interesting than just a girl standing on a boardwalk.

By using a selective shallow depth of field only the subject is in focus, blurring the background and foreground, so that all the geometric lines don't distract the viewer from the model.

Nikon D700 · ISO 200 ·
1/1250 sec. · f/3.5 ·
70–200mm lens

Be attentive to where you place your subject's head. Look for open patches of sky to avoid the appearance that branches or bridges are growing out of her noggin.

By using a telephoto lens you can compress the foreground and background of a photo, bringing them closer together, as I did with the bridge and the model.

Rather than "floating" your subjects around a scene, have them engage with the props to anchor them to their environment.

People First; All Else Second

A rose or a beautiful landscape won't mind if you rush in, shutter button blazing, and start snapping away. However, a person might feel violated by such an approach (which is exactly why no one likes the paparazzi). This is the reason that an introduction is critical. If possible, try to meet up with your subjects beforehand, perhaps over coffee to break the ice and get comfortable with each other. Being on a first-name basis is a great place to start; a handshake or a hug can formally open the lines of communication. If you don't know your subject that well, try to find some common ground, such as a hometown or favorite sports team, anything that you can both converse about to break the ice. This is also a great time to answer any lingering questions your subjects may have before you're aiming a camera at them. From this point through the end of the shoot, your goal should be to maintain that line of communication and let it translate through the lens. Building a good rapport with your subjects will result in more relaxed and genuine-looking portraits.

Once you know each other, you then need to set the mood. I don't mean dimming the lights; I mean cranking up the jams! Music is the key. Ask your subjects to bring along their iPod or phone with a playlist of their favorite music. This sets the mood and eliminates any awkward silence that can crop up while you're fiddling with gear or camera settings between shots. You want to establish a comfortable working environment, so if you're photographing children, have their parents bring along a favorite toy. Additionally, whether you're shooting someone who is 2 or 102, always have food nearby. It doesn't have to be expensive catering, but a few bottles of water and some snacks go a long way toward keeping the blood sugar and morale up. No one wants their photo taken while fighting off a nasty case of the "hangries" (a combination of being hungry and angry).

Inspiration, Prep, and Props

Although spontaneity is encouraged, a little prior planning can contribute to creating better portraits. In the commercial photography world this preparation stage is called *prepro,* an abbreviation of preproduction, and covers everything from styling, locations, props, call times, and shooting schedules. This is the time to get everyone on the same page so that the shoot runs smoothly.

Preproduction Checklist

Preproduction, or *prepro,* is an oft-overlooked vital stage in the development of your portrait session. This is where you line everything up so that on the day of your shoot everyone knows what's going to happen, and the shoot goes off without a hitch. Here are a few details to consider:

- **Styling.** What kind of clothes or outfits should your portrait subjects bring with them?

- **Location.** Where will the shoot take place: inside or outside? If outside, do you need to provide directions or get permission to shoot there?

- **Props.** Will you be providing any props, or should your subject bring them? Be sure to have hats, scarves, musical instruments on hand—anything to add to the person's story.

- **Times.** When should everyone arrive? How long will you be shooting?

Mood Boards

A great place to start planning is to create a mood board—a collection of inspirational images—that can inspire a certain look and feel of the portraits you want to produce during your shoot. It's a great source of reference both before and during a shoot to keep the process flowing. A mood board will drive the decision for the location and any possible props you'll use as well. Ask your portrait subjects to collect any images that they want to use as reference. Encourage them to look at your portfolio and Web site too. Then, combined with inspirational images of your own, you can begin to piece together this mood board to help guide you and the subject once the shooting begins. Look for lighting or posing ideas that you can use as resources in case you get "stuck" during the shoot.

A mood board doesn't have to be elaborate. Web sites like Pinterest.com are perfect places to find various styles and concepts (**Figure 3.1**). Simply create a digital board on the site and "pin" images to it as you come across them on the Web. I'll often sync a folder of images to my iPad so I can easily view them when I'm on location.

Figure 3.1 Use Web sites like Pinterest.com to create collections of inspirational images.

Locations

After deciding on the kind of look you're going for, you can then work on choosing locations. Unless you're shooting in the studio, various styles will most likely require a specific kind of location to tell their story. Do you want a sunny outdoorsy kind of portrait? If so, start looking for a local park or hiking trail. Do you want a grittier-looking portrait? Check out the downtown area of most cities for interesting alleyways or parking structures. Once you've found a great spot, scope out the parking situation. If it's private property, contact the owner right away for permission to use the site.

When you're shooting outdoors, always check the weather forecast! It also helps to have an indoor location in mind as a Plan B. Besides your local weather station, you can use a number of smartphone apps that will also tell you where the sun will be on any given day and what the weather will be like. Some will even let you access an aerial view from the comfort of your couch. This information is extremely helpful so you don't arrive on location the day of the shoot only to find the sun hiding behind a tree line or a tall office building (**Figure 3.2**).

Figure 3.2 **Use apps like The Weather Channel and Google Earth to scout out locations and weather from the comfort of your computer or smartphone.**

Props

The last item to consider in the planning stage is the use of props. Using props in a portrait session can help in two ways: They help in telling a story and can also serve to set your subject at ease. You can go as wild and crazy as you want with props, adding wardrobe and even live animals!

If your portrait session has a theme, the use of appropriate props will go a long way toward enhancing that theme and telling a story. For the series of shots in **Figures 3.3** and **3.4,** I wanted to add the element of travel to the shoot. To do this, I found a location with real train cars and styled it with vintage luggage for props. This gave the model something to interact with as well as furthered the story.

Figure 3.4
A model with antique luggage after catching the train. Again, the props help add to the story.

Nikon D700 •
ISO 200 • 1/320 sec. •
f/5.6 • 70mm lens

Most likely, you won't often be working with professional models who are used to being in front of the camera for hours. The average person begins to feel quite awkward once you train that camera on them, so by adding props you can actually alleviate a lot of this stress at the beginning of the shoot. A musician I worked with in particular had an incredible presence while singing but was very shy without a guitar in her hand. Obviously, giving her a guitar as a prop was one way to solve this problem. However, I wanted to get some shots beyond the expected musician plus instrument pairing. After breaking the ice and discussing the shoot over coffee, I discovered that she was an avid fan of poetry and loved to wear scarves. So, on the day of the shoot I asked her to bring plenty of both. Seeing her at ease with these familiar props you would have never known how nervous she was beforehand. In **Figure 3.5**, I hung the scarves in a tree and she posed with them blowing in the wind.

Figure 3.5
A model posing with familiar props—her scarves—which put her at ease during the shoot.

Nikon D700 •
ISO 400 • 1/160 sec. •
f/2.9 • 200mm lens

Giving Direction

People aren't still-life objects that you physically move around into position with your own hands. For this reason there is an art to working with and directing your subjects to strike the perfect pose using words and examples. The key is to establish a line of communication, start with broad instructions, and then fine-tune each pose. By now you should have an idea of mood and feel, so let the direction begin!

Showing Versus Telling

Let's begin by posing the entire body. Using mood boards and inspirational photos, you and the subject should be on the same page as far as where to begin. However, throughout the process you may want to give more specific direction. If you aren't able to communicate exactly what you want with words, put the camera down and show your subject what you have in mind.

Figure 3.6 shows a girl zipping along on a skateboard. The reality is that this model had never actually ridden a skateboard before! From her pose you would never know that the wheels of the board had been locked down, and that I guided her through the different poses to make the shot look believable. **Figure 3.7** shows a behind-the-scenes shot of me showing the model how to bend and twist, which would have been very difficult to relay by just telling her.

Figure 3.6 This skater girl looks like she's been skateboarding for years!

Nikon D700 • ISO 200 • 1/160 sec. • f/16 • 24mm lens

Figure 3.7 The model had never actually skated before, so I jumped in to show her how I wanted her to pose to make it look convincing.

Nikon D700 • ISO 200 • 1/250 sec. • f/11 • 24mm lens

Three Planes of Body Directions

After you've guided the model's body into position, you'll sometimes need to fine-tune poses even further. The only problem is that when you ask a model to turn left, often she'll turn her *entire* body left, even though you just meant her face or shoulders. It's a good idea to start by explaining that you'll be directing your subjects using three major planes: face, shoulders, and hips. Once you've established this understanding, be sure to let them know that you'll be posing each portion independently and not to move anything other than the plane that you reference.

In **Figure 3.8,** I've marked the three different planes you should work with. Now when you direct your model, you can be more specific. For example, you can say, "Turn your hips to the right, move your shoulders more toward the camera, and turn your face to the left." These directions are much more specific than asking the model to just turn left.

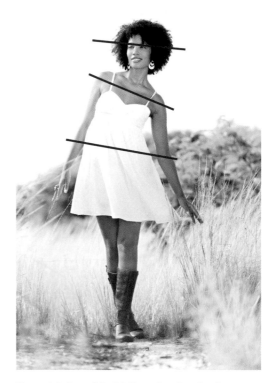

Figure 3.8 A model with lines showing the three body planes you can use to give direction.

Nikon D700 • ISO 200 • 1/1250 sec. • f/2.8 • 70–200mm lens

Fine-tuning the Face

The final nuances of a portrait are in the face. The face can look incredibly different when viewed from left to right or up (**Figure 3.9**) and down (**Figure 3.10**). For this reason you'll work with posing the face last. Once your subject is posed the way you want, by simply directing different face positions you can walk away with a variety of shots in a short period of time.

Simply hold up your hand and ask your subject to pretend that you are holding her face. You can also use analogies, such as, "Pretend my hand is a suction cup" or "Pretend I've got your nose." However you choose to phrase it is up to you. Have the subject follow your hand with her head. You can very precisely work the subject's face in different directions until you find the light or the best angle for the portrait.

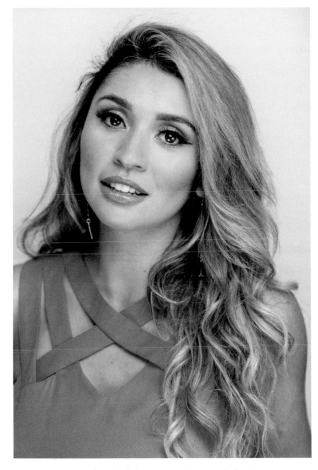

Figure 3.9 A model with her face up, highlighting her neck, chin, and lips.

Nikon D800 • ISO 100 • 1/200 sec. • f/2.8 • 70–200mm lens

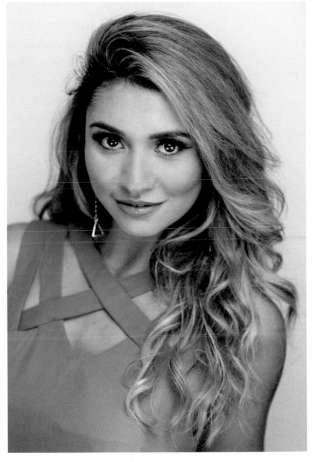

Figure 3.10 A model with her face turned down, placing the proper focus on the eyes.

Nikon D800 • ISO 100 • 1/200 sec. • f/2.8 • 70–200mm lens

Problem-Solving Poses

With the previous posing tips and tricks you'll be able to smoothly work through a photo shoot, minimizing miscommunication and walking away with perfectly posed portraits. Some specific problems will require a little more care to overcome. Let's look at a few common problems and the precise poses that will solve them.

Uneven eye sizes

Not all eyes are created equal. If you look closely, often one eye is larger than the other or one might squint slightly, as shown in **Figure 3.11**. Don't stress about using Photoshop to fix this problem; it's easily remedied with a simple pose. Have your subject face the camera and then turn away slightly, ensuring that the smaller eye is closer to the camera. By not having your subject look straight on into the camera, you can minimize the larger eye by letting it fade into the background. The result of this fix is shown in **Figure 3.12**. To enlarge the eyes even further, shoot down on your subject and have him look up slightly. These are both easy poses that take advantage of the lens distortion to tweak the face.

Figure 3.11 (left) The subject is squared to the camera showing variation in eye size; this is common.

Nikon D800 • ISO 250 • 1/250 sec. • f/8 • 95mm lens

Figure 3.12 (right) By turning the smaller eye toward the camera it appears larger and is now balanced with the back eye.

Nikon D800 • ISO 250 • 1/250 sec. • f/8 • 95mm lens

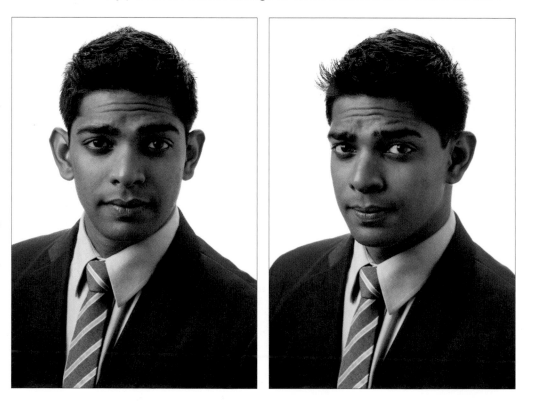

Minimizing glare in glasses

Have you ever photographed someone with glasses? The biggest obstacle when photographing someone in glasses is that dreaded reflection in the lenses. Do you want the easiest solution? Just pop out the lenses! Seriously, if there's no glass, then there's no glare. However, if you're not comfortable doing this, you can fix that glare with a simple pose. By default, many photographers turn their subjects into the main light source, whether it's a strobe light or just the sun. As shown in **Figure 3.13**, this creates glare on the glasses. To eliminate glare, simply have the subject rotate her face to the other side of the camera, and the glare will instantly disappear (**Figure 3.14**). Because you need the light to bounce off the glasses and miss your camera, you just change the angle of incidence of that light source to your camera lens, much like a pool player would bank a shot.

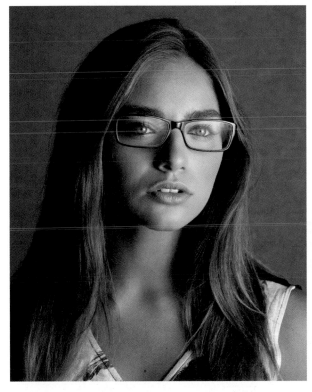

Figure 3.13 Turning your subject into the light source causes reflections to appear in the lenses.

Nikon D700 · ISO 1600 · 1/160 sec. · f/8 · 70mm lens

Figure 3.14 By simply turning your subject away from the light source, the reflection skips past your camera lens and the glare disappears.

Nikon D700 · ISO 1600 · 1/160 sec. · f/8 · 70mm lens

What's your good side?

You may have heard models or actors jokingly refer to their good side. When you spend your life in front of a lens, you quickly figure out your flattering angles—and the not so flattering ones too. But most of your everyday portrait subjects have no clue, or do they? One quick way to find your subjects' "good side" is to look at their hair part, if one exists. Normally, people part their hair to unconsciously showcase their favorite side. Pose them with this side of their face turned toward the camera, and they'll love you for it without even knowing why they favor those photos.

If no part exists, simply have the subjects pose freely from side to side and take note of which side they favor. Often, they'll show you more of one side than the other, which is usually a dead giveaway too. Because you want to work with your subjects on making sure you correctly deduce which side is their "good side," eliciting feedback is critical.

Getting Feedback

Share. Share. *Share* those photos! And I'm not talking about after the shoot is over. With today's digital cameras, photographers are constantly staring at the back of their screens but rarely ever show the models what they're looking at. After taking a few photos, if you immediately look down and silently scrutinize the LCD on your camera, it breaks the rhythm of the shoot and is also very disconcerting for your subjects. Turn that camera around and show your subjects a few photos. After all, you're on the same team (**Figure 3.15**). By showing them a good photo, they'll be excited to take more. And by showing them an imperfect photo, you can point out the pose or wardrobe that needs to be adjusted to make the photo great. If you just stand there without saying a word with a "thinking face" on, many subjects will start worrying that they've done something wrong. It's your job as a portrait photographer to avoid this at all costs!

Figure 3.15 Showing your subject the images on the back of your camera can build excitement, and is a good way to show them what they're doing right or what they can improve on in the next shot.

Fuji X100s · ISO 800 · 1/250 sec. · f/2 · 35mm lens

You can take this collaboration a step further by using the HDMI port on the side of most modern DSLRs to run a cable to your HDTV and then display the contents from your camera in extra-large detail for everyone on set to see! Another more advanced option is to use Wi-Fi memory cards, like the Eye-Fi line of SD cards, which can instantly and wirelessly send the photos you take to a phone or tablet to more easily share with your subjects. Check out www.eye.fi for more information because using these SD cards requires extra hardware and a little setup.

Chapter 3 Assignments

Mood boards in motion

Hop online and set up a free Pinterest.com or Tumblr.com account. Then familiarize yourself with either site (or both) and start collecting inspirational images and ideas. When the time comes to plan a shoot, you'll already be familiar with the tools you need to share your ideas with your subject.

Practice that posing

Grab a friend or a family member and practice posing with them. Review the basics of communication. Start with broad poses, and then work on fine-tuning those poses, specifically using the three body planes discussed earlier; finally, tweak the face. No cameras are necessary; just practice giving direction, and don't worry about being silly. Humor is a great way to lighten the mood on set.

Find your good side

Look in the mirror and find *your* good side. Photographers have the ability to make great portraits, but we seldom like how we look on the rare occasion when we're actually in a photograph ourselves. Examine your poses—up, down, left, right—to determine how you look your best, and it'll be easier to see in your next subject.

Share your results with the book's Flickr group!
Join the group here: flickr.com/groups/portraitsfromsnapshotstogreatshots

4
Working with Natural Light

Identify the quality and direction of natural light to capture great shots

In this chapter, you'll be taking your portraiture outdoors. By understanding the quality and direction of natural light, you can then work to tame or redirect that natural light for better portraits.

Natural light, or more specifically sunlight, is the most plentiful and affordable light source photographers have. That doesn't mean it's always pretty light, though. Before you begin to blindly fight an uphill battle with a very bright opponent, you first need to learn to see light and the different characteristics of light you'll be dealing with. When you're looking at light, there are two specific characteristics you need to see, namely the quality of light and the direction of that light. Once you understand what you're looking at, it becomes very easy to compose your portraits to put your subjects in their best light.

The existing sunlight is very harsh and direct, coming in from the side, which causes the quick transition to shadow on the hat.

Using the diffusion fabric on a reflector to filter the direct sunlight creates a much softer light with subtle shadows for the female subject.

Nikon D800 • ISO 80 • 1/1250 sec. • f/1.4 • 35mm lens

By taking a behind-the-scenes look at the cover photo, you can see what a difference a simple reflector makes in the final photo. Compare the quality of light on the exposed assistant to the final light on the model's face.

The silver material of a 5-in-1 Reflector can be used to bounce light back into the face for fill and an extra spark in the eyes.

Don't be afraid to ask your subject to get in on the action by helping to hold a reflector.

Understanding Light

Light is something that you most likely take for granted in your day-to-day lives. But once you pick up a camera, you are literally painting with light, and much like there are many different kinds of paint, light is equally as dynamic. To really understand what's on your palette as a photographer, you need to understand light. To do so, let's look at the different properties of light: its intensity, its quality, and its direction.

Quality of Light

The quality of light can be described as *hard light* or *soft light*. This is a very important differentiation that you need to make as portrait photographers, because soft light is often the most flattering light for peoples' faces. If you look closely at **Figure 4.1** and then at **Figure 4.2**, it's very easy to see a big difference in the quality of light. But do you know what you're looking at specifically in each image that defines the light as hard or soft? Seeing light is equally about seeing the highlights as it is seeing the shadows. To identify quality of light, you need only look at the *transition* between the two. In Figure 4.1, you see that the light *instantly* falls to shadow, whereas in Figure 4.2 the transition is more gradual, so much so that you can barely see where the highlight ends and the shadow begins. This is extremely soft light and is perfect for flattering a person's face. Hard light on the other hand is not so flattering because that quick transition to shadow will call attention to any wrinkles or blemishes on your subject's face.

Fortunately, there aren't many rules that you need to follow as photographers, but there are two that you really should take to heart: To get that beautiful soft light, you need to make sure that the light source is as *large* and as *close* to your subject as possible. A large light source spreads light evenly everywhere, washing the subject in illumination. Also, by moving the light source closer to the subject, you increase its relative size to the subject. This *combination* is what produces the great portrait light you saw in Figure 4.2.

When you step outside and assess your light, the sun becomes your light source. You'd think that such a massive ball of fire would produce soft light, right? Well, not exactly, because it only adheres to the first rule, size. The fact that it is 92,960,000 miles away means that in relation to your subject it is actually quite small. This "small" and faraway light source creates very harsh shadows, which is why no one likes to photograph at high noon, because the direct light by itself is horribly hard and unforgiving. But have you noticed on cloudy days that the light is infinitely softer? This is because the clouds become the new light source, with the sun shining through them. Clouds are large and much closer than the bare sun.

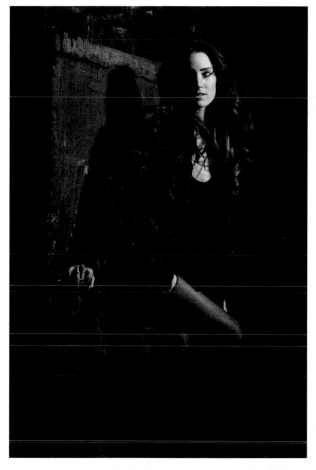

Figure 4.1 A portrait lit with hard light. The highlight-to-shadow transition is instant.

Nikon D800 • ISO 80 • 1/1250 sec. • f/1.4 • 35mm lens

Figure 4.2 A portrait lit with soft light. The highlight-to-shadow transition is extremely gradual. You can hardly see where the highlights end and the shadows begin.

Nikon D800 • ISO 80 • 1/1250 sec. • f/1.4 • 35mm lens

Rules for Soft Light

Keep these two lighting rules in mind when you want to create soft light:

- The larger the light source, the softer the light.

- The closer the light source, the softer the light.

Soft light = bigger source + closer to the subject.

Direction of Light

The second characteristic of light that you need to keep in mind is the direction of light. Depending on where the light is coming from, the amount of shadow on your subject's face can change dramatically. Shadow is necessary to create depth in a portrait, making a person look more three dimensional, but deep shadows don't look good at every angle. In direct sunlight you now know you'll be dealing with very hard light, but even on overcast days with soft light there is still a direction to the light if you look closely.

Two common directions of light that you'll run into when shooting portraits outdoors are direct overhead sunlight and side lighting in direct sun.

Overhead light

On days when the sun is shining brightly and directly overhead, you have plenty of light to work with. However, the sun in that position usually produces those dreaded raccoon eye shadows, and under those deep shadows your poor subjects are usually squinting pretty hard. Shooting in direct overhead sunlight is uncomfortable for them and uncomfortable for anyone who has to look at a bad portrait, like the one in **Figure 4.3**. Images like this have scared photographers away from shooting in midday light for ages.

Side light

Conventional wisdom tells you not to shoot at noon and to just wait until the sun starts its descent. **Figure 4.4** was taken later in the afternoon when the sun was lower in the sky, so I was able to avoid that nasty direct overhead light. But because of the harsh side lighting, now half of the model's face is covered in shadow. On their own, neither direction scenario—direct overhead nor side lighting—will yield a great portrait. For this reason, as portrait photographers, you need to have a few tricks up your sleeve to produce flattering photos no matter which direction the light is coming from, which I'll talk about next.

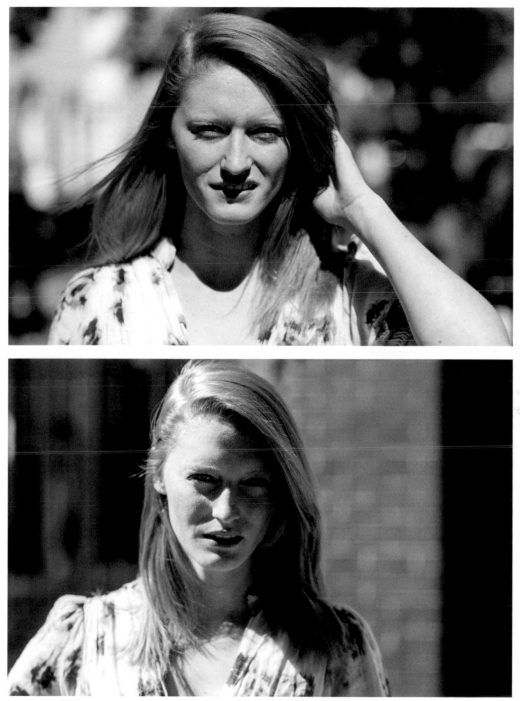

Figure 4.3
Harsh direct overhead sunlight produces unflattering light and deep eye shadows.

Nikon D800 •
ISO 100 • 1/2500 sec. •
f/2.8 • 85mm lens

Figure 4.4
Direct sunlight coming in from the side produces unflattering light and deep shadows on half of the model's face.

Nikon D800 •
ISO 100 • 1/1000 sec. •
f/2.8 • 85mm lens

Overcoming Difficult Lighting Scenarios

Now that you know how to identify and analyze the characteristics of light—its quality and direction—let's explore some common scenarios that you'll run into when you're wandering outdoors to take some portraits. Most often you'll get stuck taking shots in broad daylight, but if you're lucky, you may have access to some shade. Or, you might be shooting on an overcast day with softer light, which has its own host of challenges.

Figure 4.5 A portrait shot with the subject facing into the direction of the sun for even lighting on the face and minimal shadows.

Nikon D800 · ISO 100 · 1/2500 sec. · f/2.8 · 85mm lens

General Quick Fixes—No Kit Required

Whether the sun is high in the sky or on its way to sunset, there is a definite direction to the light, and now that you know to look for it you can begin working to overcome it. In either case there are two simple solutions that require no extra equipment at all.

Turn your subject into the sun

One simple solution is rather than fighting with the sun, embrace it. When the sun lights only part of your subject's face, harsh shadows immediately crop up on the opposite side. To get rid of shadows, you simply put *your* back to the sun, which will cause your subject to turn into the light, producing an even wash of light across her face. When the subject is side lit, reducing shadows is simply a matter of turning your subject into the light. When the light is directly overhead, you can eliminate shadows by getting slightly higher than your subject and having the person look up into the light. For elevation, look for existing structures like park benches or low walls. If those aren't available, bring a lightweight step stool on location with you. **Figure 4.5** shows that by turning the subject's face slightly upward and completely into the sun there are no shadows.

Turn your subject's back to the sun

The second solution for overcoming direct harsh light is equally simple; just turn your *subject's* back to the sun! This will throw the subject's entire face into the shadow. When you readjust your exposure for this type of shot, the result will be even lighting on the face and nice, bright backlighting, which works nicely as both hair light and rim lighting (I'll cover the various types of lighting—key light, hair light, and rim lighting—in Chapters 7 and 8). Notice the difference between the direct side-lighting scenario in **Figure 4.6** and the completely backlit scenario in **Figure 4.7**. Now, there is that heavenly glow and nice lighting on the face that you want!

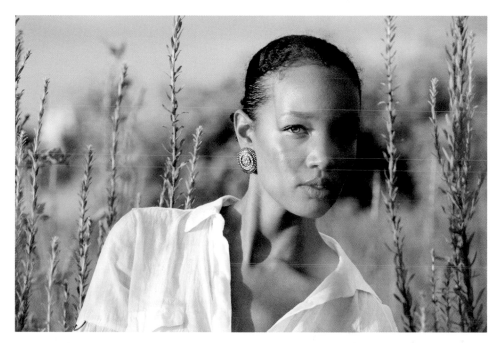

Figure 4.6
The subject is side lit by direct sunlight, causing half of the face to plunge into shadows.

Nikon D800 • ISO 100 • 1/2500 sec. • f/2.8 • 85mm lens

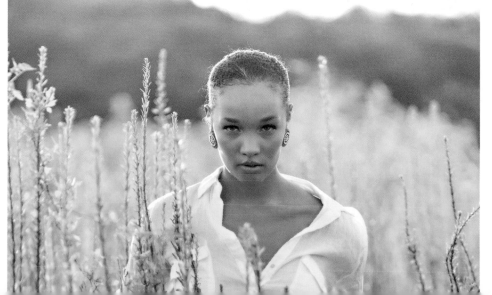

Figure 4.7
By turning the subject's back to the sun and exposing for her face, you get even lighting and a beautiful glow around her.

Nikon D800 • ISO 100 • 1/2500 sec. • f/2.8 • 85mm lens

Aside from the nice lighting that a backlit scenario offers, your subjects are not looking directly into the sun anymore, which makes this approach preferable to directing your subjects into the light, because it is much easier on your subjects' eyes. The easiest solutions are usually the best ones, and by just keeping these strategies in mind on your next shoot you'll have nice even lighting on your subject's face. And your subject will thank you too! It's tough to force a smile through squinting watery eyes as you're grimacing into the sun.

Use Spot Metering

Remember to use spot metering in high-contrast lighting situations where there's a large exposure difference between your subject and the background. This is to ensure that your camera properly exposes for the subjects and doesn't turn them into silhouettes against the bright backlighting. Refer to Chapter 2 for a refresher on metering modes.

Direct Sunlight—No Shade

All summer long you hope for bright sunny days. The only problem is you can't really adjust the direction of the sun at will. This is the reason you should direct your subject to change the position of her face instead. With direction taken care of, you're still left with a poor quality of light, as you saw in Figures 4.3 and 4.4. One option is to avoid the direct sunlight altogether by finding shade, which I'll discuss shortly. If shade is not available, you can use some affordable tools to tame that direct sunlight by creating your own shade or reflecting light back into the shadows. A versatile tool that allows you to do both is a 5-in-1 Reflector. It has multiple reflective surfaces to bounce light, and it also breaks down to a frame with diffusion material that you can use to filter light.

5-in-1 Reflector Surfaces

These five surfaces allow you to diffuse or reflect light quickly, easily, and affordably:

- **White.** Reflective surface for soft fill light
- **Silver.** Reflective surface with higher output and more direct light
- **Gold.** Reflective surface similar to silver but also warms the light temperature
- **Black.** Used to completely block light or build contrast through subtractive lighting
- **Translucent.** Used to diffuse light, much like the front of a softbox does

Filling in backlight with a reflector

Starting with the nasty light in Figure 4.3 you can easily establish the foundations of a well-lit portrait by again simply turning the subject's back to the sun, like I did in **Figures 4.8 and 4.9.** This approach works for headshots and full body shots too! Simply turning your subject away from the sun not only removes the bad shadows, it removes *all* of the defining shadows on her face.

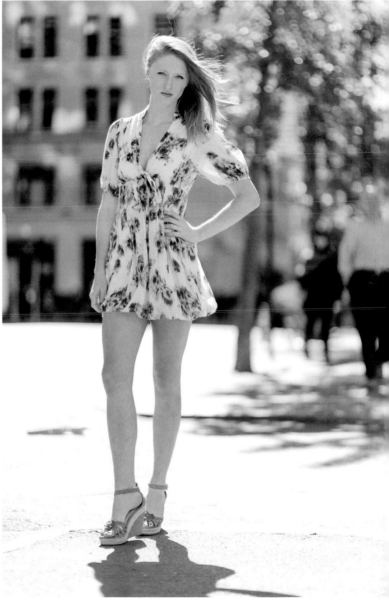

Figure 4.8 (above) By turning the subject's back to the sun and exposing for her face, you get beautiful even lighting and a nice rim of light around her head.

Nikon D800 • ISO 100 • 1/640 sec. • f/2.0 • 85mm lens

Figure 4.9 (right) By turning the subject's back to the sun and exposing for the shadowed side, you get beautiful even lighting from head to toe.

Nikon D800 • ISO 100 • 1/1600 sec. • f/1.4 • 85mm lens

Here's why I recommend taking it a step further and where a reflector with a high-output silver surface comes in handy: **Figure 4.10** shows my assistant holding a reflector up high to catch that direct sunlight to bounce it back into the subject's face. The result is the final shot in **Figure 4.11** with great backlighting, an evenly lit and exposed subject, and a kiss of light on the model's face to illuminate it and lend some sculpting shadow that I can now control.

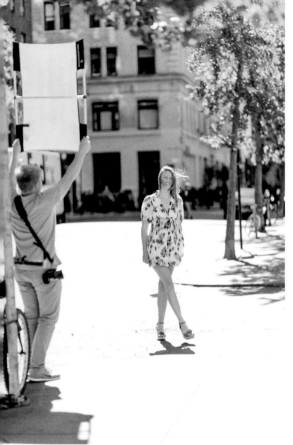

Figure 4.10 (above) My assistant uses a high-output silver reflector to bounce light into the model's face.

Nikon D800 · ISO 100 · 1/1600 sec. · f/1.4 · 85mm lens

Figure 4.11 (right) The bounce light from the silver reflector adds controlled highlights and shadow to the model's face, while the direct sunlight backlights her hair and body.

ISO 100 · 1/1600 sec. · f/1.4 · 85mm lens

Using a Bounce Reflector

When you're using a bounce reflector, keep in mind the direction of the light that you cast, just as you would when analyzing the sun's light. By reflecting the light from above the subject's eye line, the light appears natural. If you hold the reflector below the subject's eye line and bounce light up, you'll create odd and unflattering shadows. The sun shines down, so your reflected sunlight should too.

Diffusing side light with a reflector

To change the hard light in Figure 4.4 into a soft pleasing light, you would need to enlarge the light source and bring it closer to the subject. Obviously, you still can't move the sun, but if you put something between the sun and your subject, you can get the same effect, which is a lot like a cloud softening the sun on an overcast day. Instead of a cloud, you simply need some sort of diffusion material. In **Figure 4.12**, the reflector is placed between the sun and the subject, and is brought in as close as possible. The results are easy to see in **Figure 4.13.** The highlight-to-shadow transition is very smooth, producing a much softer quality of light, and the model is squinting less too.

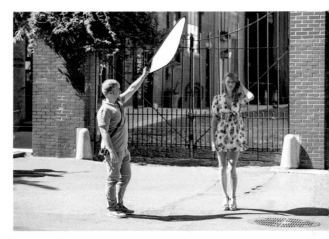

Figure 4.12 (above) Placing the diffusion panel of the reflector between the sun and the subject acts like a cloud by enlarging the light source and allowing it to be brought in close to the subject for softer light.

Nikon D800 • ISO 100 • 1/1250 sec. • f/2.8 • 85mm lens

Figure 4.13 (left) A beautifully soft, side-lit portrait is created by using the diffusion panel of a reflector to modify the sunlight.

Nikon D800 • ISO 100 • 1/500 sec. • f/2.8 • 85mm lens

Working with Shade

Shade is your friend. It protects you from the heat and unsightly camera strap tan lines. It also offers a variety of photographic opportunities without needing to hold a big diffusion panel or reflector overhead. However, not all shade is created equal, and some shaded areas offer up natural reflectors to really make your images sing. Let's run through a few opportunities you'll have when you have shade on hand.

Covered shade

One flavor of shade is covered shade. This is the kind of shade that you should first look for because it's the most obvious. Covered shade is created by something overhead, like an overhang or thick tree branches. Not only is covered shade easy to identify, it's also easier to anticipate what the light underneath will look like. Because the overhead covering blocks all the light from that direction, you know that the only place left for it to sneak in is from the side. **Figure 4.14** is a great example of thick overhead tree branches creating covered shade. If you look at the direction of the highlights to shadows on the subject's face, you'll see the soft side lighting.

Figure 4.14
Example of covered shade. The trees overhead block the harsh direct light, so now light is bouncing in from the side with a much softer quality and pleasing direction.

Fuji X100s • ISO 400 • 1/600 sec. • f/2.0 • 35mm lens

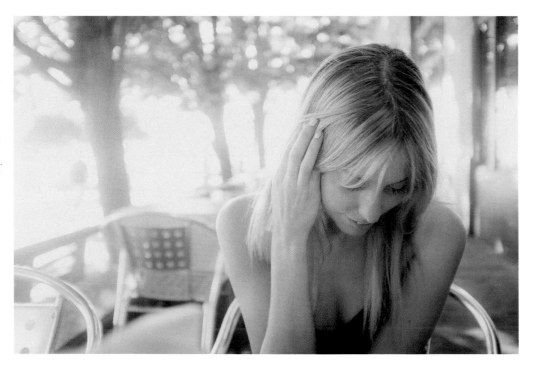

If you wanted less shadow, all you have to do is turn your subject's face out toward where the overhang ends. In **Figure 4.15**, I did just that. The model was standing under a small overhang blocking the sun from coming straight down and forcing it to bend and bounce in from the side. Only this time rather than shooting from the side, I stood looking directly at the shaded area with the light washing in from my direction, which created a soft, flat-looking light.

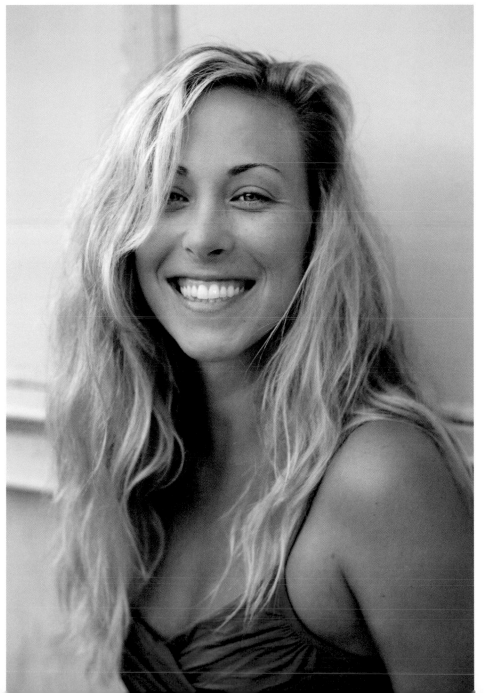

Figure 4.15
Another example of covered shade; this time the model is facing out from under the shade into the sunlight for an even wash of light on her face.

Nikon D800 • ISO 100 • 1/1250 sec. • f/2.8 • 85mm lens

Open shade

Open shade is often overlooked and incredibly plentiful in urban areas. Open shade is cast by something like a tall building but has nothing directly overhead and still casts a long shadow. In **Figure 4.16**, the subject is standing in the sun right next to a large area of open shade.

Figure 4.16
You can see the model standing just outside of a patch of open shade cast by a nearby building.

Nikon D800 •
ISO 500 • 1/250 sec. •
f/16 • 35mm lens

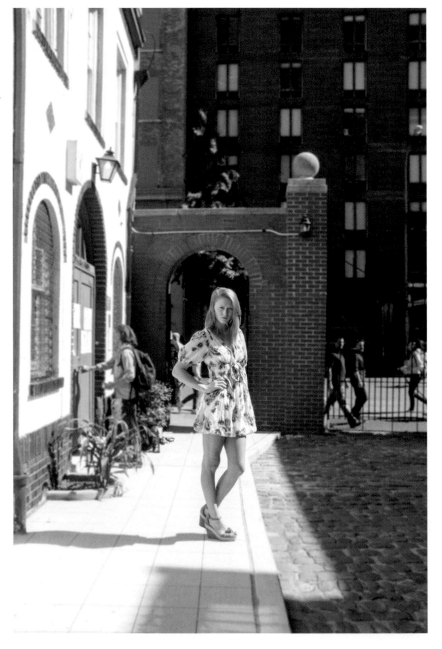

In **Figure 4.17**, you again see how bad direct sunlight is without finessing it a bit. But after asking the model to take a few steps forward into the open shade, the result is a much better quality of light on her face, although it is underexposed in the next shot in **Figure 4.18**.

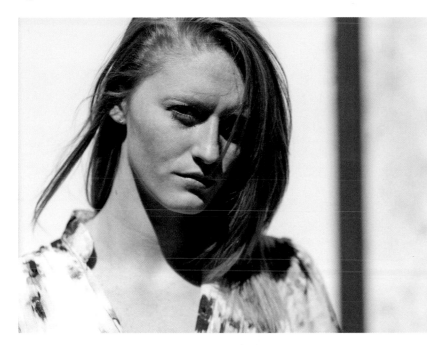

Figure 4.17
A close-up portrait of the harsh light and shadow cast by direct light without using the nearby shade.

Nikon D800 •
ISO 100 • 1/4000 sec. •
f/2.8 • 85mm lens

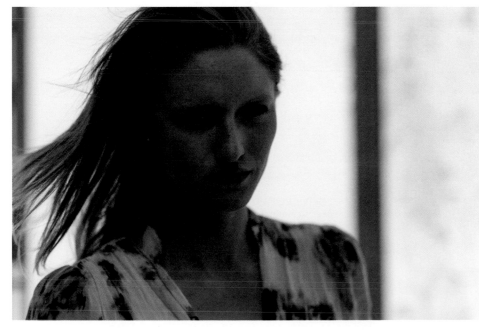

Figure 4.18
By having the model step forward into the open shade the quality of light greatly improves, although the intensity or brightness has decreased and left the photo underexposed.

Nikon D800 •
ISO 100 • 1/6400 sec. •
f/2.8 • 85mm lens

If you're using Manual mode on your camera, all you need to do is slow down your shutter speed to allow more light into the exposure. If you're more comfortable in Aperture Priority mode, just make sure you spot meter on the subject's face and your very next shot will look like **Figure 4.19**. It's pretty incredible how a little open shade makes such a big difference on your portraits.

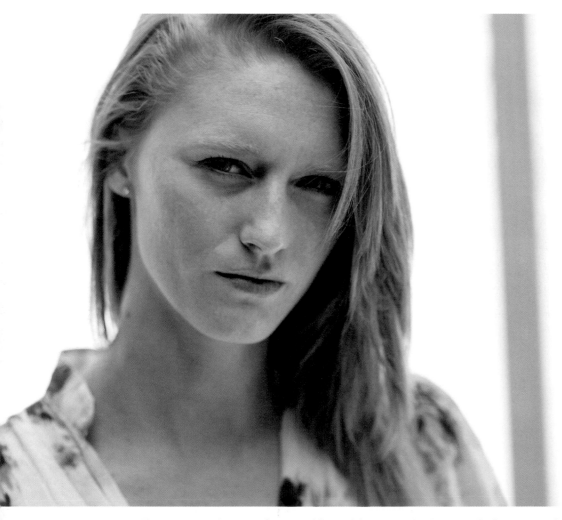

Figure 4.19 Here is a properly exposed, beautiful portrait using just open shade. You can achieve the right exposure by slowing down the shutter speed in Manual mode or by using Aperture Priority mode and spot metering for the model's face.

Nikon D800 • ISO 100 • 1/1000 sec. • f/2.8 • 85mm lens

Open shade + natural reflectors

Look at the background of the photo in Figure 4.19 again. It's pretty bright, right? This should set off some MacGyver-style bells in a photographer's mind. If the background is that bright, then that wall back there must be bouncing a serious amount of light, which makes it one massive natural reflector! Rather than shooting into the bright light source, for my next shot, I walked around and placed the bright wall at my back, capturing **Figure 4.20.** With the wall directly at my back, all of the bounced light was coming from the same direction as my camera was aiming. This on-camera axis direction is what creates such shadowless beauty lighting.

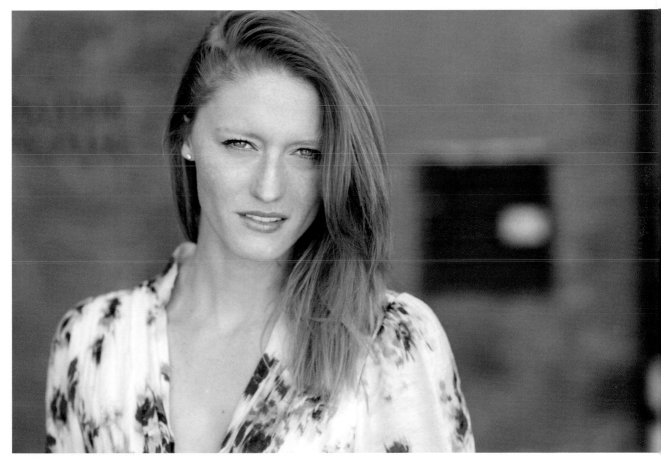

Figure 4.20 The subject is still standing in open shade, but now I used the bright wall behind me as a natural reflector to bounce the direct sunlight back onto the model.

Nikon D800 · ISO 100 · 1/250 sec. · f/2.8 · 85mm lens

The combination of open shade and a *huge* natural reflector, the bright wall, can be easily seen in **Figure 4.21.** With the big wall now effectively becoming my main light source, I was working with a light source bigger than anything I've ever seen available in a commercial photo studio, and it was free, just waiting for me on the street. With such a massive size (it was bouncing back two stories' worth of light) it's easy to get full-length portraits, like the one in **Figure 4.22,** as well as full group photos if everyone faces the wall.

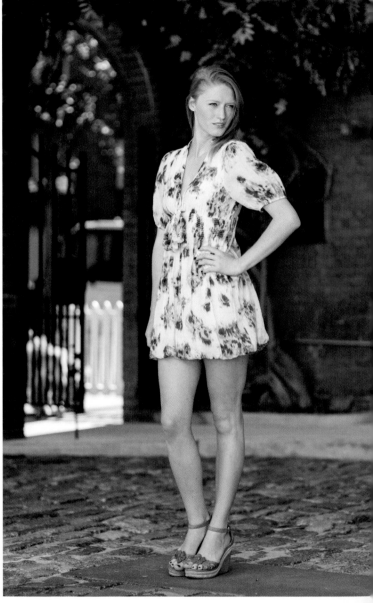

Figure 4.21 (above) A behind-the-scenes view of the model standing in open shade while being illuminated by the light bouncing off the bright wall being used as a natural reflector.

Fuji X100s • ISO 400 • 1/250 sec. • f/4.5 • 35mm lens

Figure 4.22 (right) Using a giant natural reflector like a wall is a great way to evenly light full-body portraits like this, or even whole groups of people.

Nikon D800 • ISO 200 • 1/2500 sec. • f/2.2 • 85mm lens

To add a little more depth and shadow to the next photo, I walked away from the wall and shot parallel to it. This produced the same effect as moving a studio softbox from behind me and over about 45 degrees to the side of the model. The result shown in **Figure 4.23** is a beautiful portrait with classical lighting patterns and extremely soft light.

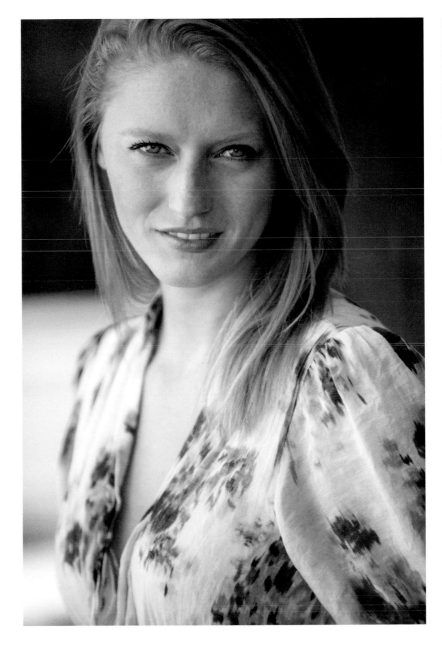

Figure 4.23 **A portrait with classical, soft portrait lighting and shadow on the model's face was created by turning her so that the wall bounced light in from the side like a giant studio softbox.**

Nikon D800 · ISO 200 · 1/2500 sec. · f/2.2 · 85mm lens

If you really want to get fancy, you can just place half of the model's body in the open shade, lighting her face with the natural wall bounce and letting the sun act as a hair light, as in **Figure 4.24.**

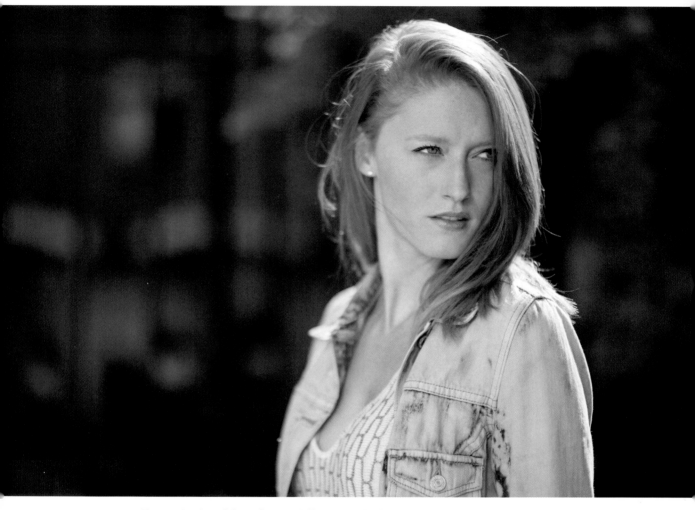

Figure 4.24 A model standing partially in open shade to allow the direct sunlight to accent her hair, while leaving the rest of her face in even shadow to then be filled by light from the wall being bounced back as a natural reflector.

Nikon D800 · ISO 100 · 1/2500 sec. · f/1.4 · 85mm lens

Diffused Sunlight—Overcast Days

Overcast days are great for portrait photographers! The low cloud cover diffuses that hard sunlight like a giant overhead softbox. This cuts down the contrast on everything underneath the cloud cover, landscape and portrait subject alike. Some photographers run outdoors on a cloudy day and just start firing away, thinking the light is just right no matter which way they point their cameras. Although the *quality* of light is much softer on cloudy days, the *direction* of light still needs to be taken into account.

Side light

Side lighting on an overcast day is *much* less severe than you saw in the sunny examples. Because the clouds soften the light for you, you usually don't need to break out the diffusion panels or reflectors. However, you do have to take notice of the more subtle, but still present, direction of the light.

In **Figure 4.25,** the model was freely posing on an overcast day in the afternoon with the sun setting to the side. Not knowing what to look for in the light, she turned her face into the shadow. I noticed this and directed her to face the other way.

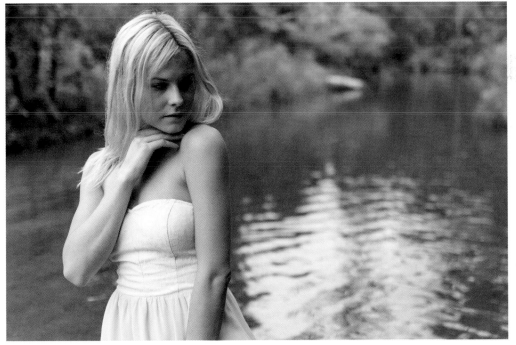

Figure 4.25
The model incorrectly turns her face into the shadow.
...
Nikon D800 •
ISO 80 • 1/1250 sec. •
f/1.4 • 35mm lens

In the very next shot (**Figure 4.26**), it looked like someone had aimed a big, beautiful soft-box at her face. To add a final bit of icing to the image, I held a silver reflector below her face. With no direct light hitting the reflector, it didn't bounce much light back, but it did create that catchlight in the bottom of the eye. That catchlight sparks the eyes and brings them to life (**Figure 4.27**).

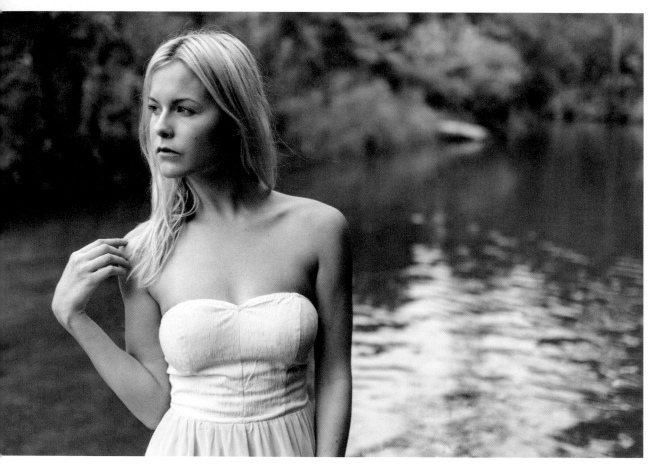

Figure 4.26 By giving the model proper direction, she is now turned into the beautifully soft overcast light for a nice portrait.

Nikon D800 • ISO 80 • 1/1250 sec. • f/1.4 • 35mm lens

Figure 4.27 On overcast days there isn't much spark to the subject's eyes. By adding a silver reflector slightly below her face, the reflection creates a catchlight and brings the eyes to life.

Nikon D800 · ISO 80 · 1/1250 sec. · f/1.4 · 35mm lens

Overhead light

As mentioned earlier, most photographers are hesitant to shoot at high noon on a clear day, but when the clouds come out, everyone grabs their camera to go play! Whether the light is diffused or not, when it's directly overhead, the shadows cast by the subject's eyebrows still go straight down and create that unflattering raccoon-eyed look. To avoid this problem, your subjects just need to turn up their faces into the light. While it may occasionally be too bright to have them do this on a sunny day, it's no trouble at all under overcast conditions. As the photographer, find a way to elevate yourself to shoot down on them, so every photo isn't looking directly up their upturned noses. In **Figure 4.28** (on the following page), I simply had the model sit down and then look up at the camera with the cloudy skies behind me, evenly illuminating her face. To get that elevated position, find something safe to stand on or bring a small step stool to the shoot.

Once you understand the quality and direction of light, you'll be able to assess any outdoor lighting condition. Then, with the techniques I covered in this chapter and some simple tools, you and your subject can conquer natural light to produce amazing portraits in all kinds of weather and at any time of day.

Figure 4.28
By standing above the model, I was able to shoot down on her while she raised her face up into the overhead cloudy light. This negated any shadows while softly and evenly illuminating her face.

Nikon D800 • ISO 400 • 1/160 sec. • f/2.8 • 120mm lens

Chapter 4 Assignments

Analyzing hard versus soft light

Make a game of analyzing the light you see on an everyday basis. Determine if it is hard light or soft light. Then take note of the light source's size and distance from the people it's illuminating. With a little practice you'll be able to identify different qualities of light automatically.

Exposing for high-contrast lighting

Work with your different camera modes to properly expose a person who is heavily backlit. Turning your subject's back to the sun is an easy way to get even lighting but is difficult for your camera to calculate. Set your camera to Spot Meter, and then place the spot sensor on your subject's face to get a proper meter reading.

Working with a silver reflector

Practice working with a silver reflector on your own. On a sunny day use a silver reflector to paint light onto a wall. Hold the reflector up high and use the bottom edge of the reflector to aim the light. Now practice doing this at different distances from the wall. Bouncing light is just like practicing your bank shot on a pool table.

Share your results with the book's Flickr group!
Join the group here: flickr.com/groups/portraitsfromsnapshotstogreatshots

Nikon D800 •
ISO 100 • 1/160 sec. •
f/3.2 • 70mm lens

5

Working with Existing Indoor Light

Conquer the obstacles of using existing light to produce great shots

Working indoors with existing light presents a host of challenges, including varying light temperatures and low light in general. In this chapter, you'll learn to overcome these challenges so that you walk away with great-looking skin tones and sharp images.

First things first; you don't want any pesky flashes popping up randomly compounding the problem, so turn *off* your pop-up or on-camera flash. On many DSLRs, this is as simple as holding down the button with the lightning bolt while rolling the camera's command dial. For specifics, check your camera manual. It's important that the flash be off. But don't worry; in a later chapter I'll cover how to get great images *with* flash as well.

Poring Over the Picture

By identifying the main light in the scene, you can share this with your subject to ensure that the subject poses in that direction for even lighting on the face.

Using a mixture of window light and existing indoor light can result in dramatic photos without the need for extra strobes.

This image was lit primarily by very dramatic window light. But the interior lights were in the frame, so by keeping them turned on they added to the photo with warm accent lighting on either side of the model's hair. This combination of light resulted in a natural yet powerfully lit photo.

Nikon D700 ·
ISO 200 · 1/200 sec. ·

Because the white balance is set for Daylight, the tungsten bulbs appear orange and worked as naturally looking accent lights.

The window light was the dominant light source, so I used the camera white balance preset for Daylight. This produced correct skin tones on the model.

Color Temperature

The first indoor curveball you need to know about is color temperature. Up until now I've been talking about portraits in general, or specifically those lit by outdoor sunlight. For much of the day, the sun's color temperature does not change that much, so you haven't had to worry about it, well, that is until you step inside. Once you walk into the realm of man-made light sources, the color of the light can vary greatly. Fortunately, there is a method to the madness of varying light sources.

Kelvin Scale

Lights actually have a temperature, just as the climate does. We even refer to the different light temperatures as "hot" or "cool," just like we would describe the weather. But rather than using Fahrenheit or Celsius, we identify light temperature by the Kelvin scale.

The Kelvin scale ranges from 1000K to 10,000K. Warmer or more reddish-orange light temperatures register low on the scale, whereas cooler light, such as light you'd find in the shade, has a higher Kelvin temperature. Take a look at the chart in **Figure 5.1** for an example of how different temperatures appear on the scale.

Figure 5.1
The Kelvin scale shows warm to cool light temperatures.

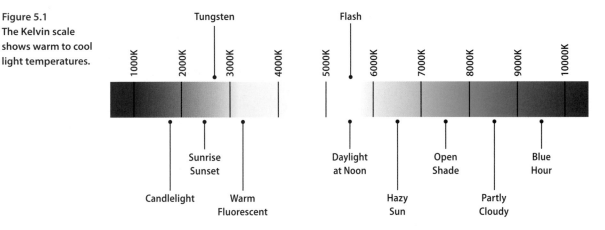

White Balance Presets

Your eyes do an amazing job of taking in all of these different light temperatures and adjusting them in your mind so people and things appear natural in color. However, when it comes to photos, you need to guide your camera to ensure that colors and whites look correct in the final photos. To do this, you need to white balance the camera. White balance is used to adjust colors to match the color of the light source so that white objects appear white.

Auto White Balance

To be fair, that little computer brain inside the latest DSLRs does a pretty good job of automatically white balancing, most of the time, that is. In fact, the Auto White Balance setting passes the responsibility of color balance on to the camera. This setting is ideal for beginners or people in a real hurry. But when you're taking portraits, you'll eventually want to take the time to set white balance manually. The reason is that Auto White Balance doesn't have the artistic sensibility that photographers have. Instead, it tries to neutralize color casts in the photo to average everything out to a medium gray—not too warm, not too cool. **Figure 5.2** shows a portrait lit by window light with the camera set to Auto White Balance. As you can see, there are no terrible color casts on her face, but she doesn't look as warm and lively as she could.

Just like you do with other camera settings, you want to take a degree of manual control to steer the final image toward what you see in your mind. This means you need to shift the white balance (using the Kelvin scale) to warm her skin tones. As a photographer I like to do as little math as possible, and I doubt I'm alone in this, which is the reason your White Balance Presets are lifesavers! Rather than having to memorize temperature values, you simply need to reference some nifty icons. Because the sun lit the window in Figure 5.2, I switched to the Daylight preset, and the very next shot came out with a more pleasing warm glow to the model's skin (**Figure 5.3**).

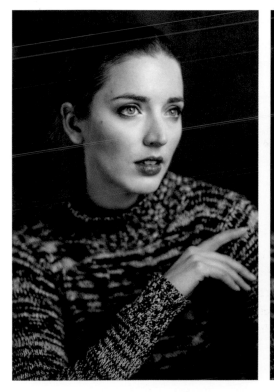 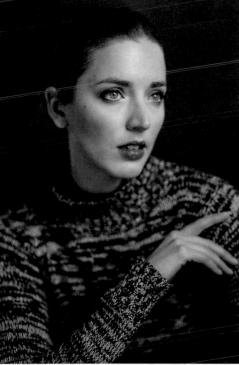

Figure 5.2 (left) An image captured with Auto White Balance.

Nikon D800 · ISO 400 · 1/200 sec. · f/2 · 85mm lens

Figure 5.3 (right) An image captured using the Daylight white balance preset.

Nikon D800 · ISO 400 · 1/200 sec. · f/2 · 85mm lens

It doesn't end there, either. Your camera provides white balance presets to help you set up your camera for all kinds of different lighting temperatures. Check out the chart in the sidebar "On-Camera White Balance Presets," and be sure to experiment with different presets if Auto White Balance isn't giving you the best results.

On-Camera White Balance Presets

Using the white balance presets provided by your camera manufacturer is a quick and easy way to ensure accurate colors and skin tones when you're shooting under different types of lighting:

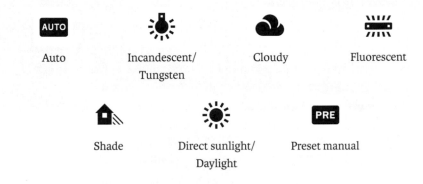

Auto Incandescent/ Cloudy Fluorescent
Tungsten

Shade Direct sunlight/ Preset manual
Daylight

Common Color Temperature Scenarios

Although light temperatures can really run the gamut, let's focus on a few of the most common scenarios you'll encounter as a portrait photographer, namely daylight, tungsten, and fluorescent lighting.

Daylight preset

In an earlier example, I compared Auto White Balance to the Daylight preset. I usually just leave my camera set to Daylight white balance because of how often I shoot outdoors or use available window light. It's especially useful when I'm shooting in window light because once inside, the window is usually competing with multiple light sources, which may confuse the camera. I'll discuss this "mixed lighting" issue shortly. In the meantime, the example in **Figure 5.4** shows how the Daylight preset made sure the final image had perfect skin tones, even when the rest of the room had an orange cast to it. In the full-body shot in **Figure 5.5**, you can really see the rest of the room compared to the model, who is being front lit by the window.

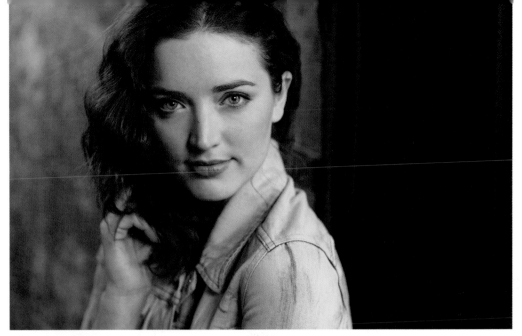

Figure 5.4
A close-up using the
Daylight preset for
window light.
Nikon D800 •
ISO 1000 • 1/80 sec. •
f/3.2 • 90mm lens

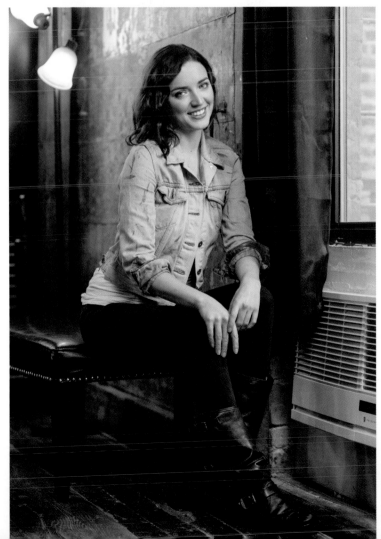

Figure 5.5
A full-body shot using the
Daylight preset for window
light. Notice how the rest
of the room is orange,
but the skin tones are
rendered beautifully.
Nikon D800 •
ISO 1000 • 1/80 sec. •
f/3.2 • 85mm lens

Tungsten preset

The Tungsten preset is the second most common preset I use and is definitely the most common when I'm shooting indoors. The reason the rest of the room looked orange in the previous two photos was because they were lit primarily by common household lamps with tungsten lightbulbs. In **Figure 5.6**, you can see what would happen if you turned the model away from the window and into that lamp light while still shooting with the Daylight white balance preset. The model's skin changes from looking nice and natural to the color of someone who just had a horrible spray-tanning experience! But don't worry; you merely change the white balance to the Tungsten preset to match the new light source, and the very next photo results in great skin tones (**Figure 5.7**).

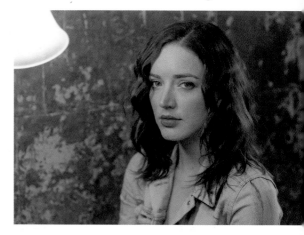

Figure 5.6 A lamp-lit subject with incorrect Daylight white balance set.

Nikon D800 • ISO 1000 • 1/80 sec. • f/3.2 • 85mm lens

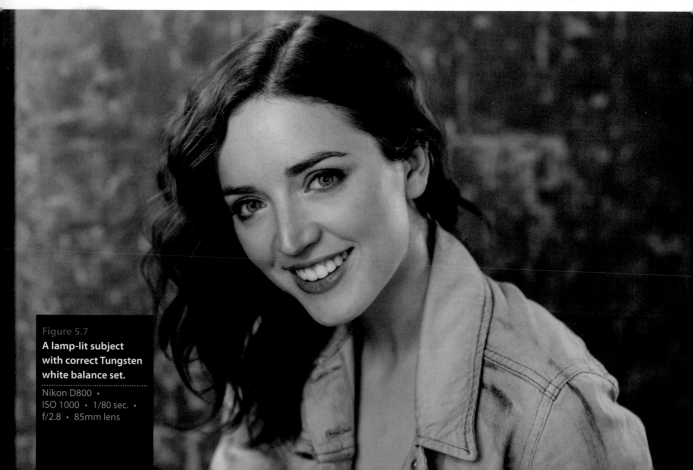

Figure 5.7
A lamp-lit subject with correct Tungsten white balance set.

Nikon D800 • ISO 1000 • 1/80 sec. • f/2.8 • 85mm lens

Fluorescent preset

Fluorescent light is another common indoor light-ing scenario you have to deal with. It is also the most vexing from a white balance standpoint. I've jokingly stated before that fluorescent bulb manu-facturers must really have it out for photographers. The older bulbs had an intense, sickly looking, green color cast to them, and many of them would even flicker! How green? This green (**Figure 5.8**)!

Newer bulbs have less of a green tint, and some are even balanced to be near daylight tempera-tures. To make matters worse, you seldom find a single fluorescent bulb in a room. Usually, the fixtures take two to four bulbs each, which can lead to quite a mix and match of bulbs and color temperatures in a single fixture.

To address this larger than average swing in color temperature within a single kind of bulb, camera manufacturers have added a submenu of options for the Fluorescent white balance preset (**Figure 5.9**). Within this more extensive list you'll often find a preset that will give you satisfactory skin tones in your images. Now that you know it's there, go explore!

Figure 5.8 Older fluorescent bulbs can make your subject look very green without the proper white balance settings.

Nikon D700 • ISO 3200 • 1/250 sec. • f/2 • 50mm lens

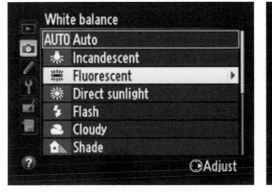

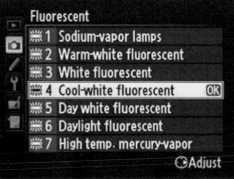

Figure 5.9 The Fluorescent white balance preset submenu.

Custom White Balance

I started off talking about Auto White Balance, which is a good place to start, and then taking control by applying white balance presets to the most common lighting scenarios. Unfortunately, not all light is created equal, and you may not find a perfect fit within all the preset options. When this occurs, you'll need to make a Custom white balance to ensure that skin tones look normal. Custom white balance profiles are perfect for difficult-to-read lights or mixed-light scenarios.

To set a Custom white balance quick reference

- For a single light source, dial in a Kelvin value and use a gray card.

- For a mixed light source, use an ExpoDisc.

Set for a single light source

If you have a single light source that seems to fall in between your presets, a very straightforward way to fix this is to just dial in the Kelvin value directly. After all, when you set your camera to the Daylight preset, you're really just setting it to 5500K. Most cameras will let you adjust the temperature up and down in 100-degree increments so you can make precise adjustments.

Figure 5.10 A neutral gray card reference target for setting a Custom white balance.

Another way to customize your white balance is to create a custom profile from a reference target. By referencing a neutral gray card (**Figure 5.10**), your camera knows what color that specific gray should be and adjusts to the correct settings to achieve it. Set your reference gray card in the light under which you plan to photograph your subject, and then zoom in to fill the frame with your reference target. Take the photo, and then select that photo within your camera menu to use as the Custom white balance reference file (**Figure 5.11**).

Figure 5.11
The Custom white balance menu used to select a reference photo of the gray card.

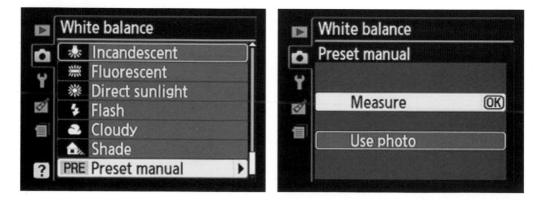

Be sure to read your camera manual for specifics on how to set a Custom white balance. The menus may vary from model to model, but the process is the same. Also, by taking gray card photos in multiple light sources ahead of time, you can quickly create new custom profiles when working with your subject, which saves you time.

Set for a mixed light source

Mixed-light scenarios are very common when you're shooting indoors and are the reason it's important for portrait photographers to have a good under- standing of white balance. When multiple lights with different color temperatures are hitting your subject (**Figure 5.12**), it's nearly impossible for your camera to figure out which one is right. As you can see in **Figure 5.13**, the camera's Auto White Balance setting doesn't know what to prioritize, so the result is an orange, yellow, bluish mix, which doesn't flatter the subject or the scene.

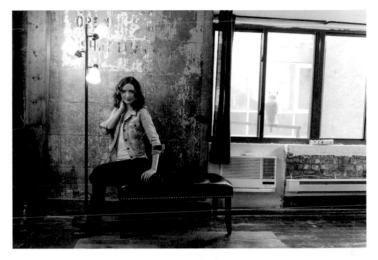

Figure 5.12 **This wide shot shows the mix of lamplight and window light that produces unflattering skin tones.**

Nikon D800 • ISO 800 • 1/60 sec. • f/3.2 • 34mm lens

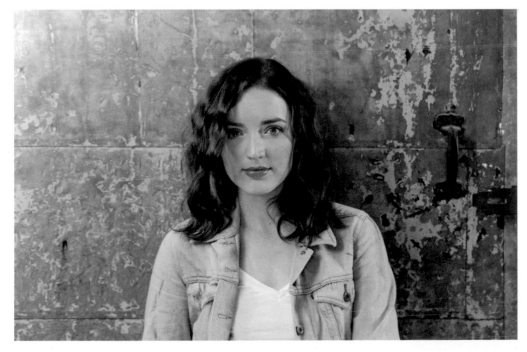

Figure 5.13 **Using Auto White Balance under difficult mixed- lighting conditions produces unflat- tering skin tones, because the camera doesn't know which to prioritize.**

Nikon D800 • ISO 800 • 1/80 sec. • f/4 • 90mm lens

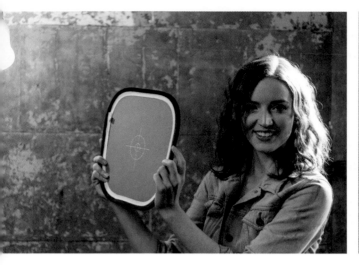

Figure 5.14 A mixed-light environment using a Custom white balance set for a gray card facing a tungsten lamp.

Nikon D800 • ISO 800 • 1/60 sec. • f/3 • 90mm lens

Figure 5.15 A mixed-light environment using a Custom white balance set for a gray card facing window light.

Nikon D800 • ISO 800 • 1/60 sec. • f/3 • 90mm lens

Using a gray card in this situation won't help you here. Depending on which way you hold the target, you'll get drastically different results (**Figures 5.14** and **5.15**). It's a great solution when you're favoring one light source over the rest, as you saw earlier, but it's not very versatile for mobile subjects and large rooms of mixed light.

However, you'll still want to make a Custom white balance in this situation because it's the lighting scenario that most desperately needs it. To do so, you need a tool that will help you gather information from multiple lights into a single photo for the camera to process. This is where the ExpoDisc White Balance Filter rides in to save the day. It's a filter-like device that you attach to the front of your camera (**Figure 5.16**). Then, rather than shooting at your subject, you stand where your subject will be and aim your lens with the ExpoDisc into the light. With its raised surface, it collects the light from multiple directions and creates an image in-camera that represents the mix. Using this file you can create a Custom white balance under even the worst lighting combinations.

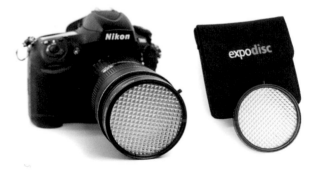

Figure 5.16 An ExpoDisc allows you to quickly get the right color balance with your camera.

With a firm grasp on white balance and how to achieve it, you can ensure that your subjects will look their very best and not like sunburnt lobsters or someone who just ate some bad sushi. You can even get

creative with white balance and slightly shift color temperatures to make your subject appear tanner or to create a cooler overall feel to images. The possibilities are immense, but most important is knowing how to get great-looking skin tones to begin with.

Combating Camera Shake

After you become comfortable with the varying color temperatures that you will encounter indoors, you then need to address the second major hurdle that makes indoor portrait photography difficult—low light. When you're dealing with light sources less powerful than the sun, these low-light conditions can often result in blurry photos due to slow shutter speeds. With the proper settings, support, and techniques, you can quickly conquer these low-light environments for tack-sharp photographs. Here's how to do just that.

High ISO

When you're shooting outdoors, you keep your ISO settings fairly low. Most DSLRs default at 100 or 200 ISO. The reason is that, with so much available light from the sun, you don't need a ton of sensitivity to get a proper exposure. However, if you walk indoors without changing any settings, you'll get very blurry images, like the one in **Figure 5.17**. This image was taken with the camera still set at ISO 200 and an aperture of f/8 in Aperture Priority mode. The camera decided it needed a *very* slow shutter speed to expose the photo, and my natural body movements while holding the camera caused it to be blurry.

Figure 5.17
By using the same camera settings I had set up for shooting outdoors, the moment I walked indoors my pictures became very blurry.

Nikon D800 •
ISO 200 • .6 sec. •
f/8 • 90mm lens

A large Rogue Flashbender softbox was placed on top of the speedlight to elevate the light and soften it for more even and pleasing highlights.

By placing a CTO gel on top of the speedlight, the color balance was matched to the existing tungsten bulbs in the room as well as the background lights. This balance results in natural skin tones and pleasing background colors.

A piece of white poster board was held underneath the subject's chin to bounce light from the speedlight back into the face to fill the shadows.

Beautiful portraits are possible in even the dimmest lighting conditions with the aid of on-camera flash and a little creative direction. This photo was lit with a single speedlight and a piece of poster board below the model's face as a bounce card.

A shallow depth of field cast the background Christmas lights out of focus and created some interesting bokeh for the background.

Nikon D800 ·

Flash Power

You can't very well turn the power of the sun up or down, but when you turn to your flash, you have an incredible amount of control. By selecting the right mode and including a little guidance of your own, you'll easily be adding that extra kiss of light to your portraits soon.

Flash Modes

Up until now you've only had to deal with the existing light in a scene to properly expose a photograph. By using a mode like Aperture Priority, almost all the thinking has been automatically done by the camera. Now, the moment you add your own light to a scene, you also add another variable to the exposure. "Oh, no!" you might say. "Not another factor to fret about when all I want is a pretty portrait!" The great news is that current cameras have an "auto mode" for flash too! It's called TTL mode. Sure, you can manually set the intensity of your flash using Manual mode, but by switching it to TTL mode the camera does all the thinking to determine just the right amount of flash to add to the photo.

Manual mode is best suited for when the distance between your flash and the subject remains constant. Once you begin to move closer or farther away, the intensity of the flash on your subject will increase and decrease. With the pop-up flash or speedlight on top of your camera, this means you need to stay put or keep manually adjusting the flash's power level.

Using Manual mode is a tedious way to take a picture to say the least. For this reason, for the sake of on-camera flash portrait photography, I recommend you keep your flashes set to TTL mode most of the time. Let your camera do the thinking here, leaving you free to worry about composition and interacting with the person in front of that flash.

Flash Modes

The two Flash modes are:

- **M – Manual mode.** You are responsible for setting the power output of the flash. This can be done precisely in fractions of the flash's total possible output (1/1, 1/2, 1/4, 1/8, 1/16, 1/32, 1/64, 1/128).

- **TTL – Automatic mode.** TTL is an abbreviation for Through The Lens metering. Your pop-up flash or speedlight sends out tiny pre-flashes that are metered through the lens of the camera as they bounce back to automatically decide the proper flash output. This can then be tweaked slightly by using your Flash Compensation. E-TTL (Canon) and I-TTL (Nikon) are essentially the same thing.

Flash Compensation

But what happens if TTL doesn't give you exactly what you're looking for? It's a computer after all, not an artist, so what it calculates as the "right" amount light of light may be too much or not enough for you. This is where Flash Compensation comes in handy. Flash Compensation takes the power output that TTL has decided is appropriate and then adds or subtracts extra intensity to it based on your adjustments. You can adjust TTL flash power output by using Flash Compensation on both your pop-up flash and the larger speedlights.

You can find the Flash Compensation button on the front of your DSLR near the pop-up flash (**Figure 6.1**). By holding down this button and rotating the command dial on your camera you can adjust the compensation up and down, which is denoted by the +/− symbols on the camera's display. To do this while using an external speedlight, just press the + or − button on the actual flash while in TTL mode (**Figure 6.2**).

Figure 6.1 The Flash mode / Flash compensation button will be marked with a lightning bolt. Hold down this button to dial your compensation up and down with the camera's command dial.

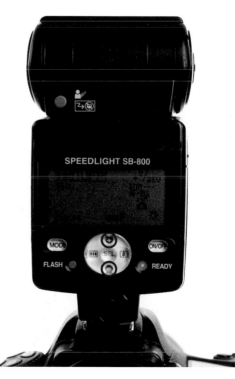

Figure 6.2 When you're using a speedlight, Flash Compensation can be found on the back of the flash. Just press the + or − button to add or subtract compensation.

Speedlights

At this point you should be hooked on the possibilities of using flash in your portrait photography—and it only gets better from here! That pop-up flash is just the tip of the iceberg. Camera manufacturers make a super-sized version of this flash called a *speedlight*. It works much the same way as a pop-up flash but attaches externally to the hot shoe on top of your camera body.

Benefits of Speedlight vs. Pop-up Flash

Although a speedlight uses all of the same modes (Manual, TTL, Flash Compensation, Red-eye Reduction) as the pop-up flash, there are a number of advantages to investing in one at some point in your photographic journey. These benefits include:

- More power and external batteries
- Zoomable flash head
- Rotating flash head (discussed later in the chapter)
- Flash modifiers (discussed later in the chapter)

Power

Power is one of the big upgrades when you use a speedlight. A speedlight has a lot more output to offer than your pop-up flash. This allows you to fill flash some serious shadows even on the brightest days. Speedlights also have their own power supply, usually a set of four AA batteries, which is important because you aren't rapidly draining the camera's battery with every pop.

Zoomable flash head

Another great feature built into most speedlights is the zoom function. Rather than just fanning light out in all directions, speedlights allow you to precisely control the spread of light they emit. It's easy to wrap your head around too: The zoom setting on the speedlight corresponds to the zoom of your camera lens. In **Figure 6.11**, the lens is set to 35mm. With the speedlight in TTL mode, the flash's zoom was automatically set to 35mm as well. This ensures even light coverage and the most efficient use of flash power. (If you refer back to Figure 6.2, you can see that the zoom setting on the flash was set to 70mm.)

I then stepped way back and zoomed in to 90mm with the camera lens and took another photo (**Figure 6.12**). TTL mode delivered another great exposure, automatically, and adjusted the zoom on the flash for a narrower, more focused beam. This again provided head-to-toe even lighting, even though I was now 10–15 feet farther away from the subject.

This zooming function is immensely beneficial when the flash head is aimed directly at the subject. It also comes in handy when you begin to indirectly aim your flash, because you can manually zoom the flash head in and out as well while still using TTL to calculate the exposure for you. In **Figure 6.13**, I aimed the flash at the ceiling and bounced light back down onto the model to make it appear more like overhead lighting. Because I was standing farther away from the model, I manually zoomed the flash head in to 105mm to focus the beam more efficiently as it traveled the long distance to the ceiling and then bounced back down and spread out.

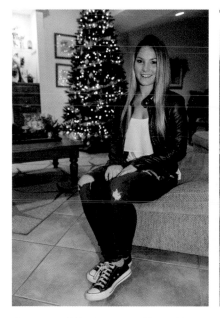
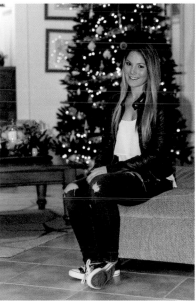
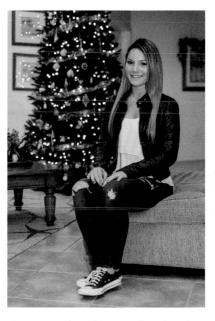

Figure 6.11 This photo was taken with a 35mm lens lit directly by a speedlight with the flash zoom setting also at 35mm.

Nikon D800 • ISO 1250 • 1/50 sec. • f/3.5 • 35mm lens

Figure 6.12 This photo was taken from much farther away with a 90mm lens. It was lit directly by a speedlight with the flash zoom setting narrowed down with a setting of 90mm. This setting evenly lights the subject from farther away without needlessly spreading light everywhere.

Nikon D800 • ISO 1250 • 1/50 sec. • f/3.5 • 90mm lens

Figure 6.13 The subject was lit indirectly by a speedlight bounced off the ceiling. The flash was manually zoomed in to 105mm to more efficiently send the light over a farther distance to the ceiling and back down.

Nikon D800 • ISO 1250 • 1/50 sec. • f/3.5 • 70mm lens

Bouncing for Better Light

If you were caught off-guard by the flash orientation in the previous photo, you're not alone. Most people don't even think to aim their flash somewhere other than directly at their subject. But when a location permits it, bouncing your flash off of things is a great way to create more pleasing and natural-looking light, all while keeping that speedlight firmly in place on top of your camera. This is precisely why your speedlight head rotates up and down and side to side.

Just a note of warning: Only bounce your flash off neutral-colored surfaces. Light adopts the color of the surface it bounces off. You don't want to bounce light off a green wall because it will then make your subject look green.

Wall bounce

Figure 6.14 shows your standard, direct, on-camera flash portrait. It's not bad, but you'll notice that the light is a little flat. The reason is that all of the shadow is being cast directly behind the model's head, where the camera can't see it. If you want a more three-dimensional portrait, you need a little shadow to show. This means the light has to come from a direction other than the same axis as the camera lens.

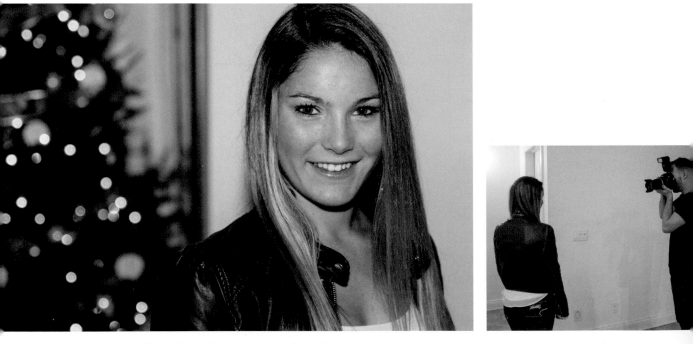

Figure 6.14 A direct, on-camera flash-lit portrait.

Nikon D800 • ISO 1000 • 1/100 sec. • f/2.8 • 70mm lens

For the next photo shot (**Figure 6.15**), you can see that I rotated the flash head to bounce off the wall to my right. No light is directly hitting the model now. This wall bounce resulted in **Figure 6.16**. Would you have ever guessed that this shot was lit with an on-camera speedlight?! After the light hit the wall, that giant wall became the new light source and created a large soft spread of light that was more like a giant softbox than a pop-up flash—not bad for just rotating the flash head and letting TTL pick the output.

Figure 6.15
**A look at the flash
rotated to the right for
a wall bounce.**

Fuji X100s •
ISO 2000 • 1/60 sec. •
f/2 • 35mm lens

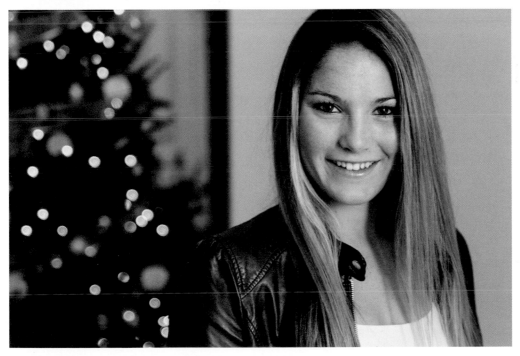

Figure 6.16 The large soft light is the result of bouncing the speedlight off the wall.

Nikon D800 • ISO 1000 • 1/100 sec. • f/2.8 • 70mm lens

Ceiling bounce

Walls aren't the only options you have to bounce light off of. If you're standing in the middle of a room, the wall may be obstructed or too far away to bounce the light off of. Here's where you look to the ceiling like I did earlier. By pointing the flash straight up into the air, as shown in **Figure 6.17**, it will bounce back from the ceiling after spreading out and become much softer. This is a better quality of light and a different direction. The result in **Figure 6.18** is much more natural, but did you notice what happened to the subject's eyes? They fell into shadow from the brows because the light is now coming straight down. This problem didn't occur back in Figure 6.13 because I was standing far enough away for the eyes to see the reflected ceiling light. But once you get in close enough, the up and down angle of the light becomes steeper.

Figure 6.17 A look at the flash rotated straight up for a ceiling bounce.

Fuji X100s • ISO 2000 • 1/60 sec. • f/2 • 35mm lens

Figure 6.18
A portrait lit by large soft light coming down as a result of bouncing the speed-light off the ceiling. If you stand too close to the subject, the eyes will be cast in shadow.

Nikon D800 •
ISO 1000 • 1/100 sec. •
f/2.8 • 70mm lens

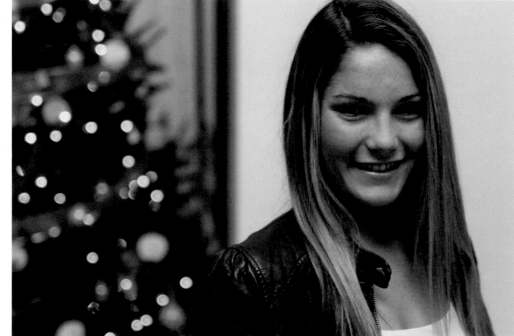

To remedy this shadowing of the eye socket, manufacturers made a built-in bounce card to push enough light forward to fill those shadows while letting the majority of the light continue to travel straight up. Although this card is certainly useful, I prefer to use a larger version of this bounce card made by ExpoImaging. It's called the Small Rogue Flashbender (**Figure 6.19**). The results are a perfect combination of that soft ceiling bounce with the right amount of fill plus that sparkling catchlight in the eyes (**Figure 6.20**).

Figure 6.19 The flash is rotated straight up for a ceiling bounce with a Small Rogue Flashbender attached to push some light forward for fill.

Fuji X100s · ISO 2000 · 1/60 sec. · f/2 · 35mm lens

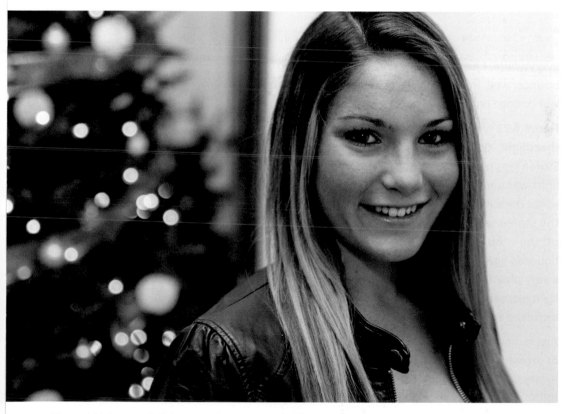

Figure 6.20 Large soft light comes down as a result of bouncing the speedlight off the ceiling. The eyes have a spark in them, and the shadows are filled because the Small Rogue Flashbender acts as a large bounce card to send some fill flash forward.

Nikon D800 · ISO 1000 · 1/100 sec. · f/2.8 · 70mm lens

A Bigger Bounce Card

So what do you do if you're shooting outdoors or somewhere inside where you can't find anything to bounce the light off of? Recall that a bounce card is built into a speedlight. That is the camera manufacturers' hint to put you on the right track. In Figure 6.20, you saw how a bigger version of this card could be combined with ceiling bounce for great fill. Well, if you look into even larger modifiers, like the Large Rogue Flashbender, they work very well as a direct, on-camera flash main light. In **Figure 6.24**, I used just that. Notice how it raised the angle of the flash slightly higher off-camera and spread the light as if I had a small softbox on top of the camera.

Figure 6.24
A behind-the-scenes photo of the Large Rogue Flashbender modifier on a speedlight.

Fuji X100s •
ISO 3200 • 1/30 sec. •
f/2.8 • 35mm lens

When you have to shoot direct, height and a bigger-sized light modifier are essential. In **Figure 6.25**, you can see how this setup creates a softer light with just enough shadow to avoid that flat "snapshot" look.

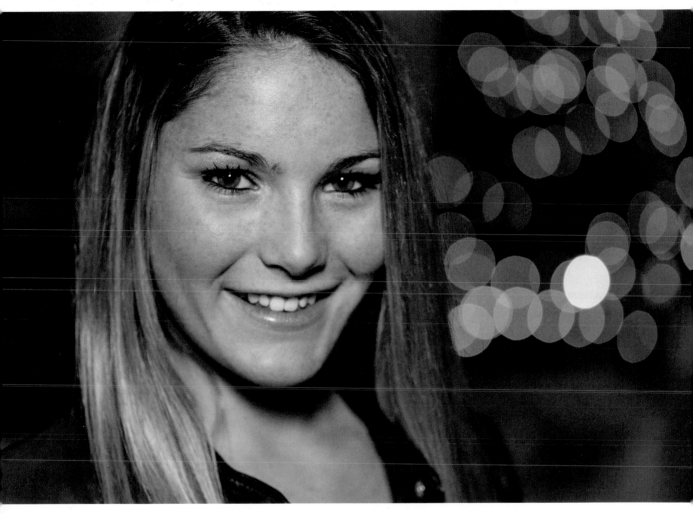

Figure 6.25 **A portrait lit with a speedlight and modified by a Large Rogue Flashbender for better quality of light.**

Nikon D800 • ISO 800 • 1/60 sec. • f/3.2 • 90mm lens

Flash Gels

In Chapter 5, you learned about setting your camera's white balance to produce accurate skin tones under different light temperatures. By flashing a portrait you are adding another light temperature to the equation. So sometimes indoor flash photos can encompass a wide range of color temperatures that can be distracting and unflattering to your portrait subject. To fix this, the last speedlight modifier I'll cover is the flash gel.

In their most basic form, flash gels are colored clear pieces of plastic that attach to the front of your speedlight. They come in a wide range of colors and intensities, but the basic ones you'll need most often for indoor flash color correction usually come packaged with your flash.

Let's look at a common scenario, like the one in **Figure 6.26**—a dimly lit living room with warm tungsten lamp light. Obviously, it was too dark for a portrait, so I turned on my speedlight and took another shot. The camera's white balance was set to the Flash WB Preset because the flash would be doing most of the work. This produced **Figure 6.27**. As you would expect, the result was a nicely lit portrait with proper skin tones.

Figure 6.26
A warm living room environment with tungsten lighting. No flash was used.

Nikon D800 ·
ISO 1600 · 1/60 sec. ·
f/3.2 · 58mm lens

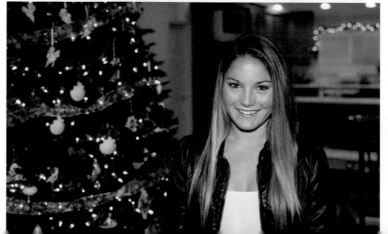

Figure 6.27
A warm living room environment with the portrait subject lit by a bare speedlight. With the camera white balance set to Flash WB Preset, the background appears too orange compared to the model.

Nikon D800 ·
ISO 1600 · 1/60 sec. ·
f/4 · 55mm lens

Upon closer examination, the rest of the room, not lit by the flash, appears very orange. However, this was not an issue. Referring back to Chapter 5, all I needed to do was set the camera's white balance to the Tungsten WB Preset to make that orange room appear neutral again (**Figure 6.28**). Oops—this global white balance shift caused the white light from the speedlight to appear blue as a result, which results in a neutral room and the poor model looking like a Smurf.

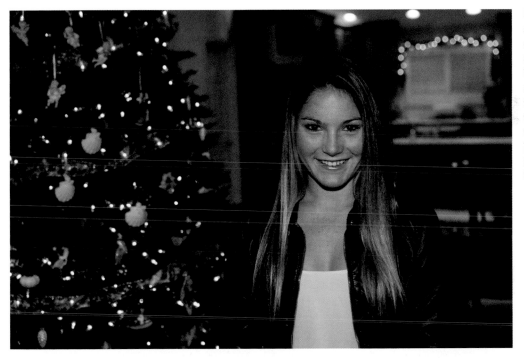

Figure 6.28
After shifting the camera's white balance to the Tungsten WB Preset, the room appears neutral, but the subject lit by the speedlight has turned blue.

Nikon D800 • ISO 1600 • 1/100 sec. • f/4 • 55mm lens

This is when you apply the flash gel (**Figure 6.29**). The orange-tinted gels—officially called CTO (Color Temperature Orange)—are designed to shift the white light of the speedlight to match the warm orange light of a tungsten bulb (shifting the flash's color temperature from 5500K to 3200K). By bringing the color of the flash in line with the color of your ambient light, everything is in sync and can easily be neutralized with in-camera white balance adjustments. **Figure 6.30** (on the following page) is a result of this balance. The portrait subject is evenly lit by the speedlight, and all of the color temperatures are balanced for a natural-looking environmental portrait.

Figure 6.29
A speedlight with a CTO correction gel attached.

Figure 6.30 With the camera's white balance set to the Tungsten WB Preset, the addition of a CTO correction gel brings the speedlight's color temperature in line with the existing ambient light, creating a balanced, even-looking photo.

Nikon D800 · ISO 1600 · 1/100 sec. · f/4 · 55mm lens

With the amount of control built into your on-camera flash and the number of modifiers you can add to this foundation, you should now have a slew of new tools in your belt to create better portraits under adverse conditions.

Chapter 6 Assignments

Pop-up Flash Inside and Out

Press that lightning bolt button on the side of your camera to deploy the pop-up flash. Then, using Flash Exposure Compensation, start using the pop-up flash in situations you wouldn't normally think to. Experiment with using it as a main light (the brightest one in the scene) and as a fill light by dialing down the Flash Exposure Compensation. Get comfortable doing this outdoors, too, when the flash wouldn't normally pop up on its own.

Start with the Basics

Before you run out to buy a million extra speedlight accessories and modifiers, get that speedlight box out of the closet and rummage through it for a few things you might have missed. First, be sure to grab the flash manual and read through it at least once. Second, find the Stofen Omni-Bounce and pack of color-correction gels that usually come packaged with the flash. Now, start with just the bare speedlight and then put these basic tools to use following the techniques covered in the chapter. Start small and then grow your lighting kit.

Balancing Color Temperatures

Build on the indoor color temperature foundations you learned in Chapter 5 by combining that information with what you learned in this chapter about colored gels. Use the orange and green color-correction gels that came with your flash to balance your speedlight with a room full of tungsten light (orange) and a room with fluorescent light (green). Simply apply the corresponding gel and set your camera's white balance accordingly.

Share your results with the book's Flickr group!
Join the group here: flickr.com/groups/portraitsfromsnapshotstogreatshots

Nikon D800 •
ISO 100 • 1/200 sec.
f/7.1 • 85mm lens

7

Adding Artificial Light and Lighting Modifiers

Deciding what type of lighting to use and when to use it

In this chapter, you'll learn to really take charge of a photo by adding your own light to the scene, indoors and outside. You'll be able to decide between different types of lighting and when to best use them. Plus, you'll have a better understanding of the tools of the trade available to you to shape up your shot by controlling that light.

I modified the portable strobe light with a large, 60-inch bounce umbrella. This enlarged and softened the light, and spread it out to light the model, the area around her, and even the photography assistant.

I used a mixture of natural light and artificial light to create a portrait showcasing the subject and the scene.

Nikon D800 •
ISO 100 • 1/125 sec. •
f/7.1 • 85mm lens

To light the model's face, I used a small portable strobe light with a battery pack. This gave me enough power to balance her exposure with the brightness of the sky.

With just the natural light by itself, the subject's face would have been cast in deep shadow, and she would have been nothing more than a silhouette in front of the sunset.

I positioned the model with the warm setting sun behind her, which caused it to act as a nice rim light, highlighting her hair and body.

In the opening photo is a brightly lit photograph of a girl sitting seaside at sunset. Natural light alone would have rendered her as a pitch-dark silhouette. Let's look behind the scenes at the artificial light source and light modifiers that were blended with the daylight to create that image.

Light Direction, Placement, and Quality

Before you can decide which light source and modifier to light your subject with, you'll need to understand the quality of light, how placement of light affects the photo, and what kind of control different modifiers offer.

Light Direction

Photographic lighting isn't always full-speed dead ahead. In the previous chapter, you learned to bounce your flash up and to the side for different lighting results. In this chapter, you'll discover why you may want to change the direction of your light and how bouncing it into certain light modifiers will create great portrait lighting, too.

On-camera vs. Off-camera lighting

In Chapter 6, you learned about on-camera lighting. You probably noticed that many of the techniques in that chapter dealt with bouncing or redirecting the light. In this chapter, all of your light will be off-camera to build contrast in the photo and to make your subjects appear more lifelike and three dimensional. For example, **Figure 7.1** is a photo lit entirely by on-camera flash. It looks rather flat, right? Now, by taking that speedlight off the camera and placing it to the left about 45 degrees from the model, the result is a drastically different photograph (**Figure 7.2**). Notice how moving the light off to the side caused it to cast more shadow on the visible portion of her face? This shadow is what creates contrast and depth in a portrait.

Figure 7.1
A portrait lit with an on-camera speed-light is very flat, with minimal contrast.

Nikon D800 •
ISO 100 • 1/250 sec. •
f/5.6 • 70mm lens

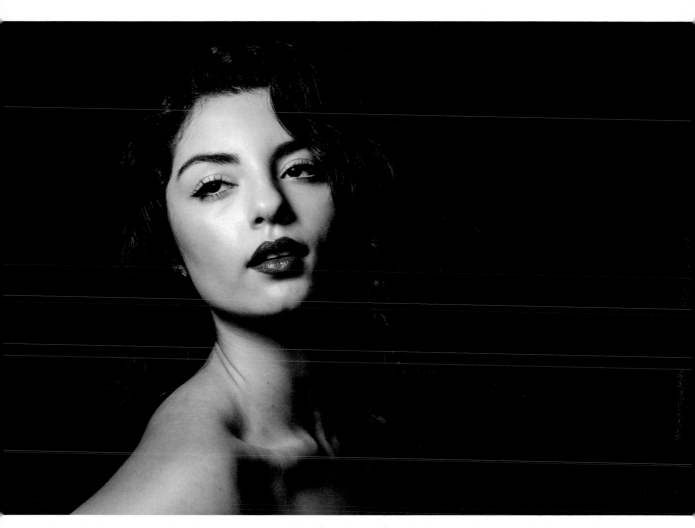

Figure 7.2 By moving the light off-camera and over to the side, more shadows can be seen, which create more contrast and a three-dimensional feel.

Nikon D800 • ISO 100 • 1/250 sec. • f/5.6 • 70mm lens

An important concept to understand is that the farther off-camera axis you go, the more contrast you create. The reason is that the farther off your camera and around the subject that you move the light, the more shadow you create that is visible to the camera.

Creating more contrast

Although it's common to create these shadows by moving just your light, you can also achieve this look by moving your feet. This approach is often quicker because you're not adjusting light stands and having to reset your camera settings or flash power. **Figure 7.3** shows a simple portrait taken with flat lighting, because the light and softbox are right behind my head, casting light in the same direction as if the flash were physically on top of the camera. In **Figure 7.4**, instead of moving the light to the side to create more shadow, I simply sidestepped over myself and took the next shot. Then, to get even more contrast and shadow, I walked over to the side of the model and captured **Figure 7.5**.

Figure 7.3
An example of flat lighting with the constant light source on a stand behind the photographer's head.

Nikon D800 •
ISO 800 • 1/125 sec. •
f/5.6 • 85mm lens

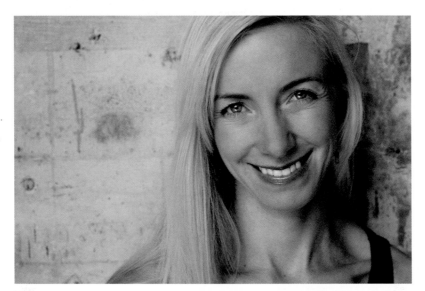

Figure 7.4
By keeping the light and the model in the same place and just moving a few feet, I was able to capture an image with more shadow and contrast.

Nikon D800 •
ISO 800 • 1/125 sec. •
f/5.6 • 85mm lens

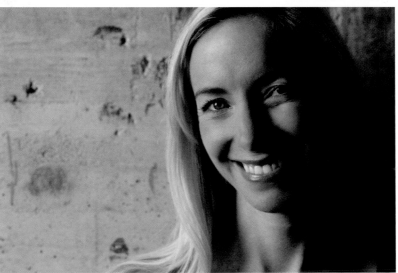

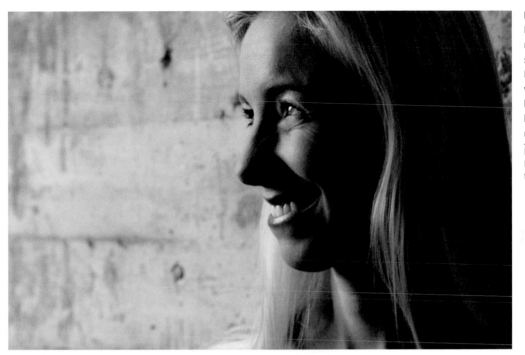

Figure 7.5
By completely
moving to the
side of the model,
I captured an image
with dramatic side
lighting without
having to move the
model or light.
Nikon D800 •
ISO 800 • 1/125 sec. •
f/5.6 • 85mm lens

Figure 7.3

Figure 7.5

Figure 7.4

To get that dramatic side lighting another way I would have had to be running back and forth to my light stand and moving it around between shots. The method you use to create shadows doesn't matter as long as you understand how to get more or less contrast by moving the light closer to or farther away from the camera.

Light Placement

Great portrait photographers don't place their lights randomly about and hope for the best. You should be in control of where the light goes and understand how much you can transform a face by simply placing the light in different spots.

Broad lighting vs. Short lighting

Now that you understand how moving the light off-camera gives you ultimate control and that varying the distance from the camera axis creates more contrast, is there any rhyme or reason as to where you *should* place the light? Absolutely! Creating the shadow is just step one. Thereafter, great portrait photographers use the shadow to sculpt their subject's faces, filling them out when needed, and most important, thinning them as well. The terms *broad lighting* and *short lighting* were coined to describe these techniques using just the placement of the light to transform a face.

Broad lighting, shown in **Figure 7.6**, is when the light is placed to the side of the model with her facing away from it. Notice how the light falls on the front half of her face, the broad side, while the shadow appears on the side of her face farthest from the camera, the short side. The broad side of the face appears wider under this light placement, which is great for photographing men and emboldening their faces. This is also where you want to place your light and pose your subject when photographing people wearing glasses to avoid that nasty reflection in the lens of the glasses.

The negatives of this lighting placement are that you would flatter most people if you *thinned* their faces rather than *expanded* them. Also, look at the ear and notice how bright it is. This can be distracting and draw people's attention away from the eyes and the rest of the face, which are equally as bright.

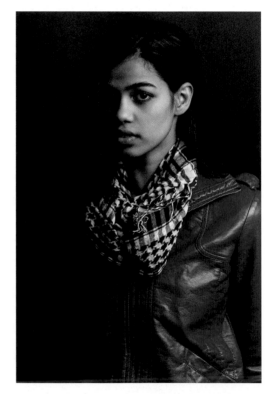

Figure 7.6 Broad lighting is used in this portrait. The highlight is on the side of the face closest to the camera, which fills out the face, making it look wider.

Nikon D800 • ISO 1250 • 1/100 sec. • f/4 • 90mm lens

So, how then do you thin the face? You use short lighting! It's really simple to do. Just turn the subject's face into the light. By doing so, you then throw the front of the face into shadow. By having the side of the face closest to the camera in shadow and only the short side of the face lit, you create the illusion of a thinner face (**Figure 7.7**). The reason is that your eyes immediately go to the brightest thing in the scene and give that the most weight. By lighting only a small fraction of the face, it tricks the viewer's brain into thinking the face is actually thinner. Knowing this technique gives a portrait photographer a lot of power when shaping a person's face with light.

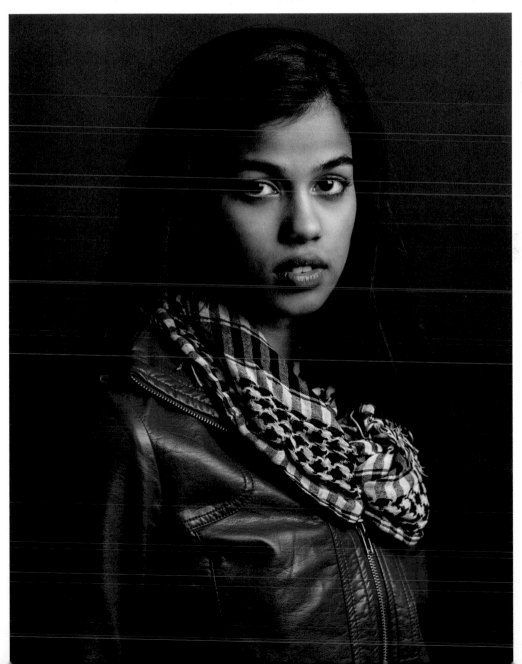

Figure 7.7
Short lighting is used in this portrait. Only the side of the face farthest from the camera is lit, casting shadow onto the front side and giving the illusion of a thinner face.

Nikon D800 •
ISO 1250 • 1/100 sec. •
f/4 • 90mm lens

Light Quality

In Chapter 4, while working with sunlight outdoors, I introduced you to the different qualities of light, namely hard light and soft light. Both qualities of light remain the same whether you're shooting indoors or outdoors and from every light source you can think of: sunlight, speedlight, studio strobe, constant light, lamplight— you name it. Understanding how to get soft flattering light and knowing which light modifiers will help you do this is incredibly important.

As a quick reminder, hard light, with its sharp edges, dark shadows, and high contrast, comes from a light source that is small in relation to your subject and is usually far away. For example, in **Figure 7.8**, I used a constant LED light source with no modifier and placed it far away from the model. Notice the sharp-edged shadow that she casts on the background. When you look closely at the photo, you can see the harsh highlights and sharp shadows on the model's face, too (**Figure 7.9**).

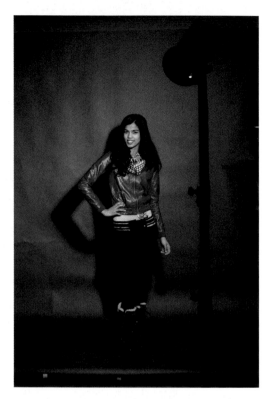

Figure 7.8 **In this photo, a small light source is used with the light stand pulled back far away from the model, creating hard light and sharp shadows on her face and the background.**

Nikon D800 • ISO 1600 • 1/125 sec. • f/4 • 70mm lens

Actually, no matter what size the light source is, if you move it far enough away, it will become a *point source*, which creates the hardest kind of light. This is the case with the sun. It's a *huge* light source, but because it's so far away, it is actually a hard point source that casts nasty shadows at high noon.

> ### Rules for Soft Light
>
> Keep these two lighting rules in mind when you want to create soft light:
>
> - The larger the light source in relation to the subject, the softer the light will be.
> - The closer the light source, the larger it appears in relation to the subject and the softer the light will be.
>
> Soft light = bigger source + closer to the subject

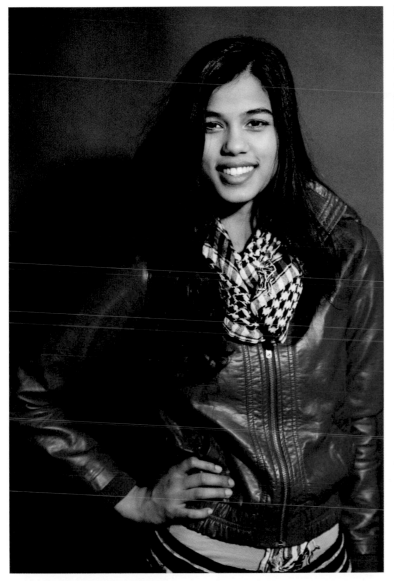

Figure 7.9
By looking closer you can see the harsh highlights and edgy shadows that this bare hard light creates on her face.

Nikon D800 •
ISO 1600 • 1/125 sec. •
f/4 • 70mm lens

Let's fix this unflattering light now. According to the rules, if you want soft light, you only need to bring the light in closer to increase its size relative to the subject. You can't make the physical light larger, but by adding a shoot-through photographic umbrella to the front of the light, I increased the light's apparent size (**Figure 7.10**). Instantly, the transitions from highlight to shadow become very soft and subtle, and the shadow on the background is so soft it has virtually faded away. Look closely at the model's face in **Figure 7.11**. You can see that the shadows on her face have now softened, and the quality of the highlights is more pleasing as well.

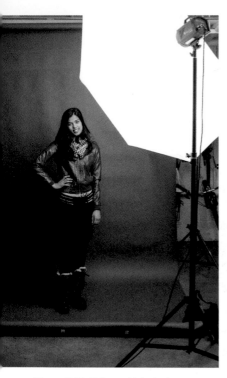

Figure 7.10 Using a 60-inch shoot-through umbrella makes the light source larger, and after bringing it in close to the subject, the shadows become so soft they almost disappear from the background.

Nikon D800 · ISO 1600 · 1/125 sec. · f/4 · 52mm lens

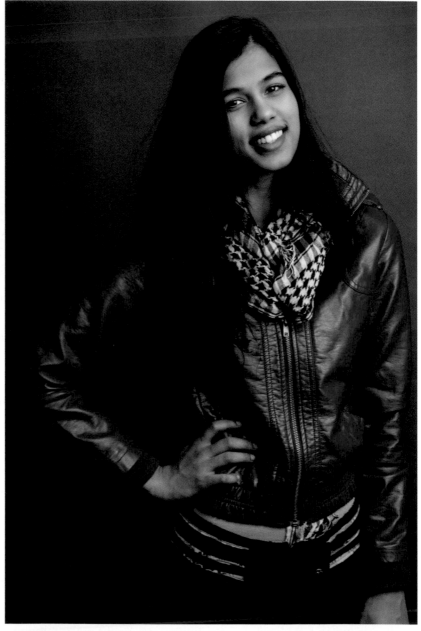

Figure 7.11 Using this large soft light also softens the shadow transition on the face for a flattering portrait light.

Nikon D800 · ISO 1600 · 1/125 sec. · f/4 · 70mm lens

Light Modifiers

In the preceding few photos, you may have noticed that I used two different light modifiers to change the shape, quality, and control of the light source. Next, I'll discuss a few of the most common light modifiers and examine the different characteristics of each.

Bare Flash with Reflector Dish

Let's begin with the bare essentials: the naked flash. You'll look at different light sources in a moment, but whether you're using a strobe or a constant light, the source by itself will be pretty harsh and unruly out of the box. This is the reason most lights often come with a reflector dish, which resembles a small funnel or cone, to attach to the front of the light.

The shape of the resulting light is now round, which is great for creating natural-looking round catchlights similar to those the sun would make. This more focused light also creates a nice round silhouette if you are using a backdrop or wall, as in **Figure 7.12**.

But if you zoom in on the face, this quality of light is not very flattering, because it is still a very small light source and not very close to the subject. As a result, it produces hard light and sharp shadows (**Figure 7.13**). Not only are the shadows bad, but also look at the harsh quality of the highlights. This is hard *nondiffused* light. When there is no diffusion material in front of the light, hot spots can occur if the subject has shiny skin.

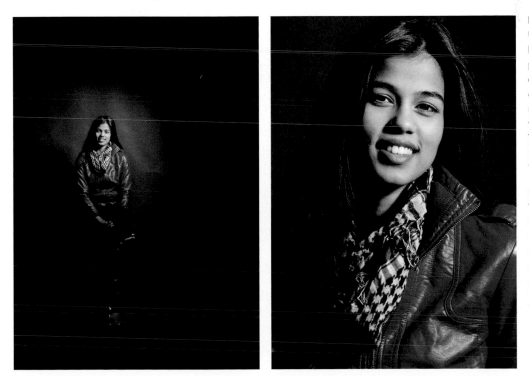

Figure 7.12 (left) Using just a bare light with its accompanying reflector dish creates round catchlights and a nice silhouette on the background.

Nikon D800 · ISO 1600 · 1/200 sec. · f/4 · 48mm lens

Figure 7.13 (right) This lighting combination produces poor-quality light for portraits, resulting in hard shadows and harsh highlights.

Nikon D800 · ISO 800 · 1/200 sec. · f/4 · 90mm lens

Although the light quality isn't the most ideal for portrait work, you have a great deal of control when you're using a bare light with the reflector cone attached. **Figure 7.14** shows the very contained and directional light created with this lighting combo.

Photographic Umbrellas

Although the reflector cone I just demonstrated usually comes included for free with a strobe when you purchase it, an extremely affordable and versatile next step is the photographic umbrella. These can also double as a rain umbrella in a pinch, too! The best route to go is to purchase a white umbrella with a removable black cover. This gives you two umbrella options in a single package. In the following figures, I specifically used a Westcott 60-inch umbrella with a removable cover. Why choose a 60-inch umbrella? Because the bigger the umbrella, the softer the light it will produce!

Figure 7.14 **The light and reflector offer a lot of control, producing a very narrow spread of light, which is good for dramatic imagery.**

Nikon D800 • ISO 800 • 1/200 sec. • f/4 • 34mm lens

Bounce umbrella

Using an umbrella to catch strobe light and bounce it back at your subject is the standard way of using these bounce (reflective) umbrellas. Simply open it up and slide the shaft through the built-in umbrella adapter on your given light source, and you're ready to go!

In **Figure 7.15**, you can see the flash aimed away from the subject into the back of the umbrella, which then bounces the larger spread of light back onto the model. Again, this is a round-shaped light source, just like the strobe with a reflector dish, so it creates round, natural-looking catchlights, only larger this time. And because the light source is much larger, it covers more of the background, too.

The quality of light using a bounce umbrella is much nicer, too! With a big increase in size the light is much softer, and the large spread offers even coverage on the subject's face and body while also softening any shadows cast on the background (**Figure 7.16**). This is a softer light now, but it is still not diffused, just like the modifier I mentioned earlier.

After the light bounces off the silver interior of the umbrella, it takes on a crisp spectral quality, which can lead to glaring hot spots on a person's cheek or forehead if the person has shiny skin. But by keeping oil-blotting sheets on hand or asking the subject to bring her makeup along to a shoot, you can matte down the skin to minimize these hot spots from non-diffused light sources.

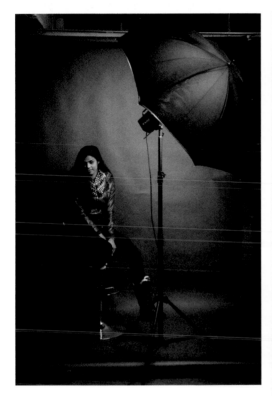

Figure 7.15 Bouncing the light back into a large bounce umbrella creates a much larger, round spread of light for even coverage, round catchlights, and lit backgrounds.

Nikon D800 · ISO 1600 · 1/125 sec. · f/4 · 48mm lens

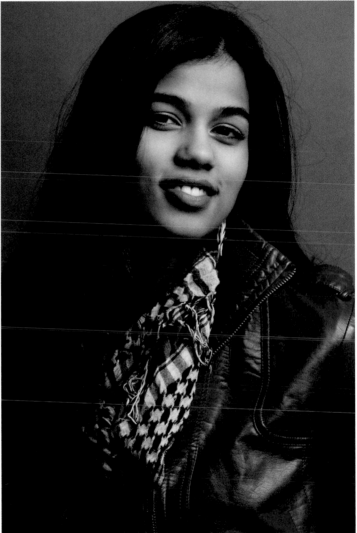

Figure 7.16 The much larger light source results in softer light on the model's face and even lighting of her head and body. The modifier is still prone to spectral highlights on shinier skin.

Nikon D800 · ISO 1600 · 1/125 sec. · f/4 · 90mm lens

Bounce umbrellas offer a little less control than the reflector dish as well. Although all of the light is forced in one direction, the spread of light is much wider. Depending on where you place your light source along the umbrella shaft, you can control the spread of light to some degree. Check out **Figure 7.17** for an example. You should also keep an eye out for that sharp shadow edge that you can see falling on the background. This is where the edge of the umbrella blocks the light. At times you may be looking only at the quality of light on the model's face and forget to check the background, only to find a giant slash of shadow on the background after reviewing your photos on your computer later. To avoid this issue, simply angle your bounce umbrella more toward the background.

Shoot-through umbrella

Recall those rules for soft light? Use a big light source and bring it in close, right? Well, the reflective umbrella and the shoot-through umbrella are the same physical size, so which do you think creates the softer light? Look at **Figure 7.18** and notice that the shoot-through umbrella allows you to move it in much closer to the subject. If you tried this with the bounce version, you'd poke the subject in the eye with the umbrella shaft before getting half as close. The shoot-through umbrella offers a distinct advantage.

Figure 7.17 A bounce umbrella provides a good deal of directional control, although the spread of light is very wide. Beware of the hard shadow line cast by the edge of the umbrella.

Nikon D800 · ISO 800 · 1/200 sec. · f/4 · 56mm lens

By bringing the shoot-through umbrella in really close, it increases the relative size of the light to the subject, creating a beautiful soft light, as you can see when I zoomed in on the face in **Figure 7.19**. Not only is the light very soft with gradual smooth shadows, but the highlight quality is much better, too. The reason is that the light is now being diffused while traveling through the umbrella and spreading out. This cuts down the intensity of any specular highlights and makes it a very forgiving kind of light for varying skin tones.

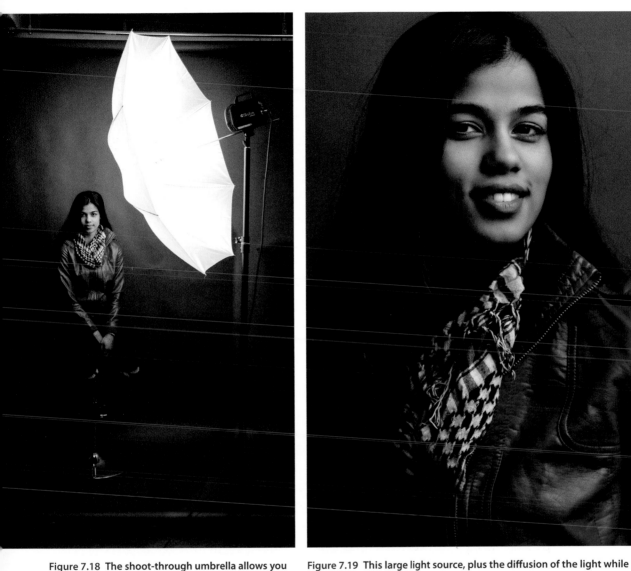

Figure 7.18 The shoot-through umbrella allows you to create a very large light source, and it can be moved in very close to the subject for soft light.

Nikon D800 · ISO 1600 · 1/125 sec. · f/4 · 48mm lens

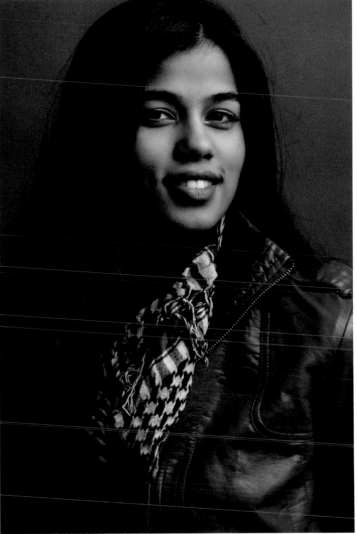

Figure 7.19 This large light source, plus the diffusion of the light while traveling through the umbrella, results in a very soft light with smooth diffused highlights.

Nikon D800 · ISO 1600 · 1/125 sec. · f/4 · 90mm lens

When in doubt, throw a shoot-through umbrella at your subject. Not literally of course, but when you don't know which modifier to use, the quality of light and large spread of a shoot-through umbrella is a safe place to start.

So what kind of control do you have with this beautiful light? Control? What control? Although the shoot-through umbrella is guaranteed to deliver beautiful soft light with a lot of coverage, you have absolutely no control over where that beautiful light goes. It's the equivalent of lobbing a light grenade into a scene. Light goes through the umbrella and lands softly on the subject, but it can also cast a shadow line from the umbrella's edge, as shown in **Figure 7.20**, plus it also bounces back toward the light source—the opposite direction you usually want it to go.

Figure 7.20 Although the light from the shoot-through umbrella is very beautiful, there is no control whatsoever, meaning that beautiful light spills everywhere for good or bad.

Nikon D800 · ISO 800 · 1/200 sec. · f/4 · 50mm lens

Softboxes

The light modifier that provides the perfect marriage of softness and control, and is a staple in every major portrait studio, is the softbox! It's unique compared to the modifiers just discussed because of its square shape (**Figure 7.21**). This square, or sometimes rectangular, shape is designed to mimic the shape of a window. So when you look into the subject's eyes you see a square catchlight, and it creates the illusion that the portrait was lit by having the subject sit near a window on a sunny day.

The quality of softbox light is another thing that sets it apart. If you zoom in on the face like I did in **Figure 7.22**, you can see the nice soft quality of the light. Softboxes incorporate the best of both the bounce and shoot-through umbrellas. They are silver on the inside so that the light efficiently bounces around and spreads out; then the light leaves through the front of the softbox and travels through diffusion material to cut down the punchiness of the light. The result is a large light source with soft light and smooth highlights.

Figure 7.21 Many softboxes are square shaped, allowing them to uniquely mimic window light.

Nikon D800 • ISO 1600 • 1/125 sec. • f/4 • 55mm lens

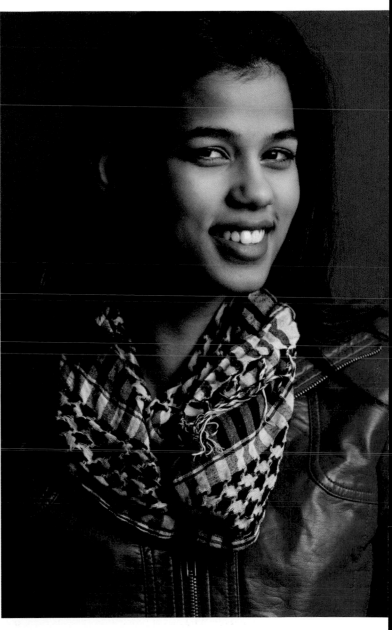

Figure 7.22 Softboxes efficiently bounce light back at the subject. They also enlarge, diffuse, and soften it along the way, resulting in beautifully soft and diffused light.

Nikon D800 • ISO 1250 • 1/100 sec. • f/4 • 90mm lens

The softbox is also ideal for working indoors because of the huge amount of control you have. In **Figure 7.23**, you'll see that the soft light goes only where it's directed. This means you can let it spill onto the background to light that up as well as the subject, or you can aim it away, letting the background go dark to make the subject stand out more.

Reflectors

Last but not least you have the option of using reflectors. Although I've covered these extremely handy and affordable light modifiers in previous chapters, I want to show you just how useful they can be, especially when paired with an umbrella or softbox. Most people start out with a single light when they are beginning to work with off-camera lighting like strobes or speedlights. But who wouldn't want a lightweight, collapsible modifier that acts as a second light on command without the

Figure 7.23 Softboxes are very directional light modifiers, shining light only where you want it.
Nikon D800 • ISO 1600 • 1/125 sec. • f/4 • 55mm lens

extra cost or weight of a second strobe?! That's exactly what reflectors can be. It's best to get a 5-in-1 Reflector, like the one I used in Chapter 4, for the maximum amount of options.

5-in-1 Reflector Surfaces

- **White.** Reflective surface for soft, nondirectional fill light; very subtle
- **Silver.** Highly reflective surface with more output than white; very directional
- **Gold.** Same output and directionality as silver, but also warms up the reflected light temperature
- **Black.** Used to completely block light, or build contrast through subtractive lighting—that is, adding more shadow
- **Translucent.** Used to diffuse light, much like the front of a softbox does

Take a look at **Figure 7.24** to see the basic setups for the next few photographs. I used a Westcott Skylux LED constant light source and modified it with a Westcott 28-inch Apollo softbox. This created a nice soft light on the face that was easy to aim and control. On the opposite side of the model, I set up a reflector holder so I didn't need an extra person to hold the reflectors for me. By placing the holder on the opposite side of the face as the light, I could quickly swap out the different reflectors to add or subtract fill light.

In **Figure 7.25**, I placed a white-sided reflector on the reflector stand. This is the reflector surface that I use most often for fill. Look how it subtly lifts the shadows on the side of the face. The white reflector is also nondirectional, meaning it does not need to be precisely aimed to work as a fill light. It is rather low output, though, so it needs to be closer to the model than, say, a silver or gold reflector.

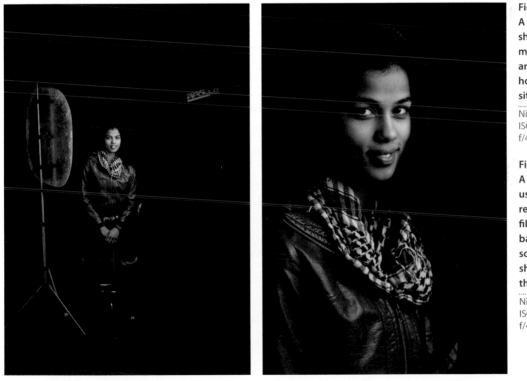

Figure 7.24 (left)
A pullback photo showing the placement of the softbox and the reflector holder on the opposite side of the face.
Nikon D800 •
ISO 1250 • 1/100 sec. •
f/4 • 90mm lens

Figure 7.25 (right)
A studio portrait using a white reflector as a subtle fill light, bouncing back light from the softbox into the shadowed side of the face.
Nikon D800 •
ISO 1250 • 1/100 sec. •
f/4 • 90mm lens

The silver reflector is the second most common reflector that I use. Compared to the white surface after swapping them out, it acts like a more powerful fill light, because it produces a more concentrated higher output when reflecting light back into the face. The results are shown in **Figure 7.26**. Also, it can be used from farther away from the model, allowing you to compose a wider photo without the reflector being in the shot. It is a more direct light source, so it needs to be carefully aimed or else the reflection might miss your subject's face entirely.

Figure 7.26
A studio portrait using a silver reflec-tor as a high-output fill light, bouncing back more intense light from the softbox into the shadowed side of the face.
Nikon D800 ·
ISO 1250 · 1/100 sec. ·
f/4 · 90mm lens

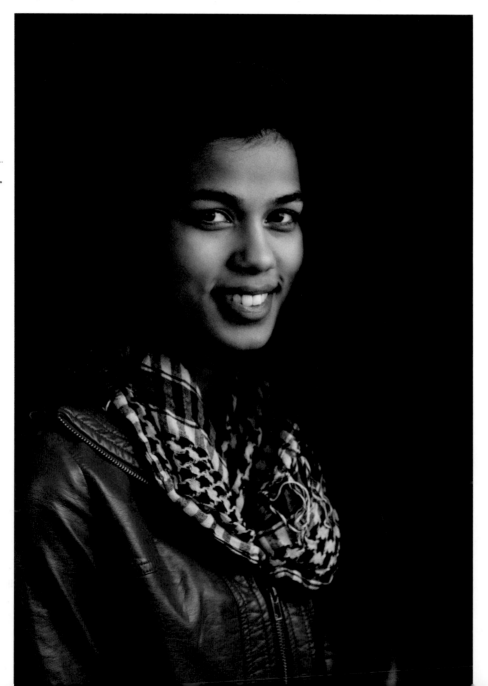

Next up is the gold-sided reflector. Solid gold is often too heavy-handed for today's taste, although it was all the rage back in the glory days of the 1980s and 1990s swimsuit calendars. Nowadays, you'll often find that the gold side of the reflector has silver woven in, which is sometimes called *sunlight* or *sunfire*, rather than solid gold. This gives you the same output and characteristics of the solid silver reflector; only it adds a good amount of warmth into the fill light, as shown in the shadowed side of the face in **Figure 7.27**.

The black side of the reflector I used didn't actually reflect any light at all. The black side is used to block unwanted light or is used as a negative fill. By setting it up on the reflector stand on the shadowed side of the face, it *increases* the shadow intensity rather than filling it with light (**Figure 7.28**). This is called negative fill and is a great way to add more contrast to an image.

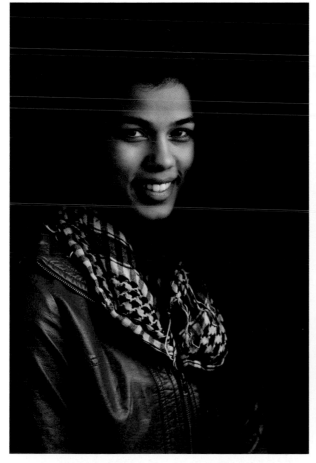

Figure 7.27 **A studio portrait using a gold reflector as a high-output fill light, bouncing back more intense light from the softbox into the shadowed side of the face while adding warmth to the reflected light.**

Nikon D800 • ISO 1250 • 1/100 sec. • f/4 • 90mm lens

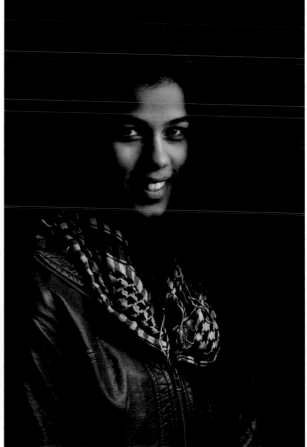

Figure 7.28 **By placing a black reflector on the shadowed side of the face, the shadows are enhanced, adding more contrast to the portrait.**

Nikon D800 • ISO 1250 • 1/100 sec. • f/4 • 90mm lens

Light Sources

So far I've talked a lot about the quality of light, which way to aim it, and how to control it. However, I haven't really touched on how to create that light. There isn't an existing one-size-fits-all light source unless you're an available light shooter, which photojournalist W. Eugene Smith defined this way: "Available light is any damn light that is available!"

Following that train of thought, I'll cover the pros and cons of the different light sources available to you, and then you can let budget, your environment, and your shooting style determine the best light source for you. The two main categories I'll discuss are strobe lights, which will encompass any photographic flash that fires off a pulse of light when you take a photo, and continuous lights, which are always on, creating a constant light source. **Table 7.1** contains factors to consider when you're choosing either light source.

Table 7.1

Considerations for Choosing a Light Source	
Strobe Lights	**Continuous Lights**
Flash freezes motion	Shutter speed freezes motion
Modeling light to visualize results	WYSIWYG
More output (brightness)	Less output (brightness)
Manually set flash power	Works with camera metering modes

Strobe Lights

Let's look at strobe lights first. This category of light source is ideal in that it generates light only when you need it, which is just as the exposure is being made. This includes your speedlight that I covered in Chapter 6, as well as larger strobe lights you would find in the photo studio that plug into a wall outlet. You'll need to deal with a few tasks when you use strobe lights, such as triggering the strobes and setting their power output, so let's explore those first and then look at the specific differences between speedlights and their big brothers, the studio strobes.

Wireless triggering

When a speedlight or strobe light is no longer attached to the camera, it has no way of knowing when to fire. To synchronize the shutter opening on your camera with that instantaneous pulse of light from your flash, you need to open the lines of communication again.

You can physically plug a cable into your camera and run the other end all the way to your strobe, but this is a good way to trip people on set and is limited by the length of your cable.

The best way to trigger a strobe is with a wireless trigger system. The PocketWizard PlusX (**Figure 7.29**) is a transceiver that serves as the basis of just such a system. You place one unit on top of your camera's hot shoe to transmit a radio signal every time you take a photo. Then you plug a second unit into your speedlight (**Figure 7.30**) or strobe to receive the signal—hence the name transceiver (transmit + receive). This second unit gets the radio signal and tells the flash to fire just as your camera's shutter opens.

PocketWizard PlusX
Radio Transceiver

Figure 7.29 A radio transceiver serves as the transmitter and receiver of radio signals, allowing your camera to tell your flash when to fire, wirelessly.

PocketWizard PlusX Radio Transceiver plugged into a speedlight

Figure 7.30 You need to plug the transceiver into whatever flash you want it to trigger.

Manual flash power output

Once you have the flash and camera communicating, you need to tell the flash just how much light to send downrange at your subject. When you're using an off-camera flash unit, you'll usually have to manually set the flash power. I briefly touched on this in the previous chapter, and the setup is actually quite simple. Look at the back of your speedlight and make sure it's set to M mode for Manual. Studio strobes can only be set to Manual mode, so just look for the power dial. Then you can dial the power up and down,

Continuous Lights

The other artificial lighting option available to you is continuous lights. These lights stay on constantly, much like a lamp or overhead light, except they are designed for photographic use, which demands constant color temperatures and long-life expectancies. They all need to be plugged into a wall outlet for power but offer same major advantages for portrait photographers.

Benefits of Continuous Lights

The advantages of continuous lights include:

- What you see is what you get (WYSIWYG) with these lights.
- You can use the camera modes (A mode, S mode) to get a proper exposure.
- No recycle time is needed, so you can shoot as fast as you like.
- These constant lights work for video, too.

Unlike strobe lights that require modeling lights to be able to visualize your lighting setup, continuous lights are on all of the time, so as you adjust them and modify them what you see is what you get (WYSIWYG). This makes continuous lighting a *great* way to go if you are just starting out as a portrait photographer and getting comfortable with off-camera lighting. You simply keep moving the light or the model around until you like what you see, and then fire away!

That final step, the "firing away," brings up another huge advantage of continuous lighting. Although constant light sources can often be adjusted to different power levels, they are much easier to shoot with because you can use your camera to automatically give you the correct exposure. After turning up the brightness to whatever level you see fit, you then set your camera to P, S, or A mode as if you were shooting in natural light. Then, as you're firing away, the camera will be making the necessary adjustments to ensure that the model is properly exposed.

Different kinds of continuous light

Not all continuous lights are created equal; in fact, manufacturers are currently embracing many different kinds of bulbs and color temperatures in this arena.

Here are a few of the current photographic constant light sources on the market and the color temperature of their bulbs:

- Hot lights with tungsten bulbs or tubes—tungsten balanced
- Photo and video fluorescent lights—daylight balanced
- Photographic LEDs—daylight balanced

Hot lights used to be the gold standard of constant lighting, basically because they were the only option. Unfortunately, as the name implies, these old tungsten lamps would heat up quite quickly, making subjects sweat and causing fire hazards. For these reasons they aren't very prevalent nowadays. Film sets still use *massive* hot lights for movies because the smaller photo variety just don't have the output filmmakers need.

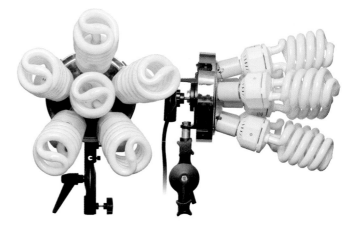

Figure 7.33 The Westcott Spiderlite TD is an example of a daylight balanced, fluorescent, constant light source.

Fluorescent photo lights are a popular option. Don't mistake these for the ugly green fluorescent bulbs that you'd find in the supermarket or conference room (I conquered those in Chapter 5). These bulbs are powder coated and balanced to a daylight color temperature, which means they balance nicely with strobe lights and window light. The Westcott Spiderlite TD (**Figure 7.33**) is an example of a daylight balanced, fluorescent, constant light source. These create beautiful constant light and are designed to work with umbrellas and softboxes, too. The only drawbacks are their bulk when you travel with them and their fragile bulbs.

The use of LED lighting is the direction the industry seems to be heading toward, and for good reason. LED lights are usually much smaller than their glass-bulbed counterparts; they don't get hot, and they offer a lot of power for their tiny size. At the beginning of the chapter, I used a Westcott Skylux LED (**Figure 7.34**) to create all of the example photos of the model in the red jacket. This LED light source looks almost identical to a studio strobe but has the convenience of creating constant light. This light has become my go-to constant light because it also accepts all of my studio softboxes that used to be reserved strictly for use with my studio strobes.

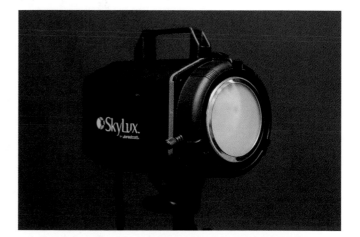

Although continuous lights offer many advantages for portrait photography, as mentioned earlier—daylight color balance, fast lighting setup with WYSIWYG, and the ability to use your camera's metering modes for correct exposure—they still aren't nearly as powerful as strobes and have a hard time balancing with daylight outdoors. For this reason, there really is no one-size-fits-all lighting solution.

Figure 7.34 The Westcott Skylux LED light is a constant light and is daylight balanced as well. It offers a lot of light output in the same form factor of a studio strobe.

Lighting Scenarios

So which light and light modifier is best for you? Because there is no magic bullet as I just explained, let's look at a few different lighting scenarios where a mix and match of lights and modifiers were used under various conditions. These examples should further guide you toward the combinations that may work best for you.

Indoors

Let's begin indoors with a nice and easy controlled environment with low existing light that won't compete too much with your attempts at making a portrait with your own lights.

Speedlight + reflector

Starting with the basic kit, let's begin with a single speedlight and a 5-in-1 Reflector. Earlier in the chapter you learned how a small light source like this produces a hard and unflattering light all by itself. Although the model in **Figure 7.35** has perfect skin, the shadows are still unpleasing. Imagine if your subject didn't have nice skin and how much such sharp shadows would draw attention to any blemishes.

Figure 7.35
This model is lit by a bare speedlight. The hard lighting is unflattering for portraits.

Nikon D800 •
ISO 200 • 1/60 sec. •
f/4 • 85mm lens

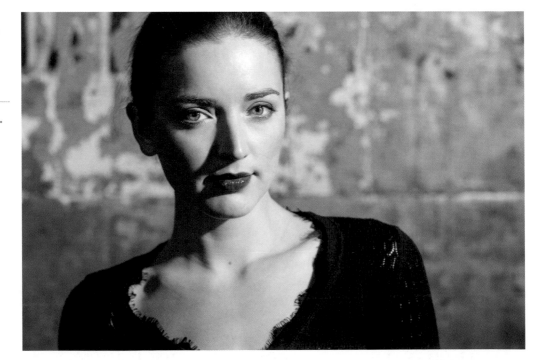

To soften this light, I had an assistant hold the diffusion panel from the reflector set in between the speedlight and subject (**Figure 7.36**). After the light has traveled through the diffusion panel, it becomes enlarged and diffused. Look at the *huge* difference this panel makes in the resulting portrait in **Figure 7.37**! This was a very easy photo to expose because I used the PocketWizard Flex units to wirelessly trigger the speedlight and still used TTL mode to automatically adjust the flash output as I shot.

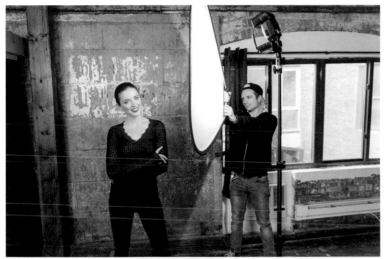

Figure 7.36
An assistant holds the diffusion panel of a 5-in-1 Reflector in between the light and the model.

Nikon D800 •
ISO 3200 • 1/100 sec. •
f/4 • 26mm lens

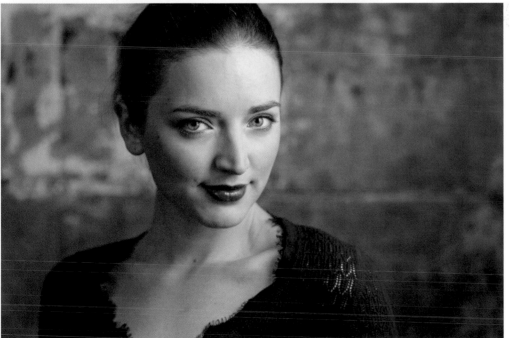

Figure 7.37
The resulting light after passing through the diffusion panel is wonderfully soft and diffused.

Nikon D800 •
ISO 200 • 1/60 sec. •
f/4 • 85mm lens

LED constant light + softbox

Now that you've seen the result of using a strobe light inside, let's work in a constant light to see how that works. For this next portrait, I used a Skylux LED and attached a large Westcott softbox to it (**Figure 7.38**). This created the equivalent of a large window light that I could move about the room. To continue this very "natural" appearing lighting scenario, I placed a regular floor lamp behind the model to light her hair, which is why the backlight looks orange. The lamp was tungsten in temperature compared to the daylight-balanced LED. The result is a photograph that looks like it was taken with no added lights at all—just a girl sitting in a living room by the window (**Figure 7.39**).

All the while my camera was set to Aperture Priority mode so that I didn't need to think about exposure and could just focus on placing the light and communicating with the model. This combination offers very cinematic lighting with a laid-back approach on set.

Figure 7.38 (left) Using a Skylux LED light and a large Westcott umbrella I created what amounts to continuous movable window light.

Nikon D800 •
ISO 400 • 1/60 sec. •
f/2.8 • 35mm lens

Figure 7.39 (right) The soft light on the face is daylight balanced, and the tungsten floor lamp in the background adds warmth as a hair light. Aperture Priority mode was used to get the correct exposure.

Nikon D800 •
ISO 400 • 1/125 sec. •
f/2.8 • 35mm lens

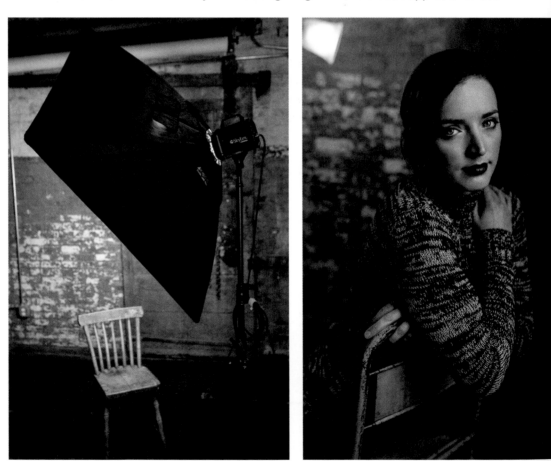

Outdoors

Now let's move outdoors. While on location no power plug was nearby, so I had to rely on strobes. I was also shooting during the day, so the constant light solutions wouldn't have had enough power to accomplish what I set out to do anyway.

Speedlight + shoot-through umbrella

Compared to the speedlight/reflector combo, a speedlight/umbrella combination is probably the next most affordable and versatile setup. It's also great for outdoor use, because the speedlight is lightweight and runs off of AA batteries.

In **Figure 7.40**, you see a test shot I took while checking my exposure. I found some very neat vines that were backlit by the setting sun and thought it'd be a great spot for a portrait. With just the natural light, the background was great, but the subject looked dull.

To add the extra spark of life to the model's eyes and to lighten up the scene, I decided to set up my speedlight. I only needed to fill in the shadows, not compete with direct sunlight, so the power output of the speedlight would be enough. To modify the harsh light of the flash, I used a shoot-through umbrella because a shoot-through creates soft light for the subject and also sprays light everywhere! In **Figure 7.41**, you can see how the light is striking the model and the foliage around her.

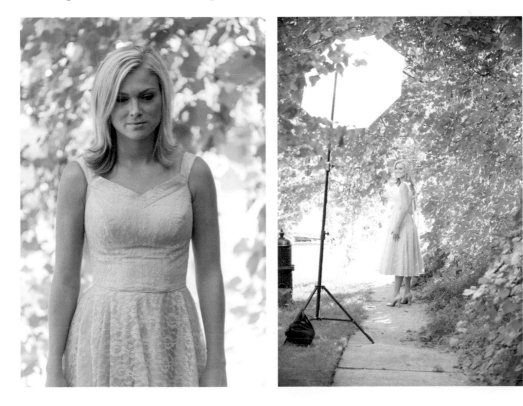

Figure 7.40 (left)
A test shot to check background exposure with no strobe light on the model.

Nikon D800 • ISO 200 • 1/250 sec. • f/2.8 • 140mm lens

Figure 7.41 (right)
A pullback shot showing the added fill of a speedlight modified with a shoot-through umbrella. This created soft light on the model and a fill light on the surrounding leaves.

Nikon D800 • ISO 400 • 1/250 sec. • f/3.2 • 70mm lens

After zooming back in and composing a careful crop for the portrait, the result is a dramatically improved photo (**Figure 7.42**)! Because I didn't have a lot of light output in the speedlight, I let the sun do most of the work and added a wide throw of soft light to finish off the photo in a flattering way for the subject.

Figure 7.42
The resulting portrait is beautifully lit with natural round catchlights and was achieved with a speedlight while the sun did most of the work everywhere else.

Nikon D800 •
ISO 400 • 1/250 sec. •
f/3.2 • 180mm lens

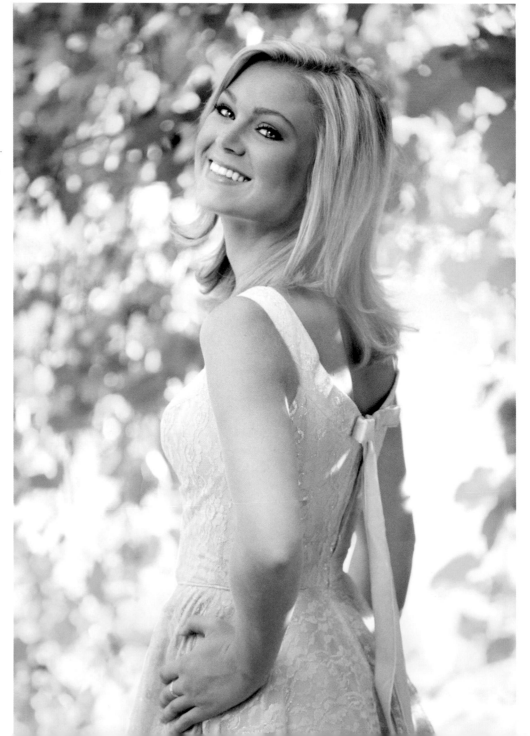

Studio strobe + softbox

There comes a time in outdoor portrait photography when you just need to go toe-to-toe with the sun, and this is where it pays to have a studio strobe with enough juice to do just that. A feature I didn't mention earlier is that you can use studio strobes outdoors without a wall outlet. In this case, I brought along a large battery unit designed to power strobes on location.

In **Figure 7.43**, you'll see that I also modified the strobe with a large octagonal softbox, called an *octabox*. Why did I use a round softbox, not a square one? The catchlights, that's why. A square softbox is meant to mimic window light. I recommend using a round softbox while working outdoors because the round catchlights in your subject's eyes will look like those created by the sun and will appear more natural.

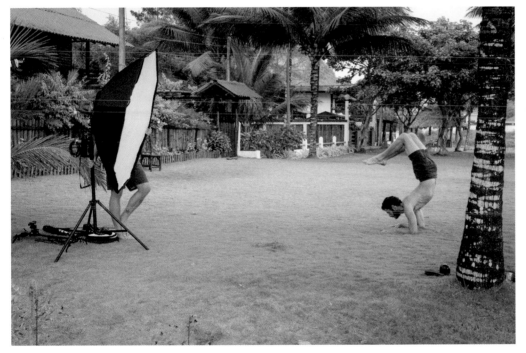

Figure 7.43
Using a battery pack, I lugged a studio strobe outdoors to compete with the brightness of the sun.

Nikon D3200 •
ISO 400 • 1/320 sec. •
f/9 • 32mm lens

After manually dialing in the power settings, I came away with **Figure 7.44** (on the following page). Because I was taking the photo outdoors on the beach, I needed a lot of power to compete with the sun. I was also photographing a subject doing an activity, and the instantaneous blast of strobe light freezes the subject so that you don't get motion blur. I also chose a softbox because hard direct light would have looked out of place. By adding in soft light as a fill, the photo appears more natural and doesn't distract from the subject.

Nikon D800 •
ISO 125 • 1/125 sec. •
f/8 • 85mm lens

8

Single-Person Portrait Scenarios

Bringing it all together

This chapter is where you begin to apply everything you've learned, from techniques to equipment, all to create a variety of single-person portraits. Let's walk through some setups, both indoors and outside, from one light to multiple lights. They will serve as a foundation for your future shoots and be great reference points when you're deciding on what look would best benefit your subject.

Poring Over the Picture

In the opening image of this chapter, I created a beautiful, Low Key portrait of a model being lit by a single softbox with the classic loop lighting pattern. In this image, I employed multiple lights to create a soft High Key image. You'll learn all about these lighting styles and classical lighting patterns in this chapter.

With minimal difference between the brightness of the subject and the brightness of the background, I created a low-contrast lighting style referred to as High Key lighting.

Multiple light sources were used to light the model in this photo. You can tell by the highlights appearing from several directions on her body, as well as from the front, lighting her face and eyes.

Nikon D800 ·
ISO 100 · 1/160 sec. ·
f/11 · 70mm lens

If you look closely at the model's eyes, you'll notice a large catchlight. From this you can tell the kind of light modifier I used, which was a large, 5-foot octagonal softbox.

You can tell from the soft light and gradual shadow transfer on the face and body that all of the light sources in this photo were equipped with very large light modifiers.

Studio Portraits

The easiest place to begin shooting portraits is indoors. By working in a room or studio with low light or no light, you're essentially beginning your portrait on a blank canvas. The only light affecting your model is the light that you paint in by using a small flash, studio strobes, or constant lights, like those discussed in the previous chapter. I love the KISS (Keep It Simple Stupid) principle when it comes to portraiture: The less lighting that you're worrying about, the more you get to focus on working with your subject. With this in mind, let's start with a single light source and some classic lighting patterns.

One-Light Classics

In Chapter 7, I covered how the direction of light creates contrast through shadows. This balance of light and shadow is easiest to see when you're working with a single source. Are you ready to run through some go-to portrait lighting setups to jump-start your off-camera lighting game? The simplest way to approach one-light setups is with a few of the classic lighting patterns available to you:

- Flat lighting

- Loop lighting

- Rembrandt lighting

- Butterfly lighting

- Beauty lighting

Flat lighting

In the first example, shown in **Figure 8.1**, I took the photograph with my strobe light up high and right behind my head. This pattern is called *Flat lighting*. Much like on-camera lighting, all of the shadows are being cast behind the model's head, where the camera can't see them. Although the direction hasn't shifted much from on-camera lighting, the quality of the light is greatly improved because I used a large 5-foot octagonal softbox (Octabank) to soften the light.

Loop to Rembrandt lighting

To create more depth, I start moving that light from on-camera axis and over to the side. When you're looking at classic lighting patterns, remember to look at both the highlight and the shadow. The shadow is used to identify many of these setups. After moving the light over about 45 degrees, the subject's nose begins to cast a "loop-like" shadow, which appears on the cheek (**Figure 8.2**). This is called *Loop lighting*.

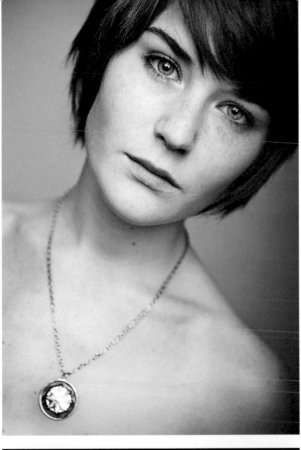

Figure 8.1
A portrait lit by a 5-foot softbox positioned behind the photographer for soft Flat lighting.

Nikon D200 ·
ISO 100 · 1/250 sec. ·
f/2.8 · 40mm lens

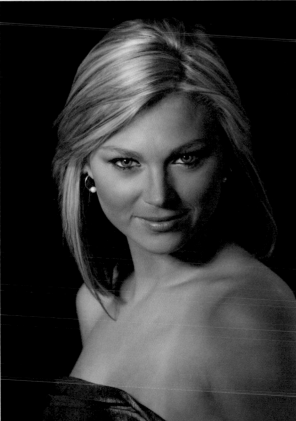

Figure 8.2
A portrait lit by a softbox placed over to the side about 45 degrees produces the Loop lighting pattern.

Nikon D700 ·
ISO 400 · 1/250 sec. ·
f/5.6 · 155mm lens

Classic Lighting Patterns

When you're trying to identify classic lighting patterns, look at the shapes that the shadows create. Many classic lighting patterns derive their names from the description of the shadows. It's also good practice for identifying the general quality of light in a given portrait.

You'll notice that I am using only one light for this setup, and you may in fact own only one light. If that's the case, there is another modifier that you should always have on hand, which is the trusty reflector that you've seen pop up elsewhere throughout the book. By using a reflector to bounce back light, it doubles as a second light source. A variation of this Loop lighting setup is shown in **Figure 8.3** where a silver reflector was used under and to the side of the model's face to bounce light back from the main light, filling in some of those shadows for less contrast.

Figure 8.3
This is the same Loop lighting pattern but with the addition of a silver reflector to fill in the shadows and lower the contrast.
Nikon D700 •
ISO 400 • 1/200 sec. •
f/5.6 • 200mm lens

If you continue to move your single light source around your subject, you'll steadily introduce more shadow into the face. Eventually, that loop of shadow from the nose will meet the shadow on the cheek, leaving you with a small triangle of light under the subject's eye (**Figure 8.4**). This is the famous *Rembrandt lighting* pattern. What's so important about this specific lighting setup? By looking for that tiny triangle of light, you'll also be guaranteed a catchlight in the eye on that same side of the face. When done correctly, this shot is just about the most contrast you can have in the subject's face while still maintaining that important sparkle in both eyes.

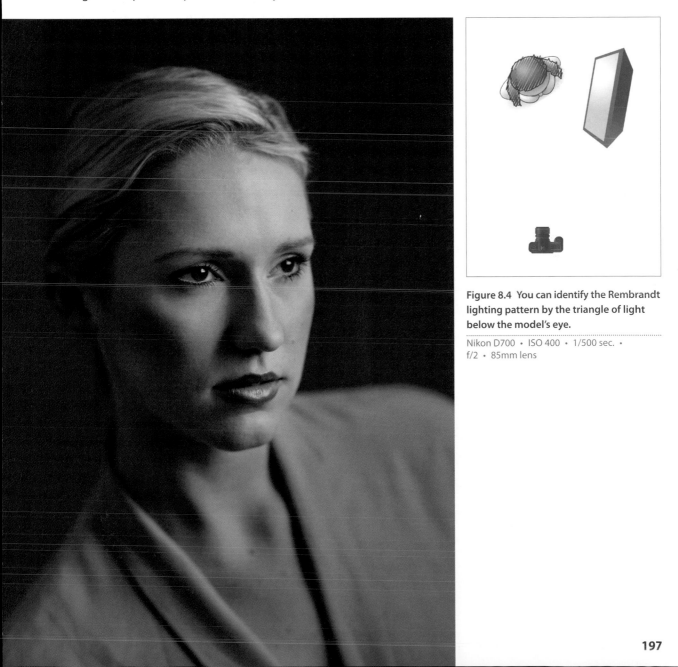

Figure 8.4 You can identify the Rembrandt lighting pattern by the triangle of light below the model's eye.

Nikon D700 · ISO 400 · 1/500 sec. · f/2 · 85mm lens

Butterfly to Beauty lighting

For the next couple of setups you'll move the light source up and down rather than around your subject. Start by placing your light on a light stand directly behind your head, aiming at the subject. Then begin to raise the height of the light until the bottom of the light modifier is above the subject's eye level. A shadow begins to appear under the subject's nose. In **Figure 8.5**, you'll clearly see the shadow under her nose.

This is called *Butterfly lighting* and is a very popular lighting pattern for two reasons: First, it provides even coverage of light. In its most subtle variations it offers very nice, even lighting of the forehead, cheeks, eyes, and nose. Second, the shadows it produces are very good at sculpting the face. This is the most popular lighting for models or people with high cheekbones because it casts symmetrical shadows under the cheeks and chin to accentuate these features.

Figure 8.5
Butterfly lighting is easily identified by the small shadow below the nose and symmetrical highlights.
Nikon D700 • ISO 400 • 1/200 sec. • f/5.6 • 175mm lens

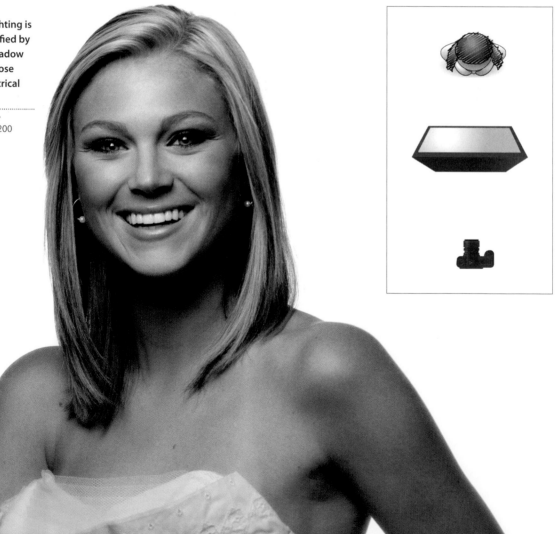

But even if you're photographing someone who doesn't have such lofty facial features, this is still a great lighting setup. You just need to add that silver reflector again to fill in some of the shadows. By placing the reflector directly below the subject's face, with the main light squarely above, you will achieve the *Beauty lighting,* or *Clamshell lighting,* shown in **Figure 8.6**. Notice how the cheeks are still defined, but the shadows aren't as harsh. The added bonus of this setup is the incredible second set of catchlights now being reflected in the lower eye. If you have one shot at flattering someone, this is a great lighting setup to employ!

Don't be afraid to get your subjects involved! I'll often ask them to hold the reflector for lighting setups like Beauty lighting rather than trying to work in another light stand.

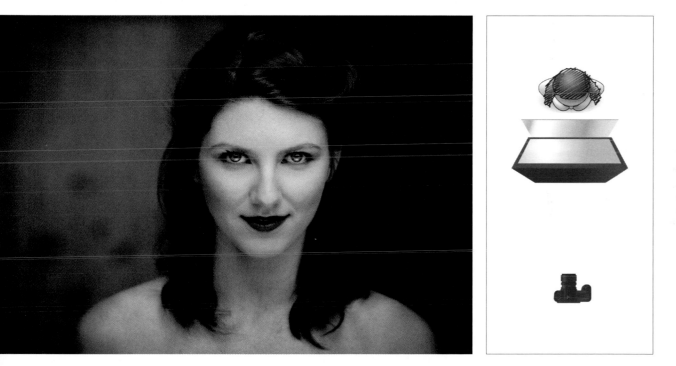

Figure 8.6 Beauty lighting, or Clamshell lighting, is Butterfly lighting with a silver reflector held below the model's face to bounce in light and fill shadows.

Nikon D800 · ISO 320 · 1/800 sec. · f/2 · 85mm lens

High Key and Low Key Lighting

When you're working with the classic lighting patterns, you'll spend a lot of time thinking about contrast via the amount of shadow on the face. Let's expand the scope a little more and look at contrast in the overall image now. Here is where Low Key and High Key lighting come up.

Low Key lighting

Low Key lighting usually requires fewer light sources, so let's start with it. Low Key lighting is an image that contains a high lighting ratio where there is a large difference between the brightness of your subject, lit by the main light, and the rest of the photo. **Figure 8.7** shows an example. Notice how the woman's face is nice and brightly exposed, and the background has gone completely black. This Low Key lighting is a creative way to use a ton of contrast to really make a face pop off the background; it also leaves a lot to the viewer's imagination.

If you take a peek back at Figure 8.6, you'll notice the same lighting setup, which is Beauty lighting with a softbox overhead and a reflector underneath. The only change is the darkening of the background to make Figure 8.7 a Low Key image.

Figure 8.7 Beauty lighting employed in a Low Key image with high contrast.

Nikon D700 •
ISO 1000 • 1/125 sec. • f/5.6 • 82mm lens

High Key lighting

On the flip side is High Key lighting, where the lighting ratio between your main light and the rest of the scene is very small, almost even at times. The image in **Figure 8.8** again uses the Beauty lighting setup with a softbox and a reflector. Only this time I turned on a second strobe and aimed it at the white wall behind the model. By turning up the power on this second strobe, it overexposed the wall, giving me a bright white background. With the combination of even lighting on the model's face and an evenly lit white background, there is minimal contrast, producing a nice and bright High Key image. This is a very popular look because of the clean images that it produces.

**Figure 8.8
Beauty lighting
employed in a
High Key image
with low contrast.**

Nikon D700 •
ISO 400 • 1/200 sec. •
f/4 • 85mm lens

3 Point Lighting

In the previous section, you finally started breaking out more lights with High Key lighting. Although you can produce a lifetime's worth of great portraits with just a single light and reflector, it's important to know what other possibilities await you if you choose to use more lights. A 3 Point Lighting setup gives you total three-dimensional control to really illuminate your subjects and shape their faces.

Main light

The main light, or key light as it's often called, is just that. It's the main light in your setup and is fundamental in illuminating the subject. The main light is usually the brightest light in a photograph and will do most of the work in lighting the subject, including creating those ever important catchlights in the eyes. As discussed in Chapter 7, softboxes make great key lights because they produce soft flattering light but still maintain a directionality to the light, making it easy to aim the light precisely at the subject. In **Figure 8.9**, the model was lit with a speedlight in a large 50-inch square softbox.

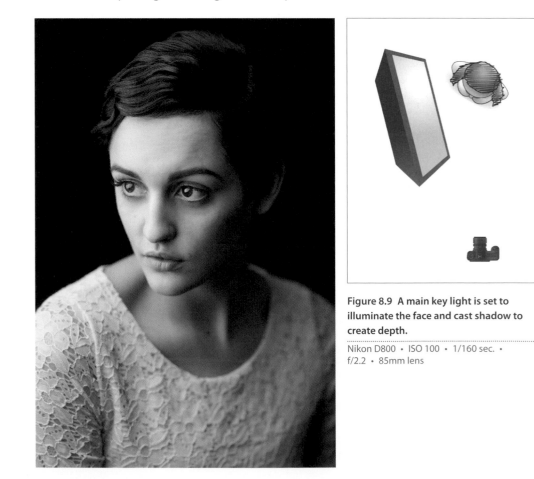

Figure 8.9 A main key light is set to illuminate the face and cast shadow to create depth.

Nikon D800 • ISO 100 • 1/160 sec. • f/2.2 • 85mm lens

Rim light

The image in Figure 8.9 is already a pretty good Low Key portrait. So where do you go from here? As is the case with many shots like this, the subject begins to fade into the background on the shadowed side of her face. Notice how her dark hair is almost as dark as the background? The next step is to prevent this melding with the use of a *rim light*, which is simply a second light set up behind the subject firing back at her. To soften this second light a bit, I used a small strip-light softbox attached to a speedlight to produce a more pleasing vertical slash of light. After turning it on in **Figure 8.10**, it actually doubled as a rim light and a *hair light*. Note how that splash of light on the hair and neck really makes the model look 3D and separates her from the dark background. That's a lot of benefits to gain by adding just a single light back there.

Figure 8.10 Using a main key light plus a rim light from behind separates the subject from the background.

Nikon D800 · ISO 100 · 1/160 sec. · f/2.2 · 85mm lens

Fill light

The last piece of the lighting setup puzzle is something that you've seen done a few times already in this chapter. A *fill light* can be an actual third light or just a reflector bouncing light back into the face from the main light. The portraits in Figures 8.9 and 8.10 contain a lot of depth and separation, but the contrast is a bit too high for what I wanted to create. To lower this contrast, all you need to do is brighten up the shadow levels a bit. By shining a light into those shadows on the subject's face, the overall contrast was lowered, which resulted in the final photo in **Figure 8.11**.

When you're using a strobe light as a fill light, make sure that the power is turned down lower than that of the main light, or else you'll flatten out the subject—or worse, create competing shadows.

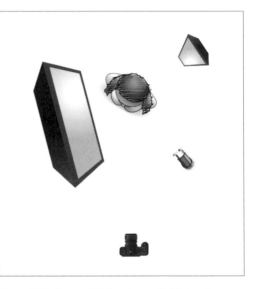

Figure 8.11 A main light and a rim light plus the addition of a third light are used to fill in the shadows on the face.

Nikon D800 • ISO 100 • 1/160 sec. • f/2.2 • 85mm lens

Headshots You Can Bank On

Headshots are a mainstay in the portrait photographer's arsenal. They are also the bread-winners in many working portrait photographers' studios. The reason is that everyone can use a headshot nowadays. Actors and models have always needed them, authors and artists need a good bio photo, salespeople and other professionals need headshots for their business cards, and seemingly everyone is on social media and therefore needs a profile picture, too. Being a proficient headshot photographer means you'll never be out of work. So let's get you proficient already!

Outdoors

One of the great advantages about getting comfortable using strobes, reflectors, and different lighting setups is that anything you can do indoors in the studio, you can usually replicate outdoors as well. Although the lighting approach and setup may be in a different order at times, the thought process and highly polished results are the same. Let's create a 3 Point Lighting setup outside using the sun as one of the lights.

Rather than starting in a dark room where any camera settings will do, when you shoot outdoors like this you'll need to manually set your camera to expose for the ambient light first. Rather than trying to compete with bright daylight using only a small strobe, I set up my subject in the shade under a tree. **Figure 8.12** is my starting shot. I set the camera so that nothing was overexposed, and the sun was already coming in from behind the subject, acting like a rim/hair light!

Figure 8.12 **In this initial photo, my camera was set so as not to overexpose the background.**

Nikon D700 · ISO 200 · 1/200 sec. · f/5.6 · 200mm lens

Next, I needed to light the model's face. As it stands, the setup gave me a good outdoors foundation but not much of a portrait. So I set up a Quantam Q-Flash strobe inside of a 43-inch octagonal softbox. This produced a soft directional light with round catchlights similar to those the sun would have created naturally. After dialing the power on the strobe up and down until the intensity on his face was correct, I came away with **Figure 8.13**, a nice outdoor headshot.

I could have easily stopped there and just worked with the subject on different poses and smiles. But a couple of details were bothering me—the deep wrinkle shadows on his cheek and the uneven rim lighting caused by the sunlight filtering through the leaves overhead. It was time to add the fill light. Rather than using a standard one- or two-sided reflector, I highly recommend using the more versatile 5-in-1 varieties. This gave me the means to use a white-sided reflector to bounce light into the shadows on his face for fill. At the same time I used another piece to diffuse the rim light. In **Figure 8.14**, you can see both in action. With the sunlight filtering through the diffusion material from the back, it's the same kind of light I would have gotten by placing a strobe and softbox back there.

Figure 8.13 (left) An ideal headshot after adding a strobe and softbox as the main light.

Nikon D700 •
ISO 200 • 1/200 sec. •
f/5.6 • 150mm lens

Figure 8.14 (right) Behind-the-scenes view of the setup after adding reflectors.

Nikon D700 •
ISO 200 • 1/160 sec. •
f/5.6 • 70mm lens

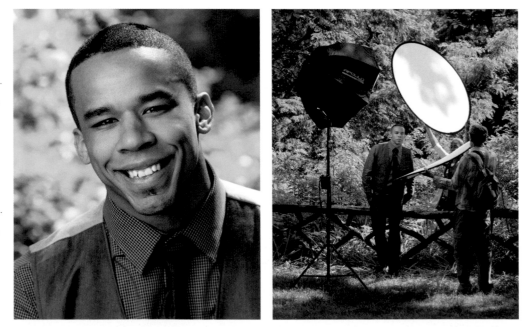

Figure 8.15 shows the final polished image. It has the same quality and control of a standard 3 Point Lighting setup with multiple strobes and softboxes, except I used only a single strobe and reflector. Getting creative with your lighting allows you to create quality images for your portrait subjects without always having to haul around a lot of gear.

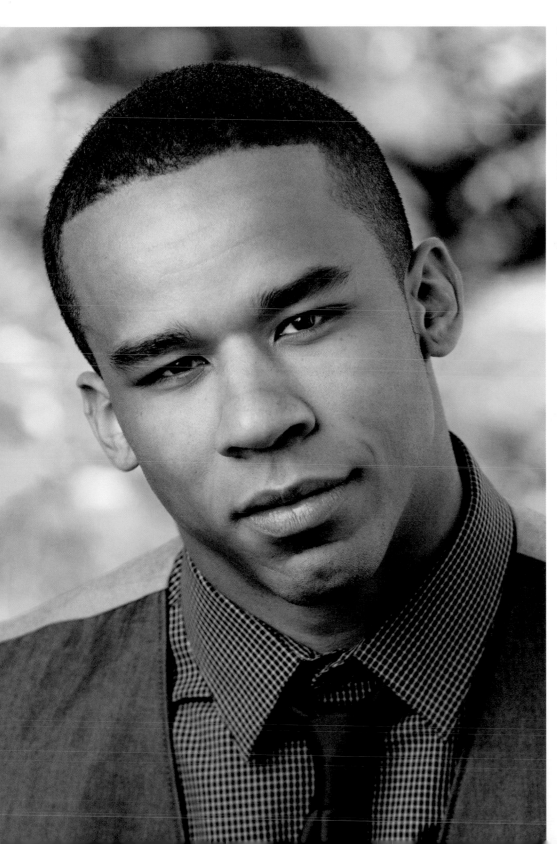

Figure 8.15
A final headshot after using a bounce reflector to add fill light and using the other side to diffuse the sun as a rim light.

Nikon D700 · ISO 200 · 1/200 sec. · f/5.6 · 160mm lens

207

Indoors Again

That standard 3 Point Lighting setup just discussed in the studio and outdoors will be one of your most often used arrangements for headshots. Of course, there are variations as well. Let's look at some.

No hair? No hair light!

For instance, what happens when your subject has no hair? Please don't add that hair light then! You'll only create a big shiny spot on the top of your subject's head, which is not usually a flattering look. Instead, you can use a number of setups in this situation, but I'll describe two to point you in the right direction. In **Figure 8.16**, I simply used those extra lights that won't be used as hair lights and aimed them at the background instead to create a High Key look while leaving the main light in a softbox aimed at the subject's face.

Figure 8.16
A classic headshot with no hair light because the subject doesn't have hair.

Nikon D700 · ISO 800 · 1/200 sec. · f/5.6 · 110mm lens

Another option is to keep the main light and rim light in place, and to just move the hair light around to the other side for a second rim light, as shown in **Figure 8.17**. Now you see great lighting on the face and nice rim lighting on both sides to separate him from the background.

The main light plus double rim lights is a very popular lighting setup for athletic portraits as well.

Figure 8.17 Using two rim lights to separate the subject from the background instead of using a hair light.

Nikon D700 · ISO 800 · 1/200 sec. · f/5.6 · 98mm lens

Natural Light Only—In and Out

All this talk of multiple strobes and softboxes may be beyond what you currently have in your camera and lighting kit. Don't think for even a minute that awesome headshots can't be taken using only natural light. So let's put away the man-made lights for a moment and grab some headshots indoors and outside using just the sun.

Indoors, window light can be overlooked sometimes for how simple it is. Honestly, there is little else that produces light as soft and beautiful as a large window on a sunny day. When you're working indoors, forget the lights, and just look for a big window instead. After all, softboxes only came about because photographers wanted to harness the quality of window light but be able to use it at all times of the day or night.

Let's start with some nice, clean, High Key lighting. After finding a large window for one of my headshot shoots, I waited until afternoon when I knew there would be plenty of sunlight filtering through the glass. I then set up a large white collapsible background close behind my subject's back. I placed myself between her and the window and had her face me. The window shaped the sunlight outside into a giant square of light and funneled it evenly into the room, as if I had a giant square softbox right behind my head. It also illuminated the white background behind her. The resulting headshot is shown in **Figure 8.18**. Nothing more than available daylight and a big window were employed.

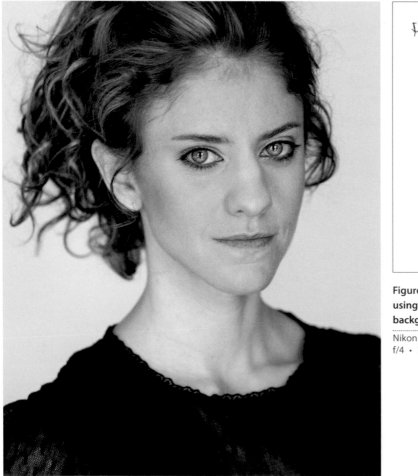

Figure 8.18 A High Key headshot using only window light and a white background.

Nikon D700 • ISO 800 • 1/160 sec. • f/4 • 102mm lens

That's a great shot for this kind of High Key, clean, beauty light, but is natural light really as versatile as, say, a studio strobe? Can you produce something more contrasty in this big wash of light? Absolutely! In **Figure 8.19**, I used a large background made by Westcott that is white on one side and solid black on the backside. All I did next was flip it around to show the black side and backed it up away from the model as far as I could. By keeping the model where she was, close to the window, the light intensity on her was much brighter than on the distant background, allowing it to remain dark black. With the same camera settings, the resulting photo was Low Key lighting with nice contrast and separation between the model and the background.

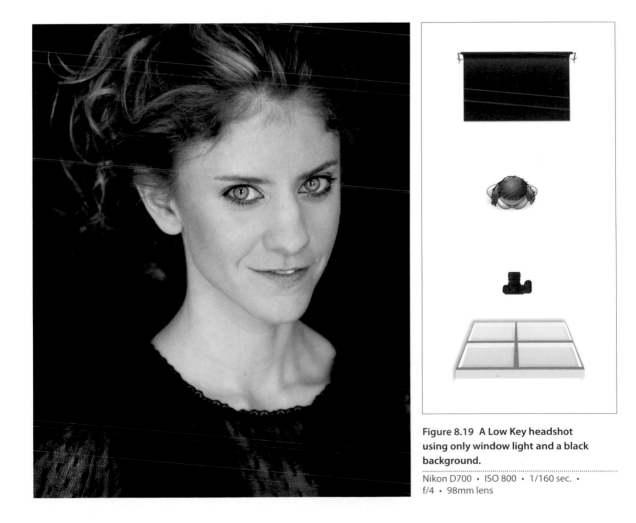

Figure 8.19 A Low Key headshot using only window light and a black background.

Nikon D700 · ISO 800 · 1/160 sec. · f/4 · 98mm lens

In the same way, if you want more contrast or shadow on the subject's face, all you need to do is turn the subject slightly away from the window. It has the same effect as if you had moved a softbox from behind you and over to the side. The image in **Figure 8.20** was lit with the same window, only this time with the male model slightly turned away.

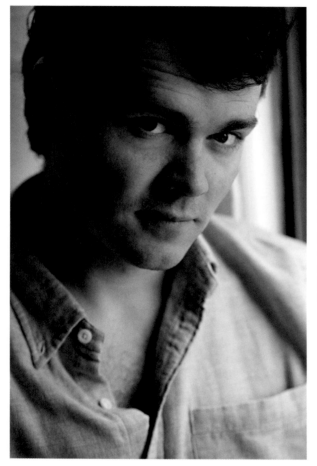

Figure 8.20 A contrastier headshot using only window light with the subject turned slightly away.

Nikon D700 · ISO 400 · 1/160 sec. · f/2.8 · 85mm lens

Beautiful headshots can be made very simply outdoors as well. I discussed this at great length in Chapter 4, where we worked with all-natural sunlight outdoors. **Figure 8.21** was taken outdoors on a slightly overcast day. Even with cloud cover there is still a direction to the light. So just like you face the model toward the window light, I faced the model into the sun hiding behind the clouds. This is what created the soft, even lighting on the face and the nice sparkle in the eyes.

So now you know that in a pinch, with any amount of gear, you can create great headshots to showcase your subjects accurately and at their very best!

Figure 8.21
An all natural-light headshot taken on a cloudy day after having the subject look in the direction of the sun.

Nikon D800 •
ISO 400 • 1/200 sec. •
f/2.8 • 85mm lens

Environmental Portraits

All right, it's time to go beyond the standard headshots and studio lighting, and out into the wild! The great thing about portrait photography is the human element. You can zoom in close and focus tightly on the person, literally with the lens and metaphorically with your scope. You can also choose to step back and view people in a much wider way, placing them in a scene and letting their environment tell part of the story while their face says the rest. This second approach is what environmental portraiture is all about.

As a commercial photographer you may be asked to photograph staff members in their office for an annual report, or as an editorial photographer you may need to photograph a person of interest in a way that tells something about who that person is beyond a pretty picture of the subject's face. **Figure 8.22** shows an example. It is an environmental portrait of a well-known musician. In Chapter 3, I covered how the use of props can aid in telling a story. For this photo, I wanted to avoid the obvious option and chose to use the environment to help me convey the story instead. I found a hallway outside of the artist's office with a ton of photos hung on the walls, all images of him performing or receiving awards over the years. By placing him in the center of this hallway

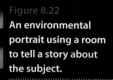

Figure 8.22

An environmental portrait using a room to tell a story about the subject.

Nikon D800 •
ISO 125 • 1/160 sec. •
f/3.2 • 24mm lens

and using a wide-angle lens to include my subject and the walls, I was able to place him in the middle of his own memorable career in a way. In the end, I added a small speedlight with a blue-colored gel on it to backlight him and to highlight the picture frames so that the viewer couldn't help but look at them.

Character Portraits

A fun subgenre of the environmental portrait is the character portrait. Although environmental portraits are often used to tell about a person's occupation or location, the character portrait can go beyond that. These portraits often break the standard rules of composition or lens selection and lighting that I've been discussing as "proper" throughout the book. Rules were meant to be broken after all!

In **Figure 8.23**, you see a character portrait of a man that breaks a few rules. The lighting is rather harsh and is coming in from the sides. The framing of his eyes puts them outside of the rule of thirds. I used a wide-angle lens, which caused a lot of distortion, stretching his face and the frame. All this and yet the photo somehow works. The reason it works is that the guy was, quite simply, a character! He owned a few bars in a downtown nightlife district known for fun parties and lots of dancing. A normal, clean-cut portrait would have been too proper for him, so I changed it up and delivered a different kind of portrait, showcasing his personality with the signage for his establishment in the background. It was simply lit with two speedlights, one on either side, and no modifiers.

Figure 8.23 This character portrait breaks all of the classic portrait "rules" to showcase the subject's unique personality.

Nikon D200 · ISO 400 · 1/250 sec. · f/2.8 · 17mm lens

Although the photo in Figure 8.23 shows the character of the subject, this type of portrait can also show made-up personas as well by finding someplace strange or uncommon and using it as a shooting environment. This portrait style is very popular in band photography. In **Figure 8.24**, you see just such a scenario. While looking for a location to shoot a character portrait of a musician friend, I found a broken-down car on the side of the road one day. I decided to use it after asking permission from the mechanic shop that owned it. With the musician's dreadlocks and rock 'n' roll attitude, it was the perfect train wreck of an environment to make an interesting portrait. It's much more exciting than a boring gray background, right? I placed one strobe outside the passenger window to light his face and another behind him to give a nice hair light to bring out his dreadlocks.

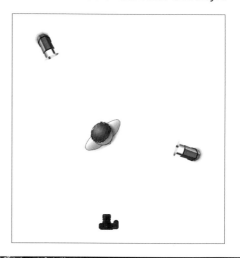

Figure 8.24 **A character portrait in an unusual location helps to fabricate a story about this musician's persona.**

Nikon D200 · ISO 100 · 1/160 sec. · f/4 · 55mm lens

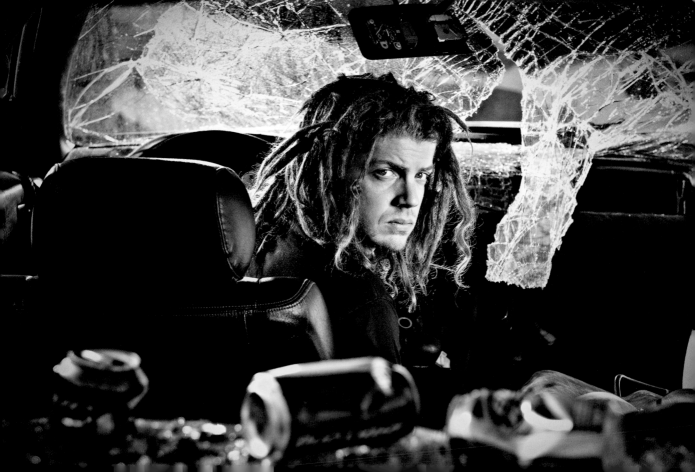

Chapter 8 Assignments

Practice the Classic

Set up a single light and whatever light modifier you have on hand. If you don't have a strobe light or modifiers, grab a simple shop light and have someone hold it for you. Then move the light around to create each of the classic lighting patterns discussed in the chapter (Loop, Rembrandt, Butterfly, etc.).

Work That Reflector

For the next few portrait sessions that you shoot, try to work your reflector into every shot. Use the white and silver bounce sides for fill light. Try to diffuse sunlight with the interior diffusion panel. Additionally, use that black side, bringing it in close to the face to add more shadow and contrast. After a few shoots like this, using your reflector will become second nature.

Incorporate the Environment

While working with a portrait subject, get to know that person a little bit. After learning something about your subject, what he or she does for a living or for fun, try to set the props aside for a minute and place the subject in an environment to help tell that part of the person in the portrait. Shoot with a wider lens if you need to, so make sure there's room in the frame.

Share your results with the book's Flickr group!
Join the group here: flickr.com/groups/portraitsfromsnapshotstogreatshots

Nikon D800 · ISO 100 ·
1/1250 sec. · f/2 ·
35mm lens

9

Group Portrait Scenarios

Establishing depth of field, perspective, and lighting

The group portrait, or the *dreaded* group portrait as many photographers might affectionately refer to it, is when you apply all of the knowledge and skill you've acquired and compound it by however many more people you can throw into the scene. But don't start smoking at the ears from overload, because the same basic concepts apply in a group portrait as they do in a single-person portrait. If you keep a few things in mind during the shoot, you'll be producing great group photos in no time.

Poring Over the Picture

This photo was framed carefully to place the subjects' heads in a clear space of sky versus a busy background like the nearby tree branches.

A wide-angle lens was used up close to the subjects to bring them forward in the photo and to capture a wide enough perspective to include the subjects and their environment in a single frame.

The Rule of Thirds was used to compose this photo, placing the subjects off-center in the frame.

The photo was taken from a low vantage point to exaggerate and enlarge the subjects in the scene.

A small aperture of f/14 with a wide depth of field was used to make sure that both the subjects and the beautiful mountain background would be in focus.

This small group portrait was taken on a mountaintop in Colorado. By using a wide-angle lens and a small aperture, you can see the subjects and scene in a single photo while keeping everything in focus.

Nikon D3200 • ISO 800 •
1/800 sec. • f/14 •
18mm lens

Camera Settings to Consider

Before you bring people into the equation, let's dial in your minds and cameras. All of the same lighting and posing techniques I've covered earlier in the book still apply, but there are a few camera settings you'll want to pay close attention to when you switch from a single subject to a group of subjects. (Refer to Chapter 2 for a refresher on camera modes, lens selection, and compression.) First, you must make sure that everyone is in focus! This concern will motivate which mode and aperture that you set your camera to. Second, you need to make sure that everyone fits into the photo and that no one looks distorted in the process; to do this, you'll look at lens selection. Third, you'll see how you can change what you say about your subjects and how they all fit into the frame when shooting multiple rows by varying your shooting height. All these thoughts boil down to depth of field, compression, and perspective. Let's jump in!

Depth of Field

What is depth of field again? It is the amount or depth of your photo that will be in focus, and also how quickly everything else will fall out of focus. This depth can be as narrow as a few millimeters or many feet wide depending on your lens and aperture.

It would be rather difficult to fit the faces of multiple people into a tiny line just a few millimeters thin, so you'll want to employ a wide depth of field for group shots. To do this, you'll use a small aperture like f/8–f/16. *The smaller the aperture, the larger the depth of field.*

Now you just need to ensure that you keep that small aperture throughout the shoot. Although Manual mode would grant you the *most* control, all you really need to use is Aperture Priority mode. This mode lets you set the desired aperture (like f/11, for example), and then it adjusts all of the other settings to produce a properly exposed photograph while keeping the aperture constant.

Compression

Once you know that everyone will be in focus no matter which row they're standing in, you'll next want to consider the compression of the scene. *Compression* is the result of your lens's focal length (24mm lens versus a 200mm lens) and how each squishes or expands the elements in your photograph differently. Again, compressing a scene works exactly like it does with single-person portraits. The longer your lens, the more you'll bring together the foreground and background of your photo, basically compacting them all together around your subject.

It's incredible the impact your focal length has on the way you want to present your subjects in their environment. For example, **Figure 9.1** was taken with a 24mm lens and distorts the couple to be the largest elements in the scene. They are undoubtedly the main subject. Now check out **Figure 9.2** of the same couple and scene. This time a medium telephoto zoom of 70mm was used. In this image, the lighthouse becomes more prominent because the longer focal length compressed the scene and brought the lighthouse forward. This is a great way to play up the environmental elements in a group photo to establish a sense of place for your subjects.

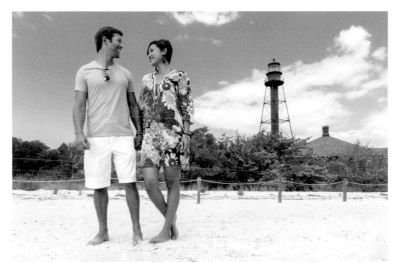

Figure 9.1
A wide-angle lens was used to distort the photo, causing the people to be the largest elements in the photo.

Nikon D700 •
ISO 200 • 1/125 sec. •
f/16 • 24mm lens

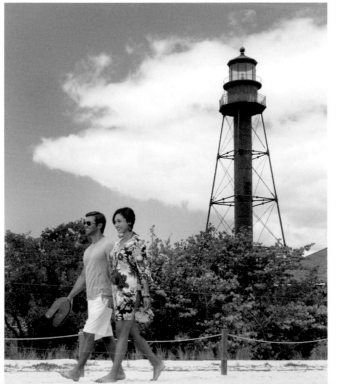

Figure 9.2
A medium telephoto lens was used to compress the scene, bringing the lighthouse forward and making it appear larger in comparison to the people.

Nikon D700 • ISO 200 • 1/165 sec. • f/16 • 70mm lens

Perspective

The final concept to keep in mind when you're taking group photos is the easiest to manipulate, and that's the perspective of the photo. In an earlier chapter, I discussed how standing above or below your subjects will portray them differently. Perspective is a combination of your subject orienting his face to the lens and inherent distortion in the lens that brings focus to the eyes and forehead versus the neck and chin. Changing your perspective as the shooter is also a great technique to keep in mind for setting a tone with groups or, more practically, to make sure everyone can be seen in the photo. If you elevate yourself to shoot slightly down on a group, you'll be able to see peoples' faces from every row. If you shoot from a lower perspective, people in the front may block those in the back. The best part is that all you need to do is squat down or step up on a stool or an apple crate to change perspective. (Later in the chapter you'll see how varying your perspective can change the tone from looking down and endearing to looking up at the subject looming over the viewer.)

Shooting Couples

Let's ease into the territory of photographing multiple moving targets. The simplest place to start is with a couple or a pair of people. This type of portrait is also one of the most common types of group portraits you'll be dealing with as a photographer and is the easiest to manage as well because you've only added one person at this point.

You now know how aperture controls your depth of field, as discussed in this chapter and in Chapter 2. Although having a wide depth of field is crucial for keeping large groups in focus, you have some room to play when you're dealing with only a pair of people. Let's start with the safe, wide depth of field, and then look at creatively using a shallow depth of field, and also what to keep in mind while doing so.

Wide Depth of Field

Figure 9.3 shows an image in which I was able to successfully get both subjects in tack-sharp focus. The resulting focus was possible because of the small aperture of f/8, which created a wide depth of field with plenty of room for two people at a good distance of 10–15 feet away. Also, note how I turned the couple's backs to the sun so they could focus on looking at each other rather than being blinded by the light.

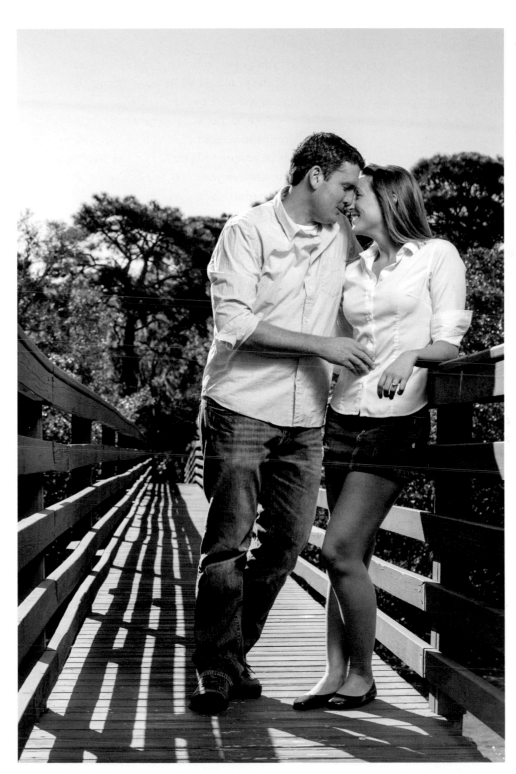

Figure 9.3
This photo of a couple was taken at a smaller aperture of f/8 to ensure adequate depth of field for two people.

Nikon D700 • ISO 200 • 1/250 sec. • f/8 • 70mm lens

Distance Matters

When you're working with a narrow depth of field, distance matters. If you're shooting at f/2.8 and are a foot away from the subject, very little will be in focus. If you back up a good distance and recompose for the entire subject, you'll be able to get the whole person in focus.

Shallow Depth of Field

Rules are meant to be broken, and you have a lot of creative room when you're working with only two people. Say you want to draw the viewer's eye to only one of the people in the couple. You can switch gears back to a single-portrait mind-set and open up the aperture as much as possible. In **Figure 9.4**, I switched from f/8 to f/1.4, which created a *drastically* shallow depth of field. Now only a few millimeters of the photo are in focus. This is a great way to highlight the female and sets up the man to be a supporting role in the background, both in placement and in focus. A great way to use this technique is to create this shallow depth-of-field photo for both people in the couple—**Figure 9.5** focuses on the male—and then present them together as a pair.

Figure 9.4 (left)
By opening up the aperture for a small depth of field, you can selectively draw focus to one person over the other in a couple's photo.

Nikon D700 ·
ISO 200 · 1/640 sec. ·
f/1.4 · 50mm lens

Figure 9.5 (right)
With this wide-open aperture for a small depth of field, you can draw focus to the other person in the couple's photo by moving your camera's focus point.

Nikon D700 ·
ISO 200 · 1/640 sec. ·
f/1.4 · 50mm lens

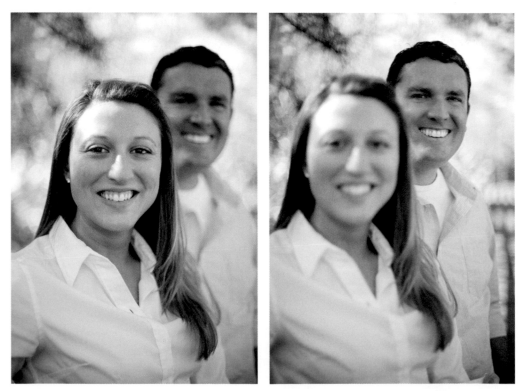

Same Focal Plane

Let's review what the focal plane actually is again, because as your subjects multiply it becomes important. Think of a focal plane as a flat plane that runs perpendicular to your camera's sensor. When you focus on something, you don't just focus on that point, you focus on an entire plane! So anything that falls into that area will also be in focus.

Now what if you want the best of both worlds, focus and shallow depth of field? Because the invisible line of focus runs long, couple's portraits can in fact be classically achieved with a shallow depth of field. If you carefully place your subjects' faces, you can get them both to fall onto the focal plane where they'll both be sharp against dramatically soft surroundings, as shown in **Figure 9.6**. However, be wary of just how small and thin this focal plane is. If you look closely, you'll see that the gentleman's left eye is slightly out of focus.

An easy way to visualize this focal plane is to picture your flat camera sensor, and then imagine another giant flat sensor oriented the same way with your focus point at the very center of it. Then just move your subjects forward and backward until their faces are flat against that second imaginary sensor.

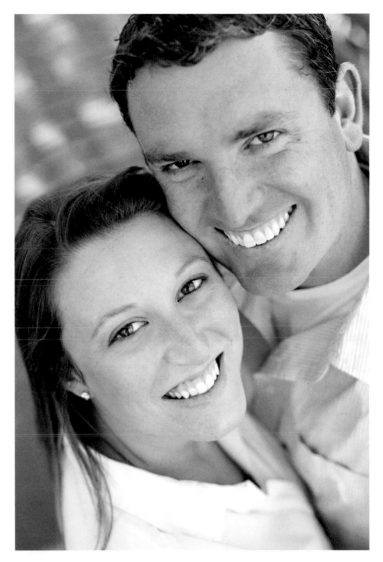

Figure 9.6 By visualizing the large but flat focal plane I was able to place the faces of both people on it to keep them both in focus, even at a shallow f/2.8.

Nikon D700 · ISO 200 · 1/160 sec. · f/2.8 · 50mm lens

Family Photos

All right, let's complicate things a bit—well, not really—by taking some family photos! Depending on the family you're working with, you could have your hands full. Let's start with a nice, manageable family of five.

Natural Light Approach

When you're working with a group of people, getting everyone in focus is key. Fortunately, most family photo shoots occur during the daylight hours, and that daylight gives you plenty of light to work with. To get two rows of people in focus in the same photo, you'll need a wider depth of field (than with a couple) and thus a smaller aperture to achieve it. An aperture of f/8–f/11 is perfect in this situation. To ensure that you maintain this desired aperture, remember to set your camera to Manual mode or Aperture Priority mode.

The family in **Figure 9.7** is outdoors and turned toward the sun to light them evenly. In Chapter 4, I discussed using natural light, and although this is an efficient way to evenly light a group of people, it may not be the best. In the figure you can see that there is a lot of squinting going on, and if the subjects keep this up for too long, their eyes would soon be watering. And there's no crying in family photography!

But turning the subjects away from the sun to save their eyes only makes things worse. In **Figure 9.8**, the subjects are half in bright sunlight and have a dark shadow falling over the other half of their faces.

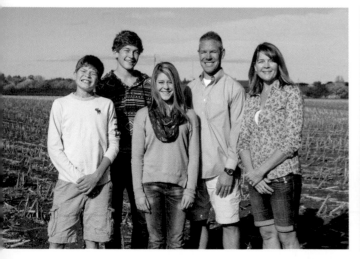

Figure 9.7 A family is lit with direct sunlight using a small aperture to ensure focus.

Nikon D800 • ISO 100 • 1/100 sec. • f/11 • 70mm lens

Figure 9.8 After turning the family away from the sun so they don't squint, the lighting is now horrible.

Nikon D800 • ISO 100 • 1/200 sec. • f/11 • 45mm lens

Just as you discovered when shooting a single-person portrait, turning your subjects' backs to the sun is usually the best route to take, which is where the sun is in **Figure 9.9**. Now there is a nice, even light on all of the subjects' faces, although now they're underexposed. If you're shooting in Av mode (Aperture Priority) with spot metering, your camera will have already adjusted your exposure to compensate for this change in exposure. If you're shooting in Manual mode, you'll need to lighten the photo on your own. To do this, you can't change the aperture or you'll lose that precious depth of field. Therefore, the only other setting to adjust is the shutter speed. By simply slowing down the shutter speed, the result is a great family photo (**Figure 9.10**).

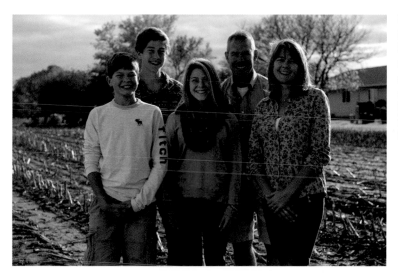

Figure 9.9
I turned the family's backs to the sun to put their faces in even shadow, but they are now underexposed.
...
Nikon D800 ·
ISO 100 · 1/200 sec. ·
f/5.6 · 70mm lens

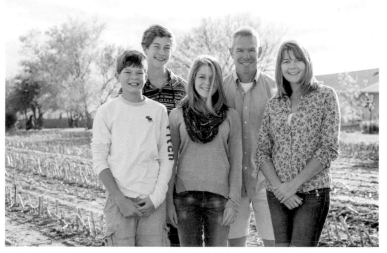

Figure 9.10
By slowing down the shutter speed to expose for the shadows, the result is a great family photo.
...
Nikon D800 ·
ISO 100 · 1/60 sec. ·
f/5.6 · 70mm lens

Strobe Light Approach

You now have a great family photo, but you can take it a step or two further still. By turning your subjects' backs to the sun, you needed to overexpose that backlight to get a proper exposure on their faces. This heavy backlighting also resulted in a loss of contrast in the photo. What if you don't want to blind your subjects but also want more contrast and detail in the sky? Simply add fill! Remember back in Chapter 7 where you saw the benefits of using strobe lights outdoors? Let's use strobe light to fill in those shadows and bring some balance to this scene.

One light

At this point you've already done the work to establish a base exposure. All you need to do is speed up your shutter to your camera's maximum sync speed. In most cases this is at 1/200 of a second. This setting will bring the detail back into the sky but underexpose the subjects again. But by simply turning on the strobe—BAM!—you have detail in the sky and beautiful fill lighting on the subjects from the strobe, as shown in **Figure 9.11**.

Remember to use a low ISO when you're shooting strobes outdoors. This allows you to use a slower shutter speed while still underexposing the ambient light. It's important to remain under your camera's x-sync speed.

Figure 9.11
I used a fast shutter speed to darken the skies and set a strobe to fill in the shadows to light the family's faces.

Nikon D800 •
ISO 100 • 1/200 sec. •
f/5.6 • 70mm lens

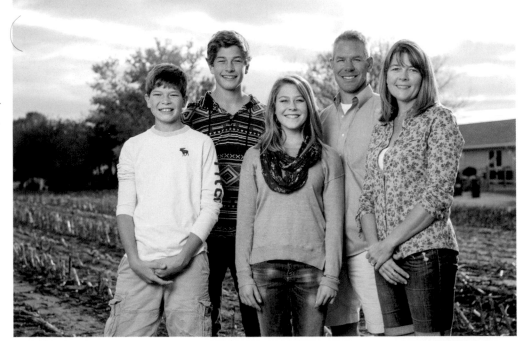

When you add your own light, you also create a bunch of shadow. If your single strobe is off to the side, it would properly fill only half of your subjects' faces. To make sure you get even lighting rather than just adding more shadow to the situation, you should place the light as close as possible to your camera axis and up above eye level. In **Figure 9.12**, I used a huge 7-foot parabolic bounce umbrella to efficiently spread out the light from the strobe. I took the final photo while standing directly beneath the strobe.

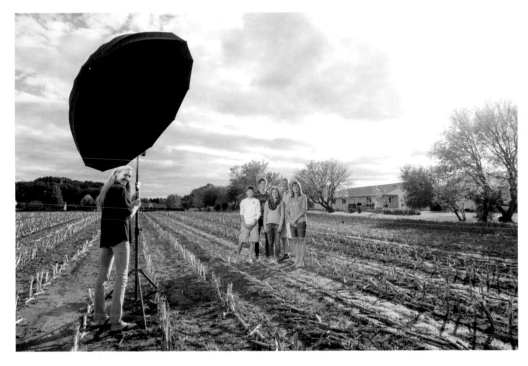

Figure 9.12
This photo was taken directly below the umbrella so as not to cast any competing shadows. The 7-foot umbrella came in handy to spread light evenly on all of the subjects.

Nikon D800 •
ISO 100 • 1/200 sec. •
f/5.6 • 24mm lens

Two lights

Although the one-light approach is a great way to achieve that awesome balance of light in group photos, it can present difficulties as well. Due to the limited power of small strobes, the light may need to be placed closer to the subjects than you'd like, which puts it directly in the way of the photo. Additionally, the light can appear flat because it is coming from the same axis as your camera, so it competely fills the shadows and creates a 2D feeling to the image. Ideally, you can overcome both of these problems by simply adding a second light.

The camera settings for a two-light setup are identical to the camera settings for the original one-light setup, but you add a second strobe and umbrella and position the lights at 45-degree angles to the photographer. If you turn down the power slightly on one of the strobes compared to the other, it will create a key-light plus fill-light scenario,

as I discussed in Chapter 8. This creates a feeling of depth on the subjects' faces and also clears the shooting lanes, because both stands are now off to either side of the photographer, as shown in **Figures 9.13** and **9.14**.

Figure 9.13
A family portrait lit with two strobes. Each strobe is in a bounce umbrella and placed at 45 degrees to the subjects for a more 3D look.

Nikon D800 •
ISO 100 • 1/200 sec. •
f/5.6 • 70mm lens

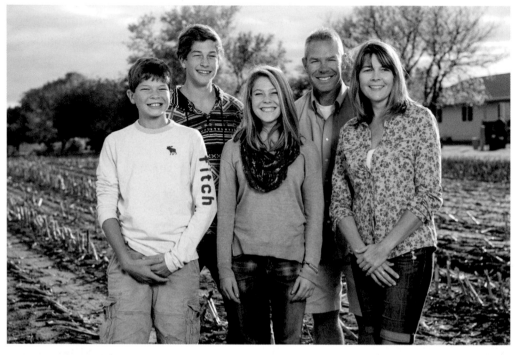

Figure 9.14
A pullback view showing how two strobes give you a clear path to shoot large groups without the stands getting in the way.

Nikon D800 •
ISO 100 • 1/200 sec. •
f/5.6 • 24mm lens

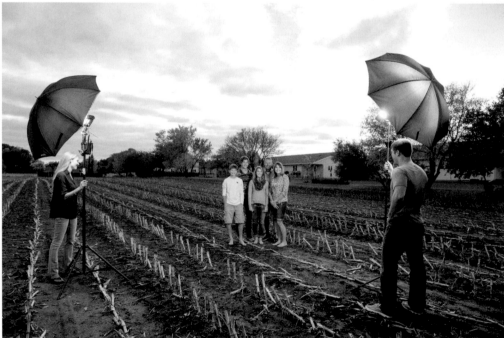

Large Groups and Sportraits

Last but not least let's tackle the elephant in the room—the *large* group portrait, which could be anything from a family reunion photo, formal portraits at a wedding, or your child's sports teams. You'll apply all of the techinques you've learned up to this point, and you'll also have to keep an eye on your perspective and compression to best tell the group's story.

One Light

For the large group example images, I enlisted the aid of a high school soccer team after one of the team's home games. It's a good thing the game had just ended because the sun was setting and the field had no stadium lights to work with. **Figure 9.15** shows the team getting into position as I assess the lighting situation. I obviously needed a light here, so I added one like I did with the family photo in Figure 9.11. I set up one strobe on a light stand with a large 7-foot parabolic umbrella and placed it up high and directly behind my head. The result is shown in **Figure 9.16**. My choice of focal length is important in this situation because it allowed me to place the subjects in the scene, allowing the environment (the soccer net) to add to the story.

Figure 9.15 An image of the soccer team before setting up strobe lights shows that there isn't much ambient light to work with.

Nikon D800 · ISO 200 · 1/250 sec. · f/4 · 45mm lens

Figure 9.16 The team is lit by a single strobe and umbrella right above the photographer's head. By zooming in to a medium telephoto of 70mm, the subjects and background are compressed together.

Nikon D800 · ISO 400 · 1/250 sec. · f/4 · 70mm lens

Compression through lens focal length

There are numerous stories to tell about the soccer team. Seeing the soccer net in the background is ideal because it helps place the team on a soccer field. But what if you wanted the players to be the only focus and cared less about the environment? You'd simply need to zoom out and step closer to the team, as you see in the next shot in **Figure 9.17**. The players almost pop off the page, and the goal fades away and is hidden in the distance. In this shot, I zoomed the lens out to 24mm wide.

Figure 9.17
 By using a wide-angle lens the team is pulled forward in the scene, hiding the soccer net in the background and making them the main focus without other distracting elements.

Nikon D800 •
ISO 400 • 1/250 sec. •
f/4 • 24mm lens

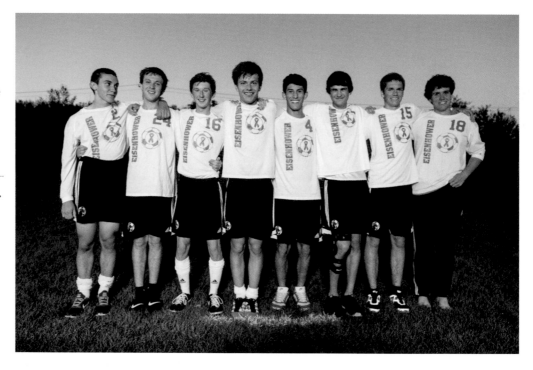

Perspective through camera angle

The last element that you can tweak in the photo—again without even touching light or camera settings—is the perspective. When most people first start shooting portraits, they take 99 percent of their photos from eye level. Although this isn't a bad thing because it is how everyone sees the world, there is a lot more to be seen photographically if you mix things up. By changing your position when taking a photo, you can drastically alter the perspective of the final shot. Let's look at how varying perspectives can portray the soccer team in different ways.

Figure 9.18 shows the same soccer team setup again, but in this photo I'm shooting down on the team at 24mm. This shift in perspective warps the players' faces up to the forefront of the photo. Recall that I talked about shooting at this angle with single-person portraits to focus on the eyes and create a more endearing image. This angle and lens selection

brings the focus to the face, but also makes people appear shorter. These guys look more like kids in this photo than the previous one.

Now if you crouch down and shoot back up at the team, as I did to shoot **Figure 9.19**, the photograph is entirely different. By shooting up I've shifted the perspective, and the players appear to be looming over the viewer of the photo. This is a great way to embolden your subjects, making them appear larger than life, which is exactly what you want to do to make a group of athletes look big and tough.

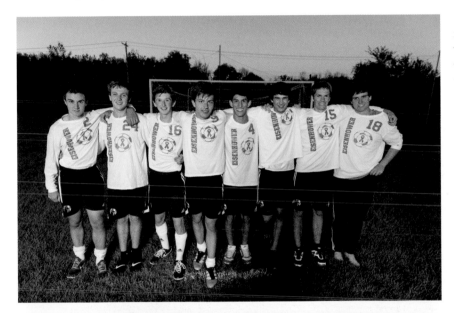

Figure 9.18
Shot from above the team looking down, which focuses on their faces but shortens people and makes them look more approachable.

Nikon D800 ·
ISO 400 · 1/250 sec. ·
f/4 · 24mm lens

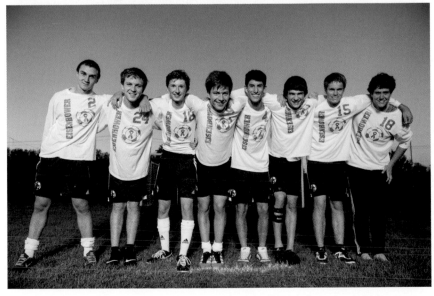

Figure 9.19
By shooting up at the team they loom over the viewer, appearing larger than life.

Nikon D800 ·
ISO 400 · 1/250 sec. ·
f/4 · 24mm lens

Multiple Lights

Now let's add the final pop to the soccer team group portrait. With a single light I've successfully lit an entire team photo. But as I mentioned earlier when taking the family photo, this one-light approach isn't always the most three-dimensional-looking light. Rather than adding a second light up front to create a different ratio (main light and fill light), I instead placed *two* more lights *behind* the subjects. These served as rim lights and outlined and defined the subjects in an edgy way.

In **Figure 9.20**, all of my camera settings remained the same—I used Manual mode—and I simply turned on two lights in the background, which immediately produced a more dramatic photograph! What you see on the ground is an added bonus: Those backlights cast cross shadows forward that give the illusion that the soccer team is standing in the middle of a field with large overhead stadium lighting.

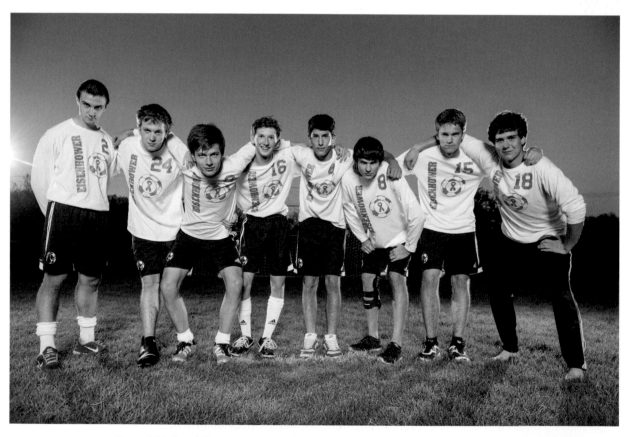

Figure 9.20 An edgier sports team portrait was achieved by adding two speedlights behind the subjects and aiming back at them to act as rim lights.

Nikon D800 • ISO 400 • 1/250 sec. • f/4 • 24mm lens

If you look at the behind-the-scenes photo in **Figure 9.21**, you'll see that the setup consists of just three lights at sunset in an empty field.

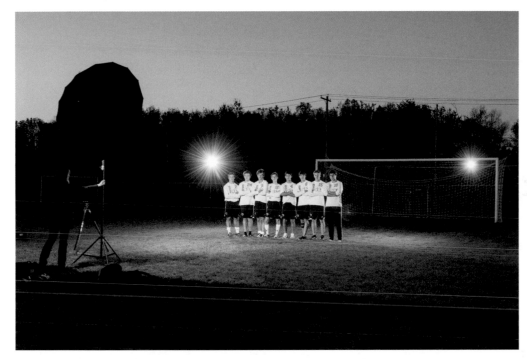

Figure 9.21
Here is a pullback of the team photo showing a large umbrella and strobe as the main light, with two speed-lights in the back as rim lights.

Nikon D800 •
ISO 400 • 1/250 sec. •
f/4 • 48mm lens

For the final shot, I needed to set up a more formal group photo, and to do so I decided to stack the team. To get both rows of players in focus, I needed a wider depth of field and an aperture like f/8. To keep the lighting ratio constant when I moved from f/4 to f/8, I needed to turn my ISO up from ISO 400 to ISO 1600. To get more depth of field, I lost two stops of light but in return got those two stops of light back by raising my ISO sensitivity two stops. The resulting photos look identical to all of the other shots, only now they have a greater depth of field to accommodate the second row of people (**Figures 9.22** and **9.23**).

By taking a wide shot at 24mm (Figure 9.22), I captured an isolated shot of the team, and then zoomed in at 70mm (Figure 9.23) to create another option with the team framed by the goal. Why did I use these move and zoom techniques? Well, would you rather move your feet and the zoom on your lens or try to move a group of high school boys and a bunch of lights? Keeping perspective and compression in mind allows you to do the moving, resulting in more photo variations and happier groups in front of your lens.

Figure 9.22
A formal group
photo using a
wide-angle lens to
bring the team to
the forefront.

Nikon D800 ·
ISO 1600 · 1/250 sec. ·
f/8 · 24mm lens

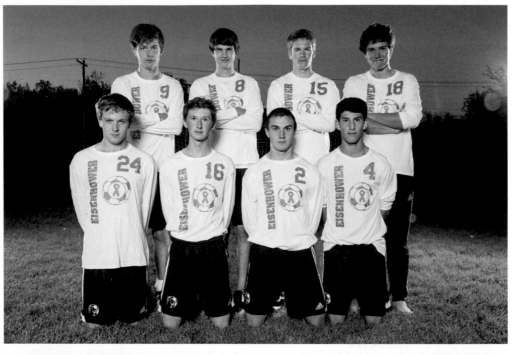

Figure 9.23
A formal group
photo using a
medium telephoto
to compress the
photo, bringing the
team and the soccer
net together in
the shot.

Nikon D800 ·
ISO 1600 · 1/250 sec. ·
f/8 · 70mm lens

Chapter 9 Assignments

Shallow Depth of Field

Practice putting two faces on the same focal plane while using a shallow depth of field. You don't need to have a 1.4 lens. An f/2.8–f/5.6 lens will do just fine to allow you to get the feel for it. By placing your subjects' eyes on an imaginary plane, you'll get them in focus while rendering a beautiful out-of-focus background.

Back to the Sun

Practice taking group photos using only natural light. Experiment with direct sunlight and then turn the group's backs to the sun. Notice the difference in the background brightness between the two and the even light on your subjects' faces.

Playing with Perspective

Get a group of people together and play around with perspective. Start by shooting wide and close like most beginning photographers do, and then step back and zoom in. Notice the difference in the distortion of the photo on peoples' faces, and take note on how the background changes.

Share your results with the book's Flickr group!
Join the group here: flickr.com/groups/portraitsfromsnapshotstogreatshots

Index

3 Point Lighting
 fill light, using, 204
 main light, 202
 rim light, 203
50mm lens, using, 38

A

A (Aperture Priority Auto) mode
 explained, 28–29
 shooting in, 4
 using with natural light, 7
 using without flash, 7
AE-L/AF-L button, 33
AF Lock and focus points, 32–33
aperture
 adjusting, 24
 and depth of field, 24
 explained, 24
 small versus large, 25–26
Aperture Priority (Av) mode
 explained, 28–29
 shooting in, 4
 using with natural light, 7
 using without flash, 7
artificial lights. *See* light sources
Auto Focus Lock button, 33
Auto mode, 4
Auto White Balance, using, 112, 117

B

background, falling out of focus, 4
background exposure, checking outdoors, 185
backlight, filling with reflector, 87–88
"baked in" settings, explained, 5
Beauty lighting, 199–200
black reflector, using, 172
blue hour temperature, 110
body cropping, 49–50
body directions, three planes of, 68

bounce
 ceiling, 142–143
 wall, 140–141
bounce cards, using, 146–147
bounce reflector, using, 89
bounce umbrella, using, 166–168
brightness
 adding, 31
 subtracting, 31
broad vs. short lighting, 160–161
Butterfly lighting, 198

C

calmness, maintaining, 19
camera, setting up, 19
camera modes
 A (Aperture Priority Auto), 28–29
 Av (Aperture Priority Auto), 28–29
 M (Manual mode), 28–29
 P (Program Auto), 28–29
 S (Shutter Priority Auto), 28–29
 Tv (Shutter Priority Auto), 28–29
camera settings
 aperture, 24–26
 depth of field, 24–26
 Exposure Triangle, 28
 freezing motion, 26–28
 monopod, 126
 shutter speed, 26–28
camera shake
 high ISO, 119–121
 image stabilization lenses, 121–123
camera support
 handholding techniques, 123–125
 tripods, 126
camera-top Tupperware, 144–145
candlelight temperature, 110
Canon
 Evaluative Metering, 5
 exposure metering modes, 30

focusing modes, 31–33
IS (Image Stabilization), 121
Picture Style (Canon) setting, 5
catchlight, effect of, 100–101, 143, 165, 167
ceiling light, using, 142–143
character portraits, 215–216
"chicken wing" handhold, 124
Clamshell lighting, 199
clean headspace, looking out for, 15
color balance, getting with ExpoDisc, 118
color temperature. *See also* indoor light
balancing, 151
Daylight preset, 112–114
Fluorescent preset, 115
Kelvin scale, 110
Tungsten preset, 114
white balance presets, 110–112
composition
depth, 47–49
explained, 41
leading lines, 44
level horizons, 42
Rule of Thirds, 43
space, 45–46
use of lines, 44
compression in group portraits, 224–225
continuous lights
benefits, 180
considering, 176
fluorescent photo, 180–181
hot lights, 180–181
LED, 181
vs. strobe lights, 180
contrast and shadow, 158
couples
focal plane, 227
shallow depth of field, 226
wide depth of field, 224–227
covered shade, 90–91
cropping
bodies, 49–51
headshots, 52–54
horizontal, 54
rules, 49–50
CTO correction gel, using, 149
Custom white balance
menu, 116

mixed light source, 117–119
single light source, 116–117

D

D200 (Nikon)
character portraits, 215–216
softbox, 195
D700 (Nikon)
body planes, 68
Butterfly lighting, 198
fluorescent bulb, 115
focal plane for couple, 227
focusing on eyes, 10
glare in glasses, 71
group portrait, 26
headshot with high contrast, 212
with high contrast, 212
High Key headshot, 210
High Key image, 201
horizontal cropping, 54
leading line, 44
level horizons, 42
Loop lighting, 196
Low Key headshot, 211
Low Key image, 200
negative space, 45
offsetting subjects in frames, 12
props, 63–65
Rembrandt lighting pattern, 197
rim lights, 209
shallow depth of field, 226
skateboarders, 67
softbox, 195
stepping back, 41
telephoto for compression, 223
telephoto lens, 39, 48
wide depth of field, 225
wide-angle distortion, 223
wide-angle lens, 37, 40, 47
zooming in, 41
D800 (Nikon)
5-in-1 Reflector, 183
50mm lens, 38
aperture and depth of field, 25
Auto White Balance, 111, 117
Beauty lighting, 199–200

black reflector, 175
body cropping, 51
bounce umbrella, 167–168
broad lighting, 160
on-camera flash, 140, 145
on-camera lighting, 156
camera shake, 119
ceiling bounce, 142–143
checking background exposure, 185
clean headspace, 15–16
covered shade, 91
cropped horizontal headshot, 53
cropping guidelines, 50
Daylight preset, 113
Daylight white balance, 111
diffused light, 183
diffused sunlight, 99–101
direct sunlight, 83
distortion, 35
environmental portrait, 214
eye-size variation, 70
family portrait, 232
fine-tuning face, 69
flash gels, 148
flash with reflector dish, 165
flat lighting, 158
gold reflector, 175
hard light, 81, 162–163
headshot cropping, 52–53
Large Rogue Flashbender modifier, 147
main key light, 202–204
mixed light source, 117
natural light for family photo, 228–229
natural reflectors, 96
natural-light headshot, 213
negative space, 46
off-camera lighting, 157
offsetting subjects in frames, 13
open shade, 95, 98
overexposed subject, 134
overhead light, 103
overhead sunlight, 83
parabolic bounce umbrella, 231
properly exposed subject, 134
pullback shot, 185
raising ISO, 120
Rule of Thirds, 43

shadow and contrast, 158
shooting down on subjects, 14
shoot-through umbrella, 169–170
shutter speed, 27
side lighting, 85, 159
silver reflector, 174
Skylux LED light, 184
soccer team, 235
soccer team formal, 236–237
soccer team with speedlights, 236–237
soccer team with strobe, 233
soccer team with wide-angle lens, 234
soft light, 81, 97, 164
soft light on face, 184
softbox and reflector, 173
softboxes, 171
speedlights, 139, 145, 182
strobe light for family photo, 230
subject turned into light, 17–18
Tungsten WB Preset, 149–150
turning subject into sun, 83
turning subject's back to sun, 85, 87
underexposed subject, 134
using reflector, 89
Vibration Compensation, 122
wall bounce, 141
white reflector, 173
wide aperture, 120
D3200 (Nikon)
 Aperture Priority mode, 7
 kit camera lens, 8
 outdoor portraits, 137
 pop-up flash, 6
 Red-eye Reduction mode, 135
 studio strobe outdoors, 187
 zooming kit lens, 8
Daylight preset, using, 112–114
depth, using in compositions, 47–49
depth of field
 adjusting, 24
 and aperture, 24
 deciding on, 25–26
 distance, 226
 explained, 24
 in group portraits, 224
 shallow, 226
 wide, 224–225

diffused sunlight
 overhead light, 103–104
 side light, 99–101
diffusion panel, using indoors, 183
direct sunlight, filling in backlight, 87–88
directing
 planes of body directions, 68
 showing versus telling, 66
distance. *See* depth
distortion, seeing, 36

E

environmental portraits
 character type, 215–216
 considerations, 217
 in rooms, 214
Evaluative Metering (Canon), 5
ExpoDisc, using for color balance, 118
Exposure Compensation, 31
exposure metering modes. *See also* metering mode
 Canon cameras, 30
 Center-weighted, 29
 Matrix, 29
 Nikon cameras, 30
 Partial, 30–31
 Spot, 29–31
Exposure Triangle, 28
eyes, focusing on, 10
eye-size variation, problem-solving, 70

F

faces
 expanding, 160
 fine-tuning, 68–69
 thinning, 160–161
family portraits
 natural light, 228–229
 parabolic bounce umbrella, 231
 strobe light, 230–232
feedback, getting, 72–73
fill light
 using, 136–137
 using in 3 Point Lighting, 204
flash. *See also* on-camera flash; pop-up flash
 fill light, 136–137

main light, 136
 using with reflector dish, 165
Flash Compensation, 133–134
flash gels, using, 148–150
flash light temperature, 110
flash modes
 Automatic, 132
 Manual, 132
 TTL (Through The Lens), 132
flat lighting, 158–159
fluorescent light temperature, 110
fluorescent photo lights, using, 181
Fluorescent preset, using, 115
Fluorescent white balance, 112
focus points and AF Lock, 32–33
focusing modes
 AF-A (Auto-servo AF), 31–33
 AF-C (Continuous-servo AF), 31–33
 AF-S (Single-servo AF), 31–33
 AI Focus AF, 31–33
 Canon, 31–33
 M (Manual focus), 31–33
 Manual focus, 31–33
 Nikon, 31–33
 One Shot AF, 31–33
 Predictive AI Servo AF, 31–33
framing subjects, 12–13
freezing motion, 26–28
f-stops, small versus large, 24
Fuji X100s
 ceiling bounce, 142–143
 covered shade, 90–91
 getting feedback on, 73
 Large Rogue Flashbender modifier, 146–147
 open shade, 96
 wall bounce, 141

G

glasses, minimizing glare in, 71
gold reflector, using, 172, 175
"good side," finding, 72, 74
gray card, using, 116, 118
group portraits
 camera settings, 222–224
 compression, 222–223
 couples, 224–227

depth of field, 222, 239
families, 228–232
large groups, 233–238
natural light, 239
perspective, 224, 239
wide depth of field, 26

H

handholding techniques
 "chicken wing," 124
 "the lean," 124
 shoulder brace, 125
hard light
 changing to soft light, 89
 explained, 80–81
 vs. soft light, 104
 source of, 162–163
headshot cropping, 52–54
headshots
 High Key, 210
 indoors, 208–209
 Low Key, 211
 natural light, 209–215
 outdoors, 205–207
High Key lighting, 201, 210
horizons, keeping level, 42
hot lights, using, 181

I

image stabilization lenses
 Active vs. Normal mode, 123
 using, 121–123
Incandescent/Tungsten white balance, 112
indoor light. *See also* color temperature; light
 diffusion panel, 183
 LED light + softbox, 184
 speedlight + reflector, 182–183
ISO settings
 low-light indoor conditions, 120
 for shooting outdoors, 119

J

JPEG format, shooting in, 5

K

Kelvin scale
 blue hour, 110
 candlelight, 110
 daylight at noon, 110
 flash, 110
 hazy sun, 110
 open shade, 110
 partly cloudy, 110
 sunrise, 110
 sunset, 110
 Tungsten, 110
 warm fluorescent, 110
kit lens, zooming in with, 8–9

L

Large Rogue Flashbender modifier, 146–147
leading lines, using in compositions, 44
"the lean" camera hold, 124–125
LED light + softbox, using indoors, 184
LED lighting, using, 181
lenses
 50mm, 38
 distortion, 35–36
 focal lengths, 33
 image stabilization, 121–123
 normal, 33
 selecting, 33
 selection and compression, 37
 stepping back, 41
 telephoto, 33, 39, 48
 wide-angle, 33, 37, 47
 zoom, 40
 zooming in, 41
light. *See also* indoor light; natural light; shade; sunlight
 bouncing, 142–143
 color temperature, 110
 direction of, 82–83
 fill, 136
 hard, 80–81, 104, 162–163

main light, 136
moving subjects toward, 17–18
overhead, 82–83
quality, 80–81
side, 82–83, 159
soft, 80–81, 104, 162–164, 184
light direction
flat lighting, 158
increasing contrast, 158–159
on- vs. off-camera, 156–157
light modifiers
flash and reflector dish, 165
photographic umbrellas, 166–170
reflectors, 172–175
softboxes, 170–172
light placement, broad vs. short, 160–161
light quality, point source, 162
light sources
choosing, 176
continuous lights, 180–181
placing, 189
strobe lights, 176–179
lighting, high-contrast, 104
lighting scenarios
indoors, 182–184
one-light classics, 194–199
outdoors, 185–188
turning subject into sun, 83
turning subject's back to sun, 85–86
lines, using in compositions, 44
locations, considering, 62
Loop lighting, using, 194–197
Low Key lighting, 200

M

M (Manual mode), 28–29
main light in 3 Point Lighting, 202
main light, using, 136
Matrix Metering (Nikon), 5
metering mode, setting, 5. *See also* exposure
metering modes
monopod, using, 126
mood boards, using, 61, 74
motion, freezing, 26–28
motion blur, creating, 27

N

natural light. *See also* light
family portrait, 228–229
High Key lighting, 210
using, 209–213
natural reflectors, using, 96. *See also* reflectors
negative space, using, 45–46
neutral gray card, using, 116, 118
Nikon
focusing modes, 31–33
Matrix Metering, 5
Picture Control setting, 5
Nikon D200
character portraits, 215–216
softbox, 195
Nikon D700
body planes, 68
Butterfly lighting, 198
fluorescent bulb, 115
focal plane for couple, 227
focusing on eyes, 10
glare in glasses, 71
group portrait, 26
headshot with high contrast, 212
with high contrast, 212
High Key headshot, 210
High Key image, 201
horizontal cropping, 54
leading line, 44
level horizons, 42
Loop lighting, 196
Low Key headshot, 211
Low Key image, 200
negative space, 45
offsetting subjects in frames, 12
props, 63–65
Rembrandt lighting pattern, 197
rim lights, 209
shallow depth of field, 226
skateboarders, 67
softbox, 195
stepping back, 41
telephoto for compression, 223
telephoto lens, 39, 48
wide depth of field, 225
wide-angle distortion, 223

wide-angle lens, 37, 40, 47
zooming in, 41
Nikon D800
 5-in-1 Reflector, 183
 50mm lens, 38
 aperture and depth of field, 25
 Auto White Balance, 111, 117
 Beauty lighting, 199–200
 black reflector, 175
 body cropping, 51
 bounce umbrella, 167–168
 broad lighting, 160
 on-camera flash, 140, 145
 on-camera lighting, 156
 camera shake, 119
 ceiling bounce, 142–143
 checking background exposure, 185
 clean headspace, 15–16
 covered shade, 91
 cropped horizontal headshot, 53
 cropping guidelines, 50
 Daylight preset, 113
 Daylight white balance, 111
 diffused light, 183
 diffused sunlight, 99–101
 direct sunlight, 83
 distortion, 35
 environmental portrait, 214
 eye-size variation, 70
 family portrait, 232
 fine-tuning face, 69
 flash gels, 148
 flash with reflector dish, 165
 flat lighting, 158
 gold reflector, 175
 hard light, 81, 162–163
 headshot cropping, 52–53
 Large Rogue Flashbender modifier, 147
 main key light, 202–204
 mixed light source, 117
 natural light for family photo, 228–229
 natural reflectors, 96
 natural-light headshot, 213
 negative space, 46
 off-camera lighting, 157
 offsetting subjects in frames, 13
 open shade, 95, 98
 overexposed subject, 134

overhead light, 103
overhead sunlight, 83
parabolic bounce umbrella, 231
properly exposed subject, 134
pullback shot, 185
raising ISO, 120
Rule of Thirds, 43
shadow and contrast, 158
shooting down on subjects, 14
shoot-through umbrella, 169–170
shutter speed, 27
side lighting, 85, 159
silver reflector, 174
Skylux LED light, 184
soccer team, 235
soccer team formal, 236–237
soccer team with speedlights, 236–237
soccer team with strobe, 233
soccer team with wide-angle lens, 234
soft light, 81, 97, 164
soft light on face, 184
softbox and reflector, 173
softboxes, 171
speedlights, 139, 145, 182
strobe light for family photo, 230
subject turned into light, 17–18
Tungsten WB Preset, 149–150
turning subject into sun, 83
turning subject's back to sun, 85, 87
underexposed subject, 134
using reflector, 89
Vibration Compensation, 122
wall bounce, 141
white reflector, 173
wide aperture, 120
Nikon D3200
 Aperture Priority mode, 7
 kit camera lens, 8
 outdoor portraits, 137
 pop-up flash, 6
 Red-eye Reduction mode, 135
 studio strobe outdoors, 187
 zooming kit lens, 8
Nikon VR (Vibration Reduction), 121
noise reduction, 127. *See also* problem solving
noon light temperature, 110
normal lenses, 33

O

octabox, using outdoors, 187
off-camera lighting, 156–157
on-camera flash. *See also* flash; speedlights
 modes, 132
 modifiers, 144–145
on-camera flash modifiers
 bounce cards, 146–147
 camera-top Tupperware, 144–145
 flash gels, 148–150
 Large Rogue Flashbender modifier, 146–147
 Stofen Omni-Bounce, 144
on-camera lighting, 156–157
one-light setups
 Beauty lighting, 199–200
 Butterfly lighting, 198
 Clamshell lighting, 199
 flat lighting, 194
 Loop lighting, 194–197
 Rembrandt lighting, 197
 softboxes, 195
open shade
 + natural reflectors, 95–98
 temperature, 110
 using, 92–94
outdoor light
 background exposure, 185
 speedlight + umbrella, 185–186
 studio strobe + softbox, 187–188
overcast days, shooting on, 99–101
overexposed subject, 134
overhead light, 82, 103–104

P

P (Program Auto) mode, 28–29
perspective, considering in group portraits, 224
photographic umbrellas
 bounce, 166–168
 family portrait, 231
 shoot-through, 168–170, 185–186
 using, 189
Picture Control (Nikon), 5
Picture Style (Canon) setting, 5
PocketWizard PlusX radio transceiver, 177
pop-up flash. *See also* flash
 red-eye reduction, 135–136

vs. speedlights, 138–139
 turning off, 6–7
 using, 151
portraits. *See* group portraits; studio portraits
poses, problem-solving, 70–72
posing, practicing, 74
positive space, using, 45
prepro
 checklist, 61
 explained, 60
 locations, 61–62
 mood boards, 61, 74
 props, 61–65
 scheduling, 61
 styling, 61
 times, 61
problem solving. *See also* noise reduction; Red-eye
 Reduction mode
 glare in glasses, 71
 uneven eye sizes, 70
props
 considering, 62
 using, 63–65

R

RAW data, interpretation of, 5
RAW file format, shooting in, 121
Red-eye Reduction mode, 135–136. *See also*
 problem solving
reflector dish, using with bare flash, 165
reflectors. *See also* natural reflectors
 5-in-1 surfaces, 172
 black, 172
 bounce type, 89
 diffusing side light, 89
 filling in backlight, 87
 gold, 172, 175
 silver, 172, 174
 translucent, 172
 using, 104, 172–175, 189
 white, 172–173
Rembrandt lighting pattern, 197
rim light
 subject and background, 209
 using in 3 Point Lighting, 202
Rule of Thirds, 43

S

S (Shutter Priority Auto) mode, 28–29
settings, "baked in," 5
shade. *See also* light; sunlight
 covered, 90–91
 open, 92–94, 98
 open + natural reflectors, 95–98
shadow
 and contrast, 158
 decreasing, 91
 increasing, 97
shoot-through umbrella, using, 168–170, 185–186
short vs. broad lighting, 160–161
shoulder brace technique, using, 125
showing versus telling, 66
side light
 diffused sunlight, 99–101
 diffusing with reflector, 89
 explained, 82
 using, 159
Sigma OS (Optical Stabilization), 121
silver reflector, using, 172, 174
single-person portraits. *See* studio portraits
skin tones, improving, 5
Skylux LED light, using, 184
soccer team
 formal photos, 238
 multiple lights, 236–238
 one light, 233–235
 shooting up at, 235
 shot from above, 235
 speedlights, 236–237
 umbrella and strobe, 237
 wide-angle lens, 234
soft light
 changing hard light to, 89
 classical, 97
 explained, 80–81
 on face, 184
 vs. hard light, 104
 rules, 162–163
softboxes
 octabox, 187
 using, 170–172
 using in one-light setups, 195
 using LED light with, 184
 using with studio strobes, 187–188

space
 negative, 45
 positive, 45
speedlight + reflector, using indoors, 182–183
speedlights. *See also* on-camera flash
 + shoot-through umbrella, 185–186
 benefits, 178
 with CTO correction gel, 149
 disadvantages, 178
 vs. pop-up flash, 138–139
 using, 133, 178
sportraits
 multiple lights, 236–238
 one light, 233–235
Stofen Omni-Bounce, 144
strobe lights
 considering, 176
 vs. continuous lights, 180
 family portrait, 230–232
 manual flash power output, 177–178
 speedlights, 178
 studio strobes, 179
 wireless triggering, 176–177
studio portraits
 3 Point Lighting, 202–204
 High Key lighting, 201
 Low Key lighting, 200
 one-light classics, 194–199
studio strobes
 benefits, 179
 modeling light, 179
 + softbox, used outdoors, 187–188
 using, 179
subject
 finding "good side" of, 72, 74
 offsetting in frame, 12–13
 overexposed, 134
 shooting down on, 14
 standing out from background, 4
 turning back to sun, 85–86
 turning into light, 17–18
 turning into sun, 84
 underexposed, 134
sunlight. *See also* light; shade
 diffused, 99–101
 direct, 86
 qualities of, 80
 temperature, 110

sunrise light temperature, 110
sunset light temperature, 110

T

taking shots, practicing, 19
Tamron VC (Vibration Compensation), 121
telephoto lenses, 33, 39, 48
translucent reflector, using, 172
tripod, using, 126
Tungsten
 light temperature, 110
 preset, 114
 WB Preset, 149–150
Tv (Shutter Priority Auto) mode, 28–29

U

umbrellas
 bounce, 166–168
 family portrait, 231
 shoot-through, 168–170, 185–186
 using, 189
underexposed subject, 134

W

wall light, using, 140–141
Westcott products
 Skylux LED light, 181
 Spiderlite TD, 181
 Strobelite, 179
white balance presets
 Auto, 112, 117
 auto, 111–112
 on-camera, 112
 Cloudy, 112
 Custom, 116–119
 Direct sunlight/Daylight, 112
 Fluorescent, 112
 Incandescent/Tungsten, 112
 Preset manual, 112
 Shade, 112
white reflector, using, 172–173
wide-angle lenses
 explained, 33
 using, 37, 40, 47

Z

zoom lens, using, 40
zooming in with kit lens, 8–9